ORAL COMMUNICATION OF THE SCRIPTURE

INSIGHTS FROM AFRICAN ORAL ART

Herbert V. Klem

William Carey Library

Library of Congress Cataloging in Publication Data

Klem, Herbert V., 1937-
 Oral communication of the Scripture.

 Bibliography: p.
 Includes Index.
 1. Communication (Theology) 2. Oral
communication--Africa, West. 3. Evangelistic
work--Africa, West. 4. Christian education--
Africa, West. I. Title.
BV4319.K59 269'.2 81-10052
ISBN 0-87808-332-4 AACR2

Published by the William Carey Library
1705 N. Sierra Bonita Ave.
Pasadena, California 91104
Telephone (213) 798-0819

In accord with some of the most recent thinking of the aca-
demic press, the William Carey Library is pleased to present
this scholarly book which has been prepared from an author-
edited and author-prepared camera ready copy.

PRINTED IN THE UNITED STATES OF AMERICA

Contents

Figures

Abbreviations

ECWA Evangelical Churches of West Africa

CRC Christian Reformed Church

DRCM Dutch Reformed Church Mission

LXX The Septuagint, a Greek version of the Old Testament

MARC Missions Advanced Research and Communications, A division of World Vision Incorporated

SUM Sudan United Mission

UCLA University of California at Los Angeles

UNESCO United Nations Educational, Scientific and Cultural Organization

Foreword

Any book that addresses the needs of 70% of the world's population needs to be taken seriously especially if it has been our habit to neglect that group. I consider this a significant book for two reasons: 1) it points us to an area that we have tended to ignore and/or to deal with in ethnocentric ways and 2) it treats the subject in such a way that we can never be so naive again.

An ethnocentric approach to non-literates assumes that they are handicapped and unable to respond properly to Christianity (or any of the myriad of other contemporary influences coming from western societies) unless they become literate. On the basis of this assumption, then, we attempt to convert them to our literacy-based communicational system "in order that they may be truly Christian." We have extreme difficulty imagining that God can work effectively with people in any other than "our" way. Indeed, we have become so locked into the assumption that people come to and grow in Christ largely through reading the Bible that we can hardly imagine how (or that) God could have worked before Gutenberg! Yet for thousands of years before the invention of printing and the consequent spread of literacy God was at work in ways just as wondrous as those He has employed in recent centuries. He simply is not limited to a single form of communication.

Literacy is important. Neither Dr. Klem nor I contend otherwise. Reading can and frequently is of great importance as a vehicle for God's interactions with human beings. But

God is not limited to literacy. Nor should we his witnesses
be. For, literate communication has extreme limitations of
which those who use and advocate it need to be more aware.
And, as Dr. Klem points out, it is not always ignorance or
perversity that leads people to reject literacy. Frequently
people turn away from literacy because they *prefer* other
forms of communication.

We in the west, with our historical orientation, have
gravitated toward using communication techniques to preserve
the past. Writing is admirably suited to such usage (as are
pictures, music and even <u>drama</u> when subjected to the pres-
sures of the printing trade to reproduce large numbers of
copies to last a long time). We have, however, often been
lulled into assuming that exact (photocopies) preservation
of the past is a good thing in and of itself. Contemporary
relevance is, therefore, often sacrificed to this drive to
preserve. And this even when the materials preserved are
(as with the Bible) intended to be intensely relevant.
Though certain readers have learned to compensate for this
deficiency, many, especially those newly literate, seldom
read in this way.

We in the west, in keeping with our mass, depersonalized
social structures, have gravitated toward depersonalized
communicational techniques such as writing, lecturing, radio
and TV. These techniques are derivative of and secondary to
such primary techniques as person to person conversation,
gesture and touch. They severely reduce or eliminate the
opportunity for interaction, feedback and consequent adjust-
ment by the communicator to meet previously unanticipated
needs of the receptors. They are, therefore, adequate only
as means of announcing, displaying or expressing what is on
the potential communicator's mind. They are one way
vehicles and it may be questioned whether it is right to
label them "media of communication." Perhaps it would be
more accurate to label them media of performance, expression
or announcement.

In most of the world people expect more from communica-
tional situations than mere preservation of the past,
announcement or performance. They expect to participate, to
interact as people with people. They, therefore, favor
communicational vehicles that are lively, flexible, oriented
toward the present and adaptable to any change in the circum-
stances. They may also prefer that as often as possible
communicational situations be transformed from humdrum
encounters into genuine events. For such people, sitting by

oneself reading a fixed presentation of information concerning events that took place long ago and far away from an impersonal book is simply not satisfying enough to induce them to expend the effort to learn how to read.

Jesus knew this and employed communicational techniques that endeared him to the common people but upset those with a past, static orientation derived at least in part from their commitment to literate communication (or at least literate credentials - see Acts 4:13). But can we, like He, learn to free ourselves from dependence on literacy? Can we come to see and to employ the vital indigenous oral systems by means of which traditional peoples worldwide expect to get "turned on"? And will we encourage national leaders (who have often become even less flexible than we in their commitment to western communicational techniques) to recognize that God endorses the use of whatever vehicles best convey the message to the receptor group in question?

Dr. Klem aims both to inform us and to challenge us to answer each of these questions positively. To do this he has surveyed an impressive amount of the material literarily preserved concerning his subject and engaged in a rather fascinating field project. He has, then (according to our custom), presented the results in a book that aims at pushing you, the reader, beyond this or any other book into forms of communicating God's Message more worthy of the livingness of that Message than any book can be. I highly commend his book to you.

<div align="right">

Charles H. Kraft
Pasadena, California
January 1980

</div>

Introduction

ABSTRACT

This study to assess issues vital to the communication of
the Gospel started in West Africa based on a wide-spread
pastoral opinion that there is an urgent need for a deeper
knowledge of the Scriptures. But these fundamental prin-
ciples and implications apply not only to most developing
countries of the world but to growing segments of European
and American audiences as well. During the last 100 years
or so we have assumed that if people were to learn the Bible
they must first learn to read it for themselves.

Yet in many parts of the world even where the Gospel has
been preached and taught for a century or more up to three
quarters of the people may not read at all. Even in Europe
and the United States which are reckoned to be quite literate
it is estimated that perhaps half of the people do not read
well enough to understand when they try to read new informa-
tion or may simply avoid the printed word as a matter of
habit. Perhaps as much as 70% of the world's population is
not likely to take an interest in the Bible if we take a
literary approach to teaching unless we can find better ways
of involving them in positive reading experiences.

There are at least three fundamental issues to face. How
can we best share Bible knowledge basic for growth in Christ
among the world's non-reading masses? What can the non-
reading masses teach us who have a more bookish orientation?
What can we learn about human communication which will give

us a better understanding of how literacy can best be intro-
duced with a most positive sociological impact when it is
introduced in a largely non-reading community? This study
is an attempt to plan for better ways of spreading Bible
knowledge and to help bridge the gap between the schooled
and the unschooled people in the churches in a West African
setting.

The first section examines the communicational complexity
in West Africa prior to the arrival of the missionaries and
the introduction of western schooling. The progress of
modernization, western education and industrialization have
done much to further divide the people into socio-economic
segments which further complicate life. The potentially
disastrous cultural gap between the wealthy and the poor is
not just a matter of money but it is also a question of the
channels of communication used by the different segments of
society. Particularly in this context the method of
communication does much to select the segments of the aud-
ience which are likely to be able to pay attention or respond
favorably to the message.

The heavy dependence upon the use of western books to
communicate Bible knowledge and Christian education has done
much to shape the popular identity of many forms of Chris-
tianity. Those who have attended Christian schools have
benefited economically but have not necessarily all become
zealous Christians. The masses who have not obtained higher
levels of schooling are too frequently separated socially
and economically from their more academic countrymen and are
also injured in their spiritual growth. They are frequently
unable to learn what is in the Bible and are also denied
places of respect in the churches. Many churches instead of
being led by converted mature believers are led by young men
who have been to the right school.

The second section focuses on first century Palestine
which had somewhat similar social and communicational divi-
sions. There were those who insisted upon a method of
religious education that depended upon a form of literacy.
Jesus apparently broke socially and religiously with this
religious elite of His day. He structured a ministry among
the common people which relied very heavily upon oral communi-
cation in a style that lent itself to memorization. With some
modification Jesus used the educational media already present
among the common people allowing the unschooled Aramaic
speakers to hear Him gladly and to learn His message well.

There is ample evidence of a large body of oral literature in West Africa today. It is learned and taught orally. This oral system employs very powerful tools for learning, teaching and influencing opinion. It is intimately related to the people's sense of cultural identity. This large and prestigious body of oral art is ample evidence that the people are capable of both learning and teaching others vital information without first learning to read it.

Various qualities of traditional African oral art are described in the third section. Reasons are given indicating why this type of communication is a very powerful approach to education. There is much evidence that even in modern Africa oral communication in a variety of styles will continue to be important for some time to come.

The concluding section is a report on the experiences of the writer in Nigeria. He arranged for the Epistle to the Hebrews to be translated into a style of modern Yoruba which was possible to sing in a traditional type of Yoruba music. Bible lessons were taught with written materials and some were taught using only song to present the Bible passages. While the most effective lessons were those using both books and songs, those who studied using only songs without any written materials learned just as much as those reading from books. Lessons taught with songs were much more pleasing to the people and attracted visitors. Such lessons taught in vernacular languages have the potential of reaching all the people of Africa with what is needed for Christian maturity today. The people do not have to wait for some distant day when most of the people reach full functional literacy before they can study the Bible for themselves.

This concept of identifying the content of the Bible passages with the culture of the audience by using the musical and oral art forms of a particular Christian or non-Christian audience has implications for indigenous Christian education in many parts of the world particularly for those people who find reading difficult or unattractive.

PERSONAL EXPERIENCE

For more than eight years I was involved in teaching Bible and Theology in Nigeria, West Africa. Part of this time was spent working in a seminary in central Nigeria, just south of the Niger River in Yorubaland. The students came from all parts of Nigeria. Many of the men were experienced pastors, and most of them were academically qualified to attend university. Most of our studies were done in English.

During these years one of my primary goals as a missionary was to help spread a healthy understanding and knowledge of the Scriptures among the ordinary working people. This is part of the work of evangelism. A correct understanding of the Bible is essential to the genuine conversion of the people and the establishment of a church that will endure the tests of time.

It was my original plan to first gain rapport with the people as I taught Bible in a secondary school, and then to help in a pastor training program. Then the Nigerian pastors could spread the Word of God more widely among their own people than I would be likely to be able to do as a missionary.

It was my privilege to work with a dedicated and talented group of pastors and students. Yet the more I listened to what my students were telling me and the more I listened to the elders in the churches, the more disturbed I became over an apparent lack of communicability to much of what we taught. Our students were very capable of doing advanced academic work and performed well in our school. But many of the things we so carefully taught in the secondary schools and the theological seminary were not being widely circulated among the common people who had not completed primary school. Even the most carefully trained pastors had great difficulty sharing their hard won knowledge with people who attended church regularly. Fellow faculty members, church leaders and pastors agreed that there was not a good flow of Bible knowledge and doctrinal information among the people.

There appeared to be a comparatively small, dedicated minority of pastors and church leaders who understood the Christian message as it was taught in the schools and by the missionaries for many years. Most of these people could read their Bibles. But this kind of understanding had not yet been extended to the vast majority of the common people (see chapter 2). I came to suspect that the great majority of the people were primarily involved with their own indigenous ways of thinking. This made it very difficult for them to appreciate our rather western presentations of the Scriptures and Bible doctrine.

This present study was undertaken in an effort to find better ways of spreading a working knowledge of the Scriptures among all of the people, with particular attention to the vast majority who had not yet completed four or more years of formal schooling. My intention was to design and

evaluate better ways of teaching the Bible among the Yoruba
people who had minimal formal schooling.

The study was approached as a problem in communication.
I began by attempting to analyze two sets of factors hinder-
ing the flow of Christian information among the people. I
sought to study the communicational and educational policies
that most missions had employed in West Africa and Nigeria.
I also started to study the communicative and social struc-
tures of West African societies and the Yoruba people in
particular. The purpose of these studies was to identify
any unnecessary conflict between the communicational poli-
cies we missionaries had been following and the indigenous
communicational structures. In any human society we may
expect natural spiritual resistance to the gospel of Jesus
Christ. But were we perhaps provoking additional human
resistance due to cross-cultural differences?

THE PROBLEM

Modern missions to Africa began during the second half of
the seventeenth century. Since that time most mission
leaders have assumed that the natural way to Christian
maturity was through literacy, schools, public and private
Bible reading. Missions have therefore established literacy
programs and schools in the lands where missionaries worked
(Ayandele 1966:290ff). It became a general mission policy
across Africa to require literacy for church membership
although there were many exceptions (Barrett 1968:127). The
need for literacy has undoubtedly done much to establish
western education in African countries such as Nigeria
(Ayandele 1966:290ff; and Parsons 1963:18). However, after
nearly one hundred years of mission and government literacy
training programs, the number of people who can or will
read to gain vital information is very small. In some areas
literacy approaches 25 percent, but in most rural areas it
is likely to be less than 5 percent (Nasution 1972:12,13).
Across the continent literacy is less than 20 percent and
is likely to remain close to this figure for some time to
come (Jeffries 1967:163; and Mahu 1965:28). Furthermore,
only about half of those counted literate could actually
read well enough to meaningfully receive new information via
written communication (chapter 2).

Therefore, if our goal is to communicate a knowledge of
the Bible and the teachings of Jesus that can set all men
free, we will have to consider more fitting methods of teach-
ing. It is simply not possible to effectively reach most of
our present generation with a written message.

The impact of the introduction of literacy into the largely non-reading societies of West Africa by missionaries and western schooling is hard to estimate. Ethnic, "horizontal" or tribal groupings have traditionally defined the major social divisions of African societies. However, as a result of missionary literacy training, western schooling, and industrialization, additional educational, economic, and communicational social divisions have been produced. This has resulted in a kind of "vertical" segmentation within the old social units. One of the most important factors in the growing communicational distance between these newer "vertical" segments is the use or non-use of written mass media (Mahu 1965:36). The fact that only a few are schooled enough to be proficient in written communication has been a potent factor in the re-distribution of power and material wealth. Those who became functionally literate acquired economic power and social prestige to become the "new elite" described by Ayandele (1966:xviiif) and Ajayi (1965:xv, 126ff).

The success of these "new elite" trained in mission schools has done much to identify Christianity with literacy and socio-economic "advancement." The use of literacy in the churches and the greater prestige granted the most literate pastors and church leaders has given the church a western image. This western image has attracted some, but discourages large numbers of others who either prefer an oral (or non-reading) social identity, or fear that they will not be able to become proficient in such a western way of communicating.

ORAL COMMUNICATION SYSTEMS

In order to probe the problems surrounding this dependence upon literacy it was found necessary to study the communicational systems indigenous to West Africa as done by Dorson (1972), Finnegan (1967 and 1970) and Babalola (1966) (see section III). The non-reading masses of Yorubaland and much of West Africa are oral communicators. They are usually illiterate only by western standards, since they give great attention to the preservation and transmission of oral literature. It is not that they do not learn, teach or communicate. It is that we from the west do not appreciate a system based on oral (rather than written) communication and memorization as is customary in an indigenous African setting. There was and is an indigenous communication system perfectly capable of being used to communicate the gospel effectively to the majority of the people. They do not have to learn a new method of communicating.

These indigenous oral communications systems are at the very heart of the indigenous social order (Finnegan 1967: 1-5; and 1970:1,4,10; and Cole 1971:44-55; and Tippett 1961:18). They have great social significance vital to the ethnic identity of the people and the survival of ethnic cohesion (Tippett 1961:18; and Orso 1974:25-35). It appears that at the very core of the conflict of cultures in Africa today is the question of which kind of communication the people will use—western printed media, or more indigenous oral-audio (aural) media. Perhaps even the survival of the indigenous social order is at stake. My findings indicate that considerable resistance to the teachings of the Bible is needlessly engendered by our heavy dependence upon written materials in segments of societies accustomed to communicating orally.

On the basis of the findings of such a study of indigenous communication it is hoped that we can learn to redesign programs for teaching the Bible in such a way as to minimize this cultural resistance to Christian teaching methods. I have attempted to find ways of working in harmony with indigenous teaching techniques and to use indigenous modes of teaching. I hope that this will enable people to learn and to teach the Bible even if they have not been to western kinds of school. Then the great majority can participate even if they have not been through a western school system. Very little work has been done in this area (Weber 1957:35).

I have sought, furthermore, to see how Biblical such an approach would be. The Bible has come to us as a book, and we tend to study it only as a written document. Yet it is a record of communicational events that were primarily oral rather than written. In section II, therefore, I attempt to analyze the social and communicational structures of first century Palestine in the light of rabbinic studies (Ebner 1956:1-50; and Moore 1946:300ff; and Rosowsky 1957:1). Of interest are such things as the extent of the Jewish school system, the types of literacy training it provided and the kinds of written and oral communication used in Christ's day. Christ stands out as an oral teacher who taught the illiterate masses through oral poetry. Burney (1925) and Toyotome (1953) devote entire books to the poetic quality of Christ's teaching.

When the levels of literacy present in Christ's day and the social meaning of elite modes of communication for Christ's day are compared with the situation in much of modern Africa, there are striking similarities. These

similarities indicate how fruitful and right it is for us to imitate the communicative policies of Jesus as we minister in Africa.

The final section of this dissertation is a report of an experiment in the use of African (Yoruba) oral art to teach Bible knowledge. The work was done with a team of Nigerian theological students, and a professional recordist, E. A. Adebiyi. The goal was to determine the viability of oral communication via African oral techniques for teaching the Bible. In this case we used distinctively Yoruba music to present the first six chapters of Hebrews. We were also interested in promoting the memorization of the text.

Two hypotheses were tested. First, that it is possible for Yoruba people to gain significant knowledge of a portion of the Word of God without going through the effort and extensive culture change involved in becoming literate. The second hypothesis is that the presentation of a Scripture text orally via indigenous music will increase the amount of information that is retained. The experiment was conducted by teaching Bible classes on the book of Hebrews in two rural towns in Yoruba-speaking territory.

THE SCOPE OF THIS STUDY

This study is focused primarily on West Africa, with a particular goal of better understanding the Yoruba people of Nigeria. There are two spheres of interest: mission policy and indigenous modes of communication.

Studies in the communicative policies of missions working among the Yoruba people cannot easily be separated from the general policies of missions working in Nigeria, West Africa or indeed in many other parts of the world (Ajayi 1965:126; and Tucker 1966:47ff). Policies are generally very similar across Africa (Barrett 1968:127). Wherever missions depend on using written teaching tools among people who rely on oral communication, this study of indigenous alternatives for communicating the Bible may be relevant.

Most of my practical experience has been in Yorubaland in Nigeria. But I have also worked with missionaries, pastors and church leaders on location in Liberia, Ivory Coast, Ghana and Kenya. There has been opportunity to discuss these issues with pastors from many parts of Africa. I have found general agreement among these pastors about the relevance of this study for much of Africa today.

Oral art exists across the continent. It is vital to indigenous social structures, and has general characteristics of form that are broadly pan-African (Finnegan 1970:520; and Dorson 1972:4,168f; and Herskovits 1958:165).

The degree to which this study may be relevant to evangel ism and Christian education in other parts of Africa and the world may depend upon such factors as: 1. The percentage of the people who readily understand and use written communication; 2. The types and amount of indigenous oral communication used among the non-readers; and 3. The values various segments of a society presently attach to indigenous versus western forms of communication.

POSITIVE VALUES OF WRITTEN MATERIALS

This inquiry into the circumstances in which oral communication ought to have priority over written communication of the Biblical texts is undertaken about 400 years after the invention of the printing press. It comes after we in the west have become accustomed to mass literacy and come to assume books to be an ideal method of popularizing information. It is only recently that scholars have begun to make a critical evaluation of the impact of the use of written communication upon the quality of human life (Goody 1963:1, 13,42; and Disch 1973:6). It is fitting that those of us who are interested in bringing Christian education to the world should study the social impact of reading from books as compared to oral memorization of the Scriptures.

The Bible itself is a written book. Various Bible characters such as Moses, Isaiah, Jeremiah and St. John were specifically instructed to write fixed records of the Word they received (Ex.17:14; Ex.34:27; Num.33:2; Isaiah 8:1; Jer.30:28; Hab.2:2; Rev.1:3,11,19ff). This fact indicates that it is God's desire that there be a written text. I am personally convinced that we should bend every effort toward the production of written translations of the Bible in every language and culture. Those who read must be encouraged to use the written Scriptures. People who want to read must be encouraged to learn to read their Bibles.

However, within the New Testament itself we find both oral and written communication employed--with a preponderant emphasis on oral techniques. Paul employed both oral and (to a lesser extent) written techniques in his ministry in a Greek cultural context. Jesus had a largely oral ministry in an Aramaic milieu. It appears that Jesus himself left no

written documents. Papias gives us our only clue that
Christ's words were ever written in Aramaic or Hebrew for
the Hebrew church. But even Papias preferred the authority
of material from Jesus that had been transmitted through
oral means (Barclay 1966:161; and Filson 1938:58,95). In an
earlier day Moses was commanded by God to teach the people
to sing a poem in order that thereby they would continually
remind each other of his mighty acts among them (Deut.31:
19-22). It is thoroughly Biblical to plan for popular dis-
tribution of the Scriptures via memorization (see section II).

It is not that non-readers do not communicate. It is
that we from the west know so little about teaching oral
communicators (Weber 1957:34). We have yet to set criteria
to determine where and when people ought to be taught via
oral means and when they ought to be taught via printed
materials. Only then can we wisely determine when and where
to use each of these Biblical patterns of teaching. Our
cultural pride in our own ways may blind us to the values of
communal oral memorization.

VALUE OF STARTING ORALLY

The evidence presented in the third and fourth sections
of this dissertation indicates that the Yoruba people and
other African peoples have a definite ability and inclina-
tion to teach Bible knowledge orally. These non-readers
are actually oral communicators because they preserve and
communicate great bodies of cultural material orally (Finne-
gan 1970:1). They are culturally prepared to learn and to
teach the Word of God without western types of literacy.
These oral methods have the potential of effectively reach-
ing the vast majority of Africans living today.

There are compelling reasons why both Christianity and
literacy are best introduced through indigenous oral media
in a society of oral communicators. It is apparent that
western methods of introducing literacy and schooling have
effectively reached only a limited part of African society
and are not likely to soon effectively reach more than a
small segment of the total population. The evidence pre-
sented in sections I and III indicates that the lamentably
slow growth of literacy is due in part to the way literacy
is usually introduced. Literacy and schooling are frequent-
ly introduced in direct conflict or competition with indig-
enous oral communication and the social structures associated
with the oral arts. This cultural confrontation of different
modes of communication sets in motion indigenous opposition

to both literacy and western forms of Christianity that
depend upon extensive use of reading (chapter 9). In the
light of the oral ministry of Jesus Christ, this cultural
opposition to Christianity need not be systematically pro-
voked. Bible knowledge can be effectively taught and
learned without literacy.

Approaching oral communicators with indigenous media
reduces resistance to literacy and Christianity in several
ways. The use of indigenous media allows the people to
approach the material with existing skills. An indigenous
definition of learning allows those who expect to memorize
what they learn to feel fulfilled. This allows them to
become teachers of the material relatively early in their
experience with the new material. It allows for continua-
tion of indigenous patterns of leadership and existing
patterns of leadership are not disrupted by a demand for
new communicative skill among Christian leaders.

Familiarity with the Christian message gained through
indigenous media prepares for the use of the Bible in
written form in several ways. Experience with the Scrip-
tures and Christian growth can motivate a strong desire to
pursue reading skills. It is easier to learn to read a
familiar message than to read completely foreign materials.
Once the passage is understood and the material is predict-
able, attention can be given to the mechanics of reading.
The problems of learning to read are then not compounded by
the problem of trying to understand new material. Practice
reading of what has already been largely memorized may help
to provide adults with satisfying practice in reading skills,
and avoid afflicting adults with childishly simple reading
materials.

ACKNOWLEDGEMENTS

Over a period of nine years the people of Kwara State,
Nigeria and in particular the churches of Egbe and Igbaja
towns added to my understanding of life and mission work.
While Nigerian scholars such as Professor E. B. Idowu and
J. F. Ajayi have taught me much through their books, the
ordinary church members who shared their lives with me and
expressed their opinions have contributed just as heavily
to the opinions expressed here.

Work initially started on the research project in 1971
when I attended the International Institute of Christian
Communications and then began supervision of the Living Bible

paraphrase project at Igbaja, Nigeria. I would like to
thank the five teachers, Pastors J. Adeyemi, M. Aina, R.
Babatunde, S. Makanju and E. Oshe for their dedicated efforts
and Mr. Jeremiah Okorie and Mr. James Obielodun for their
help in preparing materials and their supervision of the
experimental work. Thanks to the zeal of Rev. E. A. Adebiyi
the composers were found for setting the book of Hebrews to
music.

Library studies were carried out at Igbaja Seminary and
Ibadan University. Intensive study of African oral communi-
cation began at the School of World Mission in 1973 under
the supervision of Dr. Alan R. Tippett who initially dir-
ected me to the research facilities of the University of
California at Los Angeles (UCLA). Dr. Charles H. Kraft as
my mentor has directed my studies in translation theory and
the communicative strategies of our Lord Jesus Christ.
During the academic years of 1973 to 1975 a total of five
months were spent in Nigeria supervising the testing of the
translation, arranging for the musical presentations and
administering the experimental work. The work in Nigeria
is continuing under Nigerian management, with which I main-
tain regular contact.

At the School of World Mission Drs. Kraft, Tippett and
Glasser have contributed greatly to my understanding of the
issues involved in this dissertation. For the selection of
their statements, arrangements of the ideas and any conse-
quent distortion or misrepresentation of their ideas, the
present writer is, however, responsible. Particular grati-
tude is due to Dr. Kraft for his patient and extensive efforts
to promote law and order within this document, for his
encouragement along the way and for his hospitality. I am
also grateful to Mr. Carl Pierchala for his assistance in
computing the statistical data collected as part of the
experimental work.

I am greatly indebted to Dr. Donald K. Smith and the
other leaders of Daystar Communications, and to Dr. Kenneth
Taylor of Living Bibles International for their supervision
and allowance of time to do this study. My family and I owe
a special debt of gratitude to the churches that have
supported us both during this project and in our ministry as
a whole. And how shall I thank my wife, Barbara, for moving
our family about the world with me, working to pay our bills,
typing the drafts and generally putting her husband through
this epoch of our lives?

Part I

Contemporary West African Society and the Communication of the Gospel

1

Social Complexity

INDIGENOUS CULTURES – HORIZONTAL SEGMENTATION

One of the most basic factors of African society is that the homogeneous groupings tend to be small due to ethnic, linguistic and cultural divisions. Within the boundaries of modern African nations are many indigenous tribal groups that speak mutually unintelligible languages. A recent survey indicates that in Nigeria alone there are over 500 languages that are mutually unintelligible (Grimes 1974:149). A conservative estimate of the total of different languages for the continent of Africa given by Dr. Charles Kraft is between 1,500 and 2,000 mutually unintelligible languages. Each tribe or group speaking its own separate mother tongue may have a culture or way of life that is seriously different from every other tribe. We may speak of these ethnic or linguistic divisions as "horizontal" divisions among the people of the land. These "horizontal" divisions of language and culture are formidable barriers to good communication.

These divisions obstructing horizontal flow of information from one small scale society to another are diagrammed in Figure 1. This figure shows a series of larger and smaller ethnic entities (labled with numbers). These divisions are internally rather homogeneous in terms of social structure, methods of communication and cultural identification.

FIGURE 1

HORIZONTAL DIVISIONS

WESTERNIZATION

Within each of the traditional societies were a variety of social forces working for the survival of the tribal community to maintain social solidarity and dependable patterns of loyalty that Alan Tippett has called ethnic cohesion (1961:3). Goody writes about the "homeostatic organization" of traditional societies that is sustained by the arrival in Africa of western cultural influence and western schools, a comparatively new set of "vertical" social divisions began to appear within many of the traditional societies.

There is abundant evidence that the extent of western education that people gain is the major reason for this kind of vertical division in African society. Richard Dorson states that it is western civilization that has "created a chasm between the *learned* and the tradition-oriented classes" (1972:3). He writes that in tribal society all of the people were required to participate in communal ceremonies. This greatly unified the people socially in spite of the social privileges of some community members. But among those who have been to school or are westernized enough to enter what he calls "national culture" there is a great break from the traditional culture. Dorson writes,

The intellectuals in professions, on the university faculties, and in government seem sometimes to have

more in common with intellectuals in other countries
than with their tribal countrymen (1972:4).

Jack Goody agrees that the use or non-use of literacy
(resulting largely from western schools) is the primary
cause of the great cultural chasm opening between the mem-
bers of traditional African tribes (Goody 1968:1-68). He
attempts to show how the use of writing changes a person's
entire approach to life and ways of thinking.

Kimball (1973:xiii) states that the schools and the use
of writing as a means of cultural transmission prevent the
older people of Africa who do not write from successfully
enculturating those of their own children who go to school.
Only those children who remain in the home without adopting
the new method of receiving information can be enculturated
into the culture of the older generation.

It is usually the young people who go to school and
learn how to read. Mahu writes,

The relations between illiterate parents and educated
children are impoverished and distorted, making the
transfer of responsibilities difficult and even
chaotic (1965:36).

He goes on to lament that this great cultural intrusion is
dividing communities in Africa and around the world, wher-
ever large numbers of people who communicate orally live
together.

Michael Cole describes the ways schools in communities
with large numbers of non-readers create division and even
hostility between those who become westernized and those who
do not. He quotes students who have gone to school and find
they can no longer communicate with their parents because
they have been exposed to "new institutions and the correct
way to live" (1971:57). They use writing to express their
ideas and solve their problems. A student complains,

Now I'm no longer able to communicate with my family
as much as I used to do. There are many things which
my people do which I consider wrong, such as drinking
dirty water, living an in area with lots of dirt
around...(1971:55).

Cole then shows how this indoctrination into another culture,
though alienating the youth from their parents, does not
provide adequate compensation for the price they have to pay,

The negative and *hostile* attitudes that many success-
ful school children develop toward their families and
social groups are scarcely compensation for the
learning that occurs in six years of schooling (1971:
58, my emphasis).

The process of westernization and the building of a western
school system were largely initiated by missionary effort.
The major result, however, contrary to the expectations of
the missionaries, has been the establishment of a new elite,
a new "vertical" social division within Nigerian society
(Ajayi 1965:xiii; and Ayandele 1966:290ff). The commercial
success of this new "elite" or middle class has done much to
identify Christianity in West Africa with western education
and literacy. While it was hardly the aim of missions to
divide African society against itself, it can be shown that
the desire to separate the converted youth from the culture
of their elders was seen as an essential part of the program
of Christianization (Beaver 1967:103; see also Chapter 3
below).

CURRENT SITUATION - VERTICAL SEGMENTATION

The result of the introduction of western schooling and
written communication is that a continent already divided
horizontally along linguistic and ethnic lines, is now also
divided vertically according to degrees of schooling, skill
in the use of written communication and economic distinc-
tions originating in the west. The condition of an area
prior to the process of westernization, with only horizontal
ethnic divisions, can be shown in a diagram such as figure 1
above.

The following diagram presents the condition of such an
area after the introduction of literacy and western school-
ing (section A). Among these people are some who are rather
westernized and detribalized. For them the old tribal
divisions and cultural distinctives have relatively less
significance and the cross-tribal unifying influence of
westernizing factors is more important. This is indicated
by using broken lines to divide the section A (westernizing)
segments of each tribe from each other.

The segments labeled B represent those in each tribe
whose level of schooling or proficiency in the use of
written communication enables them to have only limited
communication with the outside world through written communi-
cation. These can attain only minor positions in an indus-
trial economy.

The section labeled C (with the cross strokes) represents those in each tribe who have extremely minimal literacy skills. These may merely aspire to western education or to the use of written communication.

The great masses of the people are represented by section D (see chapter 2). They are not literate, nor do they have an unambiguous desire to become literate. They have an "oral identity," and are largely negative about and resistant to becoming literate.

FIGURE 2

HORIZONTAL PLUS VERTICAL DIVISIONS

A	A					A			A	A
B	B					B			B	B
C	B					C			B	C
	C								C	
D	D	3	4	5	6	D	8	9	D	D
1	2					7			10	11

In figure 2 there is no attempt to reflect specific levels of schooling or literacy for any given ethnic group, but only to show that literacy fluctuates from group to group. There has been a general effort to reflect the proportions of literates and non-literates in Nigeria as reported by the United Nations reports. This is more fully discussed in the following chapter.

This diagram illustrates the general patterns of the distribution of reading skills and of the social and economic rewards that accompany such skills. There are certainly individual exceptions such as wealthy politically powerful non-readers. But they are not typical of Africa's new leaders. There may be societies that are exceptions. But the diagram shows my understanding of the prevailing social pattern.

2

Communicational Complexity

AN ORAL SYSTEM EXISTS

The complexity of communication in Africa has not been fully
appreciated until recently. In the early days of contact
between Europeans and Africa, Europeans were generally of
the opinion that in traditional African society there was
comparatively little knowledge, education or communication
(Finnegan 1970:20). But with the publication of works on
African oral art such as those of Ruth Finnegan (1967 and
1970), Richard Dorson (1961 and 1972) and others, it can no
longer be pretended that little worthwhile communication is
in progress among those who do not attend school. On the
contrary, even in modernizing Africa, oral (non-literacy
baséd) communication and oral tradition continue to thrive
at the very heart of the social and intellectual environment
(Vansina 1961:2). A description of the forms and functions
of the oral communication system within which the majority
of the people of Africa communicate is given in section III
of this dissertation. The point being made here is that
there is without literacy a valid and effective way of
spreading knowledge and passing on cultural tradition widely
employed in Africa.

This system is not dependent upon writing or western
schooling. It is oral and audio. It depends upon oral
performance, the memories of the individuals and the collec-
tive remembrance of the community. Because this oral system
exists we can not assume that peoples who do not read or
write do not communicate.

It is difficult to speak with complete assurance of accuracy of the extent of literacy or illiteracy in Africa. Such statistics as exist on literacy can, however, give us insight into the extent of oral communication, and the number of those who depend upon it. We need to understand what proportion of the people can effectively use printed media.

PERSPECTIVE ON WORLD LITERACY

The data on literacy in Nigeria have greater meaning if seen in the light of the more general movement toward literacy in the world. We who have come from Europe like to think that we come from a literate cultural heritage and that our people have always been literate. However, though literacy first appeared in the ancient Near East over 5,000 years ago and writing came to Europe over 2,000 years ago, as late as 1850 less than half of the adults of Europe were literate. Of every 100 adults only about 40 could read at all, and half of the 40 would have only marginal skills (Cipolla 1969:71). But by legal action public funds began at that time to be spent on universal primary education and literacy steadily increased thereafter (ibid).

Around 1850 the United States was well ahead of Europe with 90 percent of our adults over 20 years of age literate, according to U.S. census figures (ibid: II,94). The author who gives these figures believes that the progress of industrialization and the growth or prosperity in America were due in part to the contribution of literate craftsmen and amateur scientists who could transform the way they worked because they were literate. This is in general agreement with the opinions of M. Weber (1930:13,27) and Tawney (1952:279f). Now most so-called developed nations report more than 97 percent literacy (UNESCO 1971:29-35).

Much of the west has entered the era of mass literacy only in the last 150 to 200 years. Cippola argues that this is directly related to the unprecedented growth of modern material prosperity (Cipolla 1969:23-25; see also Gillette 1972:27; and Mahu 1965:29). Neither the economic conditions nor the progress in literacy of the rest of the world is as good. In 1920, 38 percent of the world was reported to be literate. The report for 1957 indicated a rise in literacy to 66 percent of those over 15 years of age. But 90 percent of the world's non-readers were in 97 countries, and three quarters of them were concentrated in only 14 countries (UNESCO 1957:10-47, 190; and UNESCO 1958: 9-13). This means

that literacy and material prosperity are centered in some
areas while poverty and the inability to read are concen-
trated together in other areas (UNESCO 1957; see also UNESCO
1970a and Mahu 1965:29).

Compared to the rest of the world, most of Africa seems
to have a combination of low per capita income and the low
rate of literacy. In 1950 the continent as a whole was
rated as 10 to 20 percent literate, with Nigeria rated about
10 percent (UNESCO Basic Facts 54 & 12). By 1960 literacy
in the continent had increased to 19 percent and by 1970
still further to 26.3 percent, according to United Nations
statistics (UNESCO 1970:29).

The recent data on Nigeria are not consistent, and the
recent census taken by the Nigerian government has been with-
drawn from circulation. As of 1951, however, the United
Nations reported 10 to 15 percent literacy in Nigeria
(UNESCO 1957:38). A 1969 report estimates that at that time
urban populations of Africa were as much as 20 percent
literate. But the rural areas where the majority of the
people lived were about two percent literate. The combined
average of rural and urban populations for Nigeria was given
as 15.5 percent (Nasution 1972:12-15). The comparative
International Almanac shows 11 percent adult literacy for
Nigeria (1968:195). A current report claiming to be based
on UNESCO data indicate 25 percent literacy for Nigeria
(Time, Dec. 22, 1975:37).

These findings for Nigeria are parallel to trends noted
by an international conference of ministers of education
that met to discuss the eradication of illiteracy. In 1950
between 55 and 60 percent of the world was estimated to be
literate (Mahu 1965:27). By 1962 the estimate had risen to
62 percent, so over the same period of years population
growth among non-readers had caused the net number of non-
readers to increase by some 35 million. So in absolute
terms the number of non-readers is growing (ibid, p. 27-29).
There is, however, a difference between statistical literacy
as reported above and what may be called functional literacy.

FUNCTIONAL LITERACY

Literacy figures as traditionally calculated mask the
fact that there is no workable standard for determining what
minimum literacy is, and who has attained it. In some sur-
veys the opinion of a head of a house or another family
member is accepted as the estimate of how many people in the

family can read. The fact that a person has attended school
may cause him to be counted literate, in spite of the fact
that in many areas where reading is not practiced, as many
as 30 to 50 percent of those people who complete primary
school may relapse into a complete inability to read
(Nasution 1972:35,36).

A standard (of sorts) for minimum literacy has, however,
been commonly adopted for many adult literacy programs.
Successful completion of a literacy course may require a
person "to read and write a simple letter" (Nasution 1972:
30). In this case the learner merely proves he can read and
write some words. There is no attempt to define any particu-
lar standard or difficulty, or how much of a simple paragraph
the reader must be able to understand.

Programs designed to help adults reach this minimum level
of literacy in Nigeria from 1960 to 1964 were described this
way,

> The classes were held for only four months...three
> days a week for only one hour...40 minutes teaching...
> Thus the total instruction which an illiterate
> received was not more than 48 hours...only a primer
> and a small reader are used...The sentences in the
> primer have hardly any meaning. None of the lessons
> has a central theme or adult concepts...There are no
> set papers for the examination...It is given locally
> and usually consists of writing a letter and a few
> sentences and figures...(Nasution 1972:30).

Since this evaluation was written the programs have been
improved. But it indicates that even passing a literacy
examination, where these are actually required, does not
mean that a person can read and understand an unfamiliar
passage from even a simple book.

In contrast to standards which reflect the ability to
read or write a few words, recent writers are now concerned
about the level of literacy that is required for a person to
be able to read new material with comprehension, to have the
skill in reading that enables him to learn new information
from what is read. This is the concept of *functional
literacy* (Literacy House 1967:7,8).

Most of those writing on functional literacy are con-
cerned with the level of literacy that is required for a
person to become an independent learner, or to use his

reading skills enough to play some part in the industrial
development of the country. While I found no specific
standard for the level of difficulty of material a person
should be able to read, it is clearly much more than simple
literacy. One example of a definition of functional literacy
comes from William Gray.

> A person is functionally literate when he has acquired
> the knowledge and skills in reading and writing which
> enable him to engage effectively in all those activities
> in which literacy is normally assumed in his culture
> or group (1956:24).

A more adequate and detailed definition comes from an inter-
national committee of UNESCO consultants:

> A person is literate when he has acquired the essen-
> tial knowledge and skills which enable him to engage
> in all those activities in which literacy is required
> for an effective functioning in his group and community
> and whose attainment in reading and writing and arith-
> metic make it possible for him to continue to use these
> skills for active participation in the life of the
> community (Literacy House 1967:7,8).

The definition of functional literacy given by Gray is
flexible enough to allow each culture to set its own stand-
ards concerning the level of difficulty of material that a
reader ought to be able to understand and write. The
committee's definition seems to me to be more practical,
however, since it expects a person to be able to understand
what he reads. The committee is concerned that the person
who learns to read be able to use this skill to go on
learning other things by his own reading and to possibly be
able to pass his learning on to others.

The committee's definition seems to indicate that func-
tional literacy should enable an individual to be able to
use printed information well enough to escape the limitations
of a small-scale society by being able to participate in the
mass media communication of the modern world. This defini-
tion may be more demanding. It seems to set a minimum
standard which would relate to a people's aspirations for
national development and economic integration into the world
community. These are important motivations for most literacy
programs.

In church work we are concerned that people be able to
read and understand the Bible for themselves. The Bible

contains some simple material, but most of it is certainly adult material. It is frequently translated at advanced levels of reading difficulty. It is therefore probable that many people could even be counted functionally literate and still have great difficulty reading their Bible with comprehension.

Some authors suggest that a minimum definition of functional literacy for effective citizenship should include the ability to read simple government directions. The same authors point out that a minimum of seven years of formal schooling is usually required to supply enough practice in reading to reach this level of proficiency (UNESCO 1957:24).

As of 1957 UNESCO estimated that only 30 to 35 percent of the world's population could be expected to have reached this level. To state it another way, as of 1957 two thirds of the world could not be expected to be able to understand a simple gospel tract in their own language--much less be able to understand a Bible passage. The estimate of those who meet the lesser standard of functional literacy was about half of those counted literate. The other half of those counted literate were only marginally literate.

In the 1960's Dr. Donald K. Smith conducted research to estimate the extent of literacy in Rhodesia. He used a simple paragraph of 50 words to be read aloud by people who had either gone to school or had obtained literacy training, and claimed to be able to read. No actual comprehension was required, just the ability to read the paragraph. The language, Shona, read very much the way it was spelled. While all counted showed some knowledge of letters, only 51.9 percent could read the simple paragraph (D. K. Smith 1969:82). This evidence indicates that half of those counted literate were not literate enough to read even at the very minimal level specified.

Of those who could read the paragraph, and thus qualify for the most minimal definition of being "functionally literate," 92 percent of them had gained their literacy in school. But of all those with from one to five years of schooling less than half could read the paragraph (ibid). Apparently, to expect lasting literacy for more than half the people trained would require more than five years of schooling.

The studies by Smith in Rhodesia and Nasution in Nigeria and other parts of the world agree in the finding that no

more than half of those counted literate are likely to be
functionally literate, even if our definition of functional
literacy is only to be able to read through a paragraph of
very simple material.

We find then, that at best two out of ten in Africa are
counted literate, but only one out of ten or less could
read a simple tract with good comprehension. Why have the
efforts to train people to read had so little success? One
reason is that many who are trained to read do not continue
to read and all too soon revert to illiteracy.

THE PROBLEM OF REVERSION

Both Smith and Nasution discuss the problem of reversion.
Many people coming from non-reading communities learn to
read, but within a year or less lapse back into nearly com-
plete illiteracy (Nasution 1972:35,36). This is largely due
to a lack of practice of vital reading skills. In many non-
reading societies there is not enough practical use of these
reading skills outside of the rather artificial school
situation.

Jeffries' study of the problem produced this conclusion
on the problem of reversion from literacy.

To add the final touch of gloom, one must recall that,
in any case, a large proportion of the children taught
will get no lasting benefit from their schooling and
will quickly reinforce the ranks of the adult illiter-
ates (1967:162).

Nasution, on the basis of surveys on several continents,
states that communities with 50-85 percent non-reading
farming populations cannot be expected to sustain the
literacy of their youths who have gone to school. There is
not enough in-culture stimulation to keep reading. Jeffries
says on this subject:

Of the 373 million school-age children in the world
only about 115 million or 30 percent are in school;
and of those who are, the majority will not even com-
plete the primary course and will very likely relapse
into illiteracy (1967:161).

Nasution concludes that if there are 70 percent non-readers
in an area you cannot expect illiteracy to decline. But if
the non-readers are a minority of 35 percent or less,

illiteracy could be expected to decline (Nasution 1972:7).
He therefore considers that for a community to reach the
take off point for modern industrialization at least 65 per-
cent of the population must engage in reading. Then the
primary school graduates will be supported in their use of
reading skills and reversion can cease to be a major threat.

In his survey of 74 literacy projects in Africa and Asia,
Nasution found that in some programs 35 percent and more per
project would drop out before completion. In some, up to 60
percent of those starting would give up along the way. Of
those who finished, another 30 to 50 percent would relapse
into illiteracy after two years (Nasution 1972:35,36). He
laments that some programs pay lip service to evaluation,
but very rarely are programs revised in the light of such
findings. There is a growing awareness of the great need
for providing interesting materials for new literates at a
level of difficulty suited to adults with a minimum of read-
ing skill. If illiteracy is to be conquered, something has
to be done in communities with a low level of literacy so
that reading becomes an "in" thing to do.

Hayes states that:

It is well known that children returning from the
primary school to largely illiterate adult communities
repidly fall back into illiteracy (1964:11).

He goes on to discuss the way non-reading parents have a
crucial impact on pre-school education, absenteeism from
school and dropoutism. He is convinced that primary schools
really serve their intended function of providing lasting
literacy only when their children return from school into a
community where the majority of the adults regularly display
the profitable uses of reading skills. Other studies indi-
cate that "60 to 70 percent of all adult illiterates have no
desire whatever to learn how to read" (P. Smith 1975:3).

AN ABSENCE OF A READING HABIT

D. K. Smith (1971) discusses his solution to the problems
related to reversion within the conceptual framework of the
development of a popular reading habit. He is concerned with
the problem of encouraging young people to make use of their
newly acquired reading skills, and the problem of publishing
culturally relevant materials for them.

One indicator of the lack of reading habits in informal
situations across Africa is the non-use of newspapers. As

of 1961, Smith estimates that only one percent of the people
in most African countries read a newspaper (1971b:51). In a
few countries such as Ghana, Rhodesia and Nigeria newspapers
were used by about 5 percent of the population (Jeffries
1967:176). The teaching of reading in western schools as
simply a mechanical skill, without enough emphasis upon com-
prehension, enjoyment, or economic reasons for reading, has
resulted in failure to stimualte a habit of informal reading
(D. K. Smith 1971b:52f).

Magazines in Africa may cost an hour's wage, enough for a
meal in a food shop or an evening meal for the family.
Crowded living conditions in the cities, with difficult
lighting conditions, work against the use of reading for
pleasure. There is virtually no literature published for
children except for school books (ibid p. 53).

These are some of the factors which account for the fact
that the majority of those who can read will usually only do
so under the pressing requirements of school, employment or
possibly religious activities. The significance of this is
that until people are accustomed to gaining important infor-
mation from casual reading, and young and old alike can be
counted on to spend time in public and private reading, the
printed page is not likely to be an effective means of
communicating with even the functionally literate segments
of African society. There must be some form of social or
private activity which will stimulate the use of written
materials at an informal social level.

Smith feels that until the general public forms a reading
habit and begins to consume a large volume of material
specifically prepared for African audiences, it will not be
economically feasible to publish even culturally relevant
materials for them. He states,

The first goal of educators and publishers in Africa
must be the provision of enjoyable and useful contact
with reading. Important and interesting materials
must be available to read (ibid p. 52).

Then, when the volume of sales has been increased, there
is a prospect of decreasing the unit cost of production of
each item sold. He concludes:

Until progress is made toward these goals however,
development of a true reading habit is a far-off
dream. Until that dream comes true, the people will

change very slowly, if at all, and the fundamental
problem of development will not have been solved
(1971:53).

These statistics indicate that less than a quarter of the
people can read at all, but less than half of those could
read a simple paragraph. The percentage of the total popula-
tion that could read a Bible passage with comprehension is
very likely to be still smaller. The proportion of the
general population that is likely to read Scripture portions
in a cultural context in which there is generally no reading
habit must be exceedingly small.

The evidence indicates that even where literacy is pre-
sent, those who want to participate in the cultural activi-
ties and share the common life of the majority who communi-
cate orally, switch to oral communication.

The writings of ethnolinguists J. B. Pride (1971) and
Gumperz and Hymes (1972) indicate that there is great
sociological significance attached to the switching of modes
of communication and even "almost trivial linguistic
differences" in oral speech (Gumperz and Hymes 1972:14,16).
The use of the appropriate modes and styles of communication
does much to establish the identity of the speaker and the
message with the group addressed, or as foreign to the
group addressed (Gumperz and Hymes 1972:16), even when they
remain outside the conscious thought of the people concerned.

This evidence suggests that the conscious or subconscious
avoidance of literate communication even by those who can
read is related to the desire to be identified with the
social majority. The interaction between the uses of written
communication, the social identity of the majority of African
peoples and the yearning of the minority who can read to
"belong" to the larger group has yet to be fully explored.
But the situation is far more complex than a mere inability
to learn to read.

It is possible to think of these issues as the sociologi-
cal forces causing resistance to the use or spread of
literacy. But in my judgment it is more productive to regard
them as indications of the vitality of the oral communication
system as it is presented below in chapter 9.

The evidence presented in this chapter indicates that only
a small proportion of the population is likely to make
regular use of written communication, or read religious

publications such as the Bible. Fewer people will read their
Bibles than literacy statistics alone would indicate. It is
therefore urgent that we find more indigenous alternatives
to literacy so that the people can come to know the Word of
God for themselves. We must support more adequate and cul-
turally relevant methods of popularizing literacy. Yet we
must call into question any strategy to evangelize the people
of Africa or lead them into Christian maturity if it depends
heavily upon the use of written materials.

In addition to the sociological pressures working against
the popular use of literacy in Africa, there may be some
technical problems not usually encountered in the west. In
this regard the problems associated with tone in African
languages need to be considered.

3

Special Difficulties in Reading Tone Languages

In the previous chapters we have noted both the horizontal and vertical segmentation of African society, and the comparatively small proportion of the people who are able to profitably make use of written communication. In Africa south of the Sahara there are also technical, non-sociological factors that contribute in a special way to the relatively small use made of literate communication.

In this part of the world, all but a handful of the languages are tonal languages (Welmers 1973:78). Yoruba is one of these languages, and the problems encountered in reading (and writing) Yoruba can serve to illustrate some of the very knotty linguistic problems for literacy raised by tone languages.

In European languages some voice inflection is used to signify such things as a question or the emotion of a given utterance. European languages, however, rarely use voice inflection to distinguish between individual words that are spelled the same way like tone languages do. In a tone language the relative pitch with which words with the same vowels and consonants (i.e. words that are spelled the same way) are spoken distinguishes completely different lexical items.

In Yoruba there are three basic tone levels. Low (marked \ in technical writing), Mid (not marked), and High

(marked ╱). There are also a rising glide (marked ╲╱ or ╱),
and a falling glide (marked ⌃ or ⌐) plus a tone slightly
below high tone, called "second" (marked with ') (Stevick
and Aremu 1963:1,61).

For a given three sound sequence with the same spelling
there may be four, five or more different tonal variations
which account for the only difference between these four,
five or more different words. Misreading a word tonally can
reduce a passage to meaninglessness or vulgarity. In Yoruba
the sequence *oko* can have different meanings as follows:

ōko	boat	mid, low
ōkó	hoe	mid, high
ōkō	husband	mid, mid
òkò	spear	low, low (Abraham 1958:511).

In the case of òré and òrě which mean respectively "friend"
and "whip," the only difference is that the former is low-
high, while the latter is low-rising glide (Stevick and
Aremu 1963:335; and Oxford Dictionary of the Yoruba Language
1913:187).

It would be possible to mark these tones consistently in
printed material. However, it is common practice to mark
only a few critical words, or none at all. A Bible Society
of Nigeria simplified version of Mark has only a few tones
per page marked (Marku Egbe Bibeli Ile Naijiria 1937).

AN OUT-OF-CONSCIOUSNESS PROCESS

Even though the distinguishing of lexical items by tone
is extremely difficult for most Americans it is quite
natural for Yoruba and other speakers of tone languages to
hear the difference between òkò and ōkó. They have been
taught (as children learning the language) to make and to
hear these tonal distinctions. But their teaching was not
of a formal, analytical nature. Their ability in this
regard, therefore, is not at the conscious level.

Linguists readily recognize that important areas of
speech conduct normally operate outside the consciousness of
people as they speak,

. . . since linguistic constraints operate largely
below the level of consciousness, speakers themselves
cannot be expected to provide adequate explanation of
their own verbal behavior. Information on language

structure must be discovered indirectly by trained
investigators (Gumperz & Hymes 1972:6).

There is considerable evidence that the Yoruba use of
tone is usually below the level of consciousness of the
speakers. When literate Yoruba people discuss a word an out-
sider may ask about, there will usually be agreement on the
word (and on its pronunciation) but not on whether it is mid-
high, or low-mid, or mid-rise.

The people learn the sounds of each word, and how to pro-
duce them correctly on demand. Parents (and teachers of
foreigners) repeat words for children (and other learners)
to imitate. But even instructors with many years of school-
ing laughed at my asking if words are mid-high, or low-high.
Their knowledge of the tonal patterns is not analytical. I
was told to do as a Yoruba child--merely imitate what I
heard without worrying if it was "high" or "low."

Furthermore, there are dialect differences from area to
area in Yorubaland. And differences of tone for some words
are an important part of the dialect differences. Within
the separate areas of Yorubaland the people learn their own
particular patterns. But when I have asked three or four
literate Yoruba speakers from different areas what tones
were used on a given word, I have often gotten three or four
different answers. With very few exceptions, neither readers
nor non-readers naturally analyze the tones apart from the
other parts of the words so that I can get an answer in terms
of tone alone.

This is about as far as their consciousness of the phenom-
enon of tone extends. The tones sound or feel correct but
they are not consciously analyzed. And it is a long and
difficult teaching assignment to bring Yoruba speakers to
the point where they can consciously analyze the tones and
write them correctly on paper. My students taking the West
African School Certificate Exams in Yoruba ordinarily felt
quite confident about the spoken section. But they were
terrified of some of the reading, and of being graded on the
tone marks they were to use in their written work. Most
Yoruba people with whom I have discussed this problem are
not prepared to make use of the rather simple and adequate
system available for marking tone, since the development of
even moderate skill in the use of the system seems to require
several years of intensive training at the secondary school
level.

AVOIDANCE OF WRITTEN YORUBA

In spite of the fact that tone is so important to intelligibility in Yoruba it is neither marked in the printed Bibles (unless, as mentioned above, a few easily confused words are marked) nor added by the readers. Most Yoruba readers who know English prefer to read in English rather than in Yoruba. I asked the first year classes I taught at Titcombe Secondary School, whether for devotional use they preferred to read the Bible in Yoruba or English. The vast majority said they read either totally in English or in English first, as a means of determining which Yoruba words were intended in the text. This was also the pattern among Yoruba students at Igbaja Bible School and Seminary.

During my time at the seminary when most Yoruba students prepared to preach they first read a Bible passage through in English. Then when they were sure of the meaning of the passage, they would figure out the way the Yoruba text was intended to read and practice reading it correctly for public use. Those few who read the Yoruba first (rather than the English) would keep the English text open to the same passage, if it was not already familiar, in order to check the difficult words for tone as they read.

The same students tell me that pastors who cannot read English fluently cannot get help from this method of checking. As a result they are extremely limited in their ability to read their Bibles. They can usually read only passages with which they are familiar, or which they have been specifically taught to read. The Yoruba alphabet is technically quite accurate (i.e. phonemic), but the problems of reading the tones correctly in materials having the level of difficulty of the standard Yoruba Bible make it extremely difficult to understand. This difficulty is largely due to the out-of-consciousness character of the use of tone. Modern European languages do not have this hindrance to the use of written communication.

Two illustrations indicate the pervasiveness of this difficulty among fluent Yoruba speakers. The Yoruba Program Director for a Christian broadcasting service, Rev. E. A. Adebiyi, is responsible for finding men who can read Yoruba for radio broadcasting. Rev. Abebiyi states that only those who have done well in the secondary school Yoruba course do at all well at reading, even with the use of the written tone markings. Many of the Yoruba men entering the seminary could preach fluently in Yoruba, but very few could read

Yoruba well enough to meet broadcast standards even if they practiced with the material before reading it.

Another striking example of the difficulty of using written Yoruba is the fact that many Yorubas with extensive schooling prefer English as the medium for written communication, in order to escape dealing with tone marks. As a member of the local chapter of the Nigerian Bible Society, I went to a regional Bible Society meeting to present our experimental paraphrase project. The meetings I attended were all conducted in Yoruba, although the vast majority had attended English-speaking post-primary schools.

A complaint was raised from the floor of one of the meetings, with the apparent approval of those present, that since it was a Yoruba branch of the Bible Society it seemed inappropriate that the mimeographed minutes of the meetings be circulated in English. The Yoruba secretary answered that he had a Yoruba typewriter which he used for notices to the churches. But he experienced great difficulty in inserting the correct tone marks into the text, and in getting people from various areas to agree on which marks were correct. Then, he continued, there was just as much difficulty in getting people to read the tone marks correctly as there was in inserting them in the first place. He told of numerous difficulties and misunderstandings which developed when the minutes were circulated in Yoruba. The meeting discussed the problems of reading Yoruba tone marks and quickly reached a consensus, with a hearty voice vote. English was approved for the minutes, in spite of the obvious emotional and esthetic preference for using Yoruba and the difficulty of translating the minutes back into Yoruba to read them in the churches.

If Yoruba church leaders, fluent to a considerable degree in both English and Yoruba, and preferring to speak Yoruba, still prefer English for written communication, then what are the prospects for communication in written Yoruba (Whiteley 1964:1)? This is a question I cannot answer. But it seems reasonably clear that the majority of literate Yoruba people will only be likely to read rather simply written Yoruba, both already familiar and simple enough for the readers to be able to anticipate the correct tones from the context.

USING TONE MARKS

As part of our paraphrase project we ran an experiment to test the ability of Yoruba people to read a simple text. We

attempted to build into the text enough redundancy so that a reader with less than eight years of schooling would be likely to correctly guess the tonally ambiguous words from the clues in the context—to guess them well enough to read through a simple Bible paraphrase with good accuracy.

We experimented with a paragraph of our Bible paraphrase of about 100 words. It was read by 60 people who had less than eight years of schooling. Twenty were given the paragraph with all the tones marked. Twenty were given the same paragraph with only key words marked. And twenty were given a copy with none of the tones marked. Every reader was timed. The average number of errors for the copy lacking all tone marks was 3.8 errors and the paragraph required an average of 58.5 seconds to be read. For the completely marked copy the average error was 2.3 in 64.0 seconds. The copy with only crucial words marked averaged 1.6 errors and an average time of 52.6 seconds.

These results indicate that if the material is simple enough for a person with only primary education to use, an absence of any tone markings will be likely to produce the most errors. Material completely marked for tone will reduce the errors by nearly half but will require longer to read. Simple material in which crucial words are marked on a selective basis, however, will probably be both read more rapidly and with less error.

The consensus of Africanist linguists such as Welmers, Kraft and Richard Bergman (of Wycliffe Bible Translators) is that it would be ideal for all tones of a tonal language to be marked in all contexts. In this way the reader would become accustomed to the presence of the tone marks on every word and the correspondence established between these marks and the way the words are spoken. When a truly ambiguous word is encountered, then, the reader will have developed enough familiarity with the marks to read it correctly.

This is an ideal toward which we shall strive. The problem is that most of the material used in the schools and generally sold to the public contains only occasional marks, if any. The editors of the Yoruba Bible presently in popular use have followed a policy of only partial tone marking. In a randomly selected passage of 296 words, a half-page column of 42 lines contained 60 tone marks, or one tone mark for every 4.93 words—1.43 marks per line.

Even if all tones were marked, however, we would still have to reckon with 1) the fact that tone is one of the

factors that varies from locality to locality, and 2) the fact that by experience with unmarked or partially marked printed materials, plus the lack of such markings in English the popular opinion of what "standard" Yoruba ought to be has been strongly influenced. If we were to confront new readers with a page unlike other printed pages, with many marks on the page which they have not been taught to use, it could be a factor in failure to buy or use the materials. We have decided, therefore, to work toward an increased use of tone marks on easily recognized words to stimulate recognition of the use of these marks. But in initial publications we shall mark tones only slightly more than most other publications in Yoruba.

SUMMARY

This discussion is intended to point to the fact that the reading of tone languages presents difficulties in reading that are not encountered in western languages. The tonal patterns must be correctly read or the words are meaningless. Since in Yoruba the correct use of tone in speech is usually accomplished without conscious analysis it requires special and extensive training in order to bring the use of tone to the level of consciousness.

In order to facilitate the wider use of reading and writing it would seem advisable to employ some special audio or other mnemonic aids to help students and pastors with this problem. In chapter 15 there is a presentation of some experimental work in which a Yoruba translation of the book of Hebrews is set to music. That experiment is one attempt to work toward a solution to this problem.

4

The Place of Literacy in Missionary Strategy

EARLY MISSION GOALS

From the very beginning of mission work in West Africa the primary goal has been solid Church Growth. The plan of mission leaders such as Henry Venn and Rufus Anderson was to plant indigenous churches that could become self-governing, self-supporting and self-extending (Warren 1971:26).

The purpose of this chapter is to present one aspect of the strategy of the great pioneer planners for reaching these objectives so that it can be evaluated in the light both of the communicational complexity of contemporary African society and of the kind of success it has produced. We are primarily concerned here with that part of the strategy that sought to spread the knowledge of the Word of God through written communication and schools.

In order to produce a strong indigenous church it was considered essential to have well schooled African pastors and a Bible reading laity. Literacy programs and schools were at the very center of missionary thinking and policy.

An early statement of missionary motives for teaching literacy and establishing schools is given by Ajayi from the writings of John Bowen (1875):

Our designs and hopes in regard to Africa are not simply to bring as many individuals as possible to the knowledge of Christ. We desire to establish the

Gospel in the hearts and minds and social life of
the people, so that truth and righteousness may remain
and flourish among them, without the instrumentality
of foreign missionaries. This cannot be done without
civilization. To establish the Gospel among *any* people,
they must have *Bibles* and the *art to make them* or *the
money to buy them*. They must *read the Bible* and this
implies *instruction* (Ajayi 1965: 126 my emphasis).

Tucker summarized evangelical mission planning from the
nineteenth century up to the present by stating:

It has been a characteristic Protestant method of
evangelism and education to seek to teach everyone
to read in order that he may find for himself in the
Bible, with the help of the Holy Spirit, that word
which God has spoken to him (1966:48).

The first statement above, by John Bowen, seems typical
of writings from the nineteenth century. Underlying it are
several implicit assumptions that have only recently begun
to be questioned. Among them are that the Scriptures must
be read. They must, therefore, be circulated in written
form. Christian maturity is developed via the reading of
the Bible, especially in private devotions. The Scriptures
must be understood, and the correct understanding requires
a degree of "civilization."

This assumption about the need for civilization was
related to other European assumptions about African culture.
Through the writings of the nineteenth century, including
those of Anderson and Venn, one finds general disparagement
of African culture. Of the "native's knowledge" Anderson
wrote,

He knows nothing of geography; nothing of astronomy;
nothing of history; nothing of his own spiritual
nature and destiny; nothing of God (Beaver 1967:58).

Such a statement assumes that the lack of knowledge is
complete. Because Africans did not communicate their know-
ledge in writing nor display it openly these observers felt
that valuable knowledge was neither possessed nor communi-
cated.

These pioneer missionary strategists can be credited with
realizing that in order to successfully evangelize the con-
tinent of Africa, an African ministry was the most able and

natural group to carry the task to completion. But their
concept of pastoral training was completely locked into the
concept of the day that saw "civilizing" and literacy as
indispensable.

Anderson pleaded for a quality seminary in each major
area of mission work. But instead of working from the
native pastor's greatest natural strength—a knowledge of
his own people—the plan was to "civilize" them out of con-
tact with the culture of their land and people.

> It is an essential feature of the plan, that the
> pupils be taken young, board in the mission, be kept
> separate from heathenism, under Christian superin-
> tendency night and day (Beaver 1967:103).

This plan for training pastors included complete "recul-
turation" for the sake of Christian purity. The process was
to start in early youth and run for eight to twelve years
and longer in some cases. To get students for these pro-
grams a special nursery was recommended (ibid).

In order to insure the correct interpretation of Scrip-
ture Venn thought it essential to include in the curriculum
of this training,

> (1) English Composition, Geography and History; (2)
> Arithmetic, Euclid, Algebra, Trigonometry, and the
> Branches of Natural Philosophy; (3) The Elements of
> Latin and Greek; (4) The most considerable of the
> Native Languages of West Africa; (5) Vocal Music;
> (6) Drawing and Perspective; (7) Scriptural Instruc-
> tion, including the Holy Scriptures, as the basis of
> all Religious teaching; (8) Ecclesiastical History. . .
> Formularies of the Church of England; (9) Exposition
> of Scripture. . . (Warren 1971:197).

Anderson outlines a similar training program, and quite
logically adds that in addition to the schools for training
the pastors, a limited number of free-schools should be
established ". . . which also greatly aid in getting
audiences for the preachers" (Beaver 1967:103). Anderson
seems to have appreciated that once you train a man as he
suggests, in isolation from his people, that you then have
to "educate" an audience to understand him.

A logical extension of this definition of and approach to
Christian maturity is a complete education system so that

the general population has the chance to become mature Christians. Anderson wrote:

> For the printing of the word of God, and teaching men to read it, are not something different from the work enjoined. They are not designed to open and smooth the way for the gospel...They are the work itself... Schools are...means for the direct inculcation of gospel truth in youthful minds and hearts (Beaver 1967: 161,162).

He came to envision a "system of elementary education for the masses of the children in pagan lands" as an essential "development of a stable Christian Church (Beaver 1967:162). But an extended program of mass education was not thought to be the work of the mission. The mission-supported work should be directed to produce the minimum of indigenous pastors and teachers necessary to educate their own people through a system adapted to local needs and supported by local funds. He felt that missions have a definite commitment to start the program so that pastors and teachers could be prepared to lead the rest of the people into a proper understanding of the Christian life.

Two major mission policies resulted from the belief that it was necessary to teach literacy before the people could learn the Word of God. One was the establishment of schools to teach literacy and the other was the requirement of literacy for church membership.

MISSIONS AND THE ESTABLISHMENT OF SCHOOLS

Missionaries were not the first ones in West Africa to promote literacy for religious purposes. Long before the first white man came to West Africa, literacy was known and used there. The major writing system before European influence was the Arabic system. This may have been introduced around the fourteenth or fifteenth century with the arrival of Islam (Ajayi 1965 and Goody 1968:165-241). It was largely restricted to religious uses, although some medical and historical works were known. But it was also restricted because students were required to memorize the texts as they learned to read them. In this system the term "read" means to "recite from memory." The personal, human qualities of the teachers were at least as important as the written texts for passing on the traditions, and the text was not thought to have an independent existence apart from the mediating oral tradition. For these reasons Goody calls it a

"Restricted System." None of the depersonalizing, analytic
or scientific attitudes we associate with western schooling
and literacy developed (Goody 1968:165-241).

The Portuguese were responsible for starting some mission
work in Nigeria as early as 1515. There was an attempt to
introduce Christianity and western reading skills, but it
was limited mostly to a few in the ruling families on the
coast (Ajayi 1965:2f). This contact had little lasting
effect, and when the royal families of Benin lost interest
in Christianity around 1620, the educational impact was
minimized (ibid).

The first Protestant mission school in West Africa was
apparently founded as early as 1752 by Rev. Thomas Thompson,
but it was not considered a success (Parsons 1963:3). It
was not until 1843 that William de Graft opened a school
that endured. This was in Bada, Ghana and was for the
children of a group of Christian freed slave immigrants from
Sierra Leone and the children of some of the local chiefs
(Ajayi 1965:33). De Graft intended the school to be the
"nursery of the infant church" (ibid).

From this start other schools grew and were established.
Virtually all of the western schools founded in Nigeria and
Ghana in the first quarter of the 20th century were founded
by mission organizations with similar objectives, even when
significant portions of the funds for these schools came
from the governments concerned (Ajayi 1965 and Talbot 1922:
125ff).

Ajayi points out that these mission schools have been
extremely important for what he considers the development
of Nigeria. By the turn of the century, mission schools
were responsible for the creation of a new middle class--a
"new elite" (Ajayi 1965:xiii). This power block became a
new and potent force in the development of the nation.

The tribal chiefs and the natural local leaders were
often reluctant to subject their own sons to the missionary's
instruction, so frequently it was slaves or other youths in
socially weak positions who were sent to the mission schools.
It was largely these youths from the margins of indigenous
society who were given the advantage of western schooling
and close contact with the colonial, economic and political
powers (Ayandele 19-6:290 and Ajayi 1965). The resultant
establishment of a "new elite" middle class, successful in
business and government, was responsible for the

identification of Christianity with western education in the minds of the people of the land.

THE LITERACY REQUIREMENT FOR CHURCH MEMBERSHIP

The second policy instituted by some missions was that, often formally but more often informally, literacy in the vernacular was made a requirement for baptism and church membership. Methodist missions in Ghana founded their churches on this policy in order that the new members would be able to:

> read and to know for themselves the Word of God...
> Part of the test for membership shall be a test of
> their ability to read (Parsons 1963:129).

David Barrett states that the requirement of vernacular literacy for purposes of Bible reading was a general requirement for baptism in Protestant churches across Africa (1968: 127). In some cases this may not have been stated as a formal requirement but it has been a widespread informal practice to not allow most non-readers to become full members of the church unless they have labored long and hard in the attempt to become literate.

There were a few notable exceptions to this point of view, such as Dan Crawford who perceived something of African oral communications (Crawford 1914:58). Mr. Sylvia, a missionary to Pakistan, tells me of sitting with non-reading tribesmen there and singing the Psalms together from memory. The Venerable Bede writes of a certain brother Caedmon who lived in the seventh century A.D. He received the gift of putting Scripture passages into "poetical expressions of much sweetness and humility into English which was his native language (Bede 1895:205ff). But in modern times I have found no systematic studies of oral communications for purposes of teaching the Bible. There have, so far as I can ascertain, been no systematic mission policies for reaching the people through indigenous oral media. On the contrary the history of missions in Africa has been the story of the spread of literacy.

As an example, the Dutch Reformed Mission (of South Africa) and the Christian Reformed Church conducted their work among the Tiv as follows. The policy established in the Tiv church was that in order to become a member of the church a person must pass a "stiff" catechumen course of which literacy is a part (Grimley and Robinson 1966:214).

We have noted Edgar Smith's comment that literacy was
required for membership as of 1940 (E. Smith 1972:62).
Grimley notes that this rule was still in force in the
1960's (ibid) but I am told that for adults seeking church
membership the literacy policy is now frequently relaxed.

The policy of accepting some converted non-readers as
junior or low status members, possibly without the sacra-
ments was also unfortunate. High status oral communicators
could be fully, securely accepted in Islam. They were fully
accepted and enjoyed the power or benefits of all the sym-
bolic ceremonies. If they could not read well enough the
church would deny them not only social status and ceremonial
leadership but also crucial symbolic tokens of complete
acceptance such as baptism or the Lord's Supper. We have
yet to fully probe what this communicated in an African
society where symbolic participation is such an important
factor (Dickson and Ellingworth 1973).

It is informative to study the growth of the Tiv church
under this policy of requiring literacy for church member-
ship. Between 1911 and 1951 membership had grown slowly to
150. After the Christian Reformed Church had taken over
supervision of the work (1951) the membership grew at the
rate of about fifty adults per year in 1952, 1953 and 1954,
bringing membership up to nearly 300 (E. Smith 1972:153).
Then, as a result of some policy changes the rate of growth
increased. Yet in 1962 though there were over 73,000 in
attendance in Tiv churches, 7,500 inquirers, 3,600 cate-
chumens, 16,400 in the instruction classes and 7,800 primary
school pupils, there were only 4,162 full members reported
(Grimley and Robinson 1966:215). This is a ratio of 17.5 in
attendance in some part of the program for each full member.
Since then the mission has sought to reduce the literacy
requirements for adults, but church members who have passed
through the keyhole of literacy are quoted as saying, "what
has been tied should not be untied" (ibid), indicating their
desire to maintain the traditional standard. As of 1970
over 134,000 were reported attending regularly, less than
16,000 on the communicant roll (E. Smith 1972:285). These
figures indicate an improvement to about 8 in attendance for
every full member.

The Sudan Interior Mission operating in Nigeria has not
to my knowledge made it a formal policy to require literacy
for church membership, though it is strongly encouraged and
some individual missionaries may have required it in some
areas. Their ratio of attenders to members is, however,

similar to that of the Tiv church. The 1972 figures from the Evangelical Churches of West Africa (ECWA), the church affiliated with the Sudan Interior Mission, indicate that they had 50,000 members and 500,000 in attendance. This is a ratio of 10 people in attendance for every church member.

While not all mission boards have actually required literacy for church membership, it has been explicitly or implicitly part of our definition of Christian maturity. The methods we have used to promote Christian maturity have presupposed literacy and private Bible study, after the traditions of western churches.

SUMMARY

The missionary emphasis on literacy and western schooling was founded on two basic assumptions. The first was that African culture was basically so evil that it could never become a vehicle for adequately expressing Christian truth. Therefore young people had to be extracted from the culture of their birth and trained in a distinctly godly or western environment. There was not much hope of an authentic Christianization of the adults who could not be separated from their indigenous culture.

The second assumption was that the most valuable and important information Christians should know is to be learned from books by reading. Only comparatively modern western modes of communication are suited to the expression of Christian truth. This was assumed because we perceived in the Scriptures only one acceptable method of teaching. We lacked the cultural exposure to realize that people are perfectly capable of learning and teaching many things without depending upon books.

We have now seen the strategies through which the pioneers of modern missionary theory hoped to reach the people of Africa with a knowledge of the Scriptures and thereby to produce a mature and indigenous church with the capacity to grow. In the next chapter we shall consider the consequences of this extractionist philosophy of Christian Education, and the missionary dependence upon written communication among the pre-literate societies of Africa.

5

Consequences of Missionary Dependence on Literacy

A NEW ELITE

The missionary insistence upon the use of reading and writing to communicate Bible knowledge among the largely oral societies of Africa has done much to shape the identity of Christianity in Africa and to condition the response of the people to the Christian message.

The literate and western image of the mission work and the church it produced has been successful, according to Ajayi (1965: xv,126ff.) and Ayandele (1966: viiif, 283ff.) in producing a nucleus of westernized leaders, "a new elite." For those who would like to become identified with these emerging leaders of the modern national states, the western identification of the church with literacy is undoubtedly attractive and valuable. But the percentage of the population that can be reached with useful knowledge through this kind of communication is still very limited. Speaking of the positive value of the programs attempting to communicate with the masses of non-reading culture through literacy, Sir Charles Jeffries writes:

The attempts at literacy teaching undertaken before the Second World War by missionaries and other phil- anthropic bodies or individuals in India and elsewhere were doubtless of value to the limited numbers of persons immediately affected, and useful as pilot schemes for trying out teaching methods, but their

impact on the problem of mass literacy was seldom
significant (1967:96,97).

The vast majority of the people have simply chosen to
remain in the sphere of oral communication. This lack of
literacy among the masses may not prevent them from attend-
ing church, but it often prevents them from becoming full
church members. It insulates them from a knowledge of the
Bible, because the primary method of teaching the Scriptures
contained in mission strategy is through the written communi-
cation. Hence the number of the new middle class "elite" is
small, and those who use their literacy skills for Bible
study is even smaller.

AFRICAN MOTIVATIONS AND REACTIONS

It is informative to study the various motives Nigerian
people had for responding favorably to missionary literacy
programs. The two basic works on this subject for Nigeria
are Ajayi (1965) and Ayandele (1966). Works with a focus on
more contemporary reactions of today's intellectual leaders
in Ghana have been done by Mobley (1970) and Parson (1963).

In the early 17th century the traditional chiefs were
leaders in religion, commerce and politics in their domains.
It was soon apparent to the chiefs that literacy and commer-
cial training would be of great benefit to their people, in
the process of obtaining the powers inherent in western tech-
nology. There were also certain political or social advan-
tages to having a white missionary in residence in one's
kingdom during the period prior to the British occupation of
Nigeria. The chiefs frequently invited missionaries to
their domains in order to enhance their earthly powers. How-
ever they frequently did not trust the missionaries enough
to send their own sons to the mission schools. Often neither
the chiefs' family nor those close to the chiefs allowed
their children to attend schools. Thus mission schools
tended to attract slaves and other people from the fringes
of tribal society rather than potential leaders.

The chiefs were shocked and resentful when they later dis-
covered certain results of the mission school system. Fringe
people's children had been prepared through the school to
become the new leaders of trade and commerce, and the commer-
cial dominance of many chiefs declined. A "new elite" was
formed. In this preparation of the way for British colonial
power and the chiefs' loss of political power, Christian
missions must take considerable responsibility (Ayandele
1966:xviif.). The missionary came for primarily religious

reasons. They introduced a new religion that turned its converts away from their religious loyalty to the chief. They often also sought to escape his political authority (ibid). Many chiefs were deeply resentful of what had happened.

According to Ayandele (1966:290ff) many of the students in the mission schools attended school primarily to obtain the earthly advantages of commercial power and the social advantages that western schooling seemed to impart. Many have been deeply thankful for the contribution missions have made to the "development" of their nation.

The primary missionary purpose in establishing schools was, however, to train pastors. As missions noted the passing of many bright students into commerce and government rather than into the pastorate or Christian education, however, their enthusiasm for schools tended to cool and they often sought to restrict their educational efforts (Ibid: 286ff). The more school graduates sought to pursue higher education for non-religious purposes the less missions wanted to provide it (ibid). The result was that many school leavers came to resent what they perceived as an attempt on the part of the mission agencies to "hold them back."

Fortunately, there have been thousands of Nigerian and Ghanain students whose primary motivation was to gain school-taught skills to be used to enhance their own Christian understanding and to lead their people into Christian maturity. These have been most thankful for the involvement of missions in education (Parsons 1963:18-28).

The great majority of the Nigerian people have until very recently simply not taken part in the mission school system. It does not seem that they are sufficiently motivated to achieve functional literacy in large numbers. This is an important sign of their fundamental attitude toward literacy or toward the way it has been introduced into their land. Chapter 9 deals further with motives people may have for the rejection of literacy.

LIMITED CHURCH GROWTH

Identification of Christianity with western schooling has hindered church growth among those who do not attend school. This can readily be perceived from the comments of the people themselves.

In 1971 along with a group of Nigerians I paid a visit to a village in Kwara State of Nigeria. We had considerable discussion with the chief of the village who was a Muslim, and a relationship was developed with him. After several visits we became aware that the chief was equating western schooling with Christianity. He showed great surprise when we suggested that there was a difference between Christianity and schooling. Missions had pioneered schools in his area.

The chief asked, "What is the difference between Christianity and book?" In local categories of expression "book" stands for schooling in the western tradition, and is in popular thought inseparable from Christianity itself--even in Muslim communities that boast their own share of university graduates and wealthy businessmen. It took some time and discussion among the gathered elders to convince the group that we did not think that western education was the same thing as Christianity. We are not sure just how much they changed their minds.

In other villages I have heard very similar comments from non-reading elders, who are quite willing for me and my students to teach their children anything we choose to teach. We asked the elders to receive forgiveness of sins and eternal life through Christ. But they answered that they were too old to learn to read. We can have the children but they are too old to learn new ways.

This could be just an excuse to avoid the issues of becoming Christians. But it is more likely to be a genuine fear of being asked to leave the security of the oral communication system with full membership in Islam in order to become neophytes in a new culture depending on foreign communicative skills. In the church their children are likely to become good readers of the Bible. In this way the same sociological forces working against the acceptance of literacy work against the acceptance of Christianity.

I am not the first person to suggest that many people are rejecting Christianity because they have rejected literacy. John Grimley wrote,

> The prominence of schools gives the unfortunate impression that Christianity is a new cultural achievement of youth, rather than a matter of faith in Christ. Some churches require literacy before baptism, and this heightens this impression. "I am an old man and cannot become a Christian," is too often heard from

those over fifty years of age. Furthermore, the school
door to the church sends Christian youth back to
communities still dominated by pagan elders. The
Christian convictions formed in the school quickly
crumble as a result of family and village traditions
(Grimley and Robinson 1966:202).

The first idea suggested in this passage is that those
who have a degree of social prestige in the indigenous
scheme of things, as a result of years of effort to become
leaders in the use of oral communication, may not be able to
attain reading skills commensurate with leadership status in
the church that is dependent on the use of written communi-
cation. Here, as a non-reader, or a weak reader one would
be put in a position of permanently low status, or even
humiliation by being refused baptism and church membership.

Fortunately, there are large numbers of people who are
interested enough in Christianity to attend church, even if
they are not willing to go through the cultural adjustments
of becoming literate. We have noted in the Tiv and ECWA
churches that issues related to literacy have produced
ratios of 17 to 1 and 10 to 1 respectively of those who
attend to those who become members. We have no way of know-
ing how many other people there are with secure positions in
other religious systems who might be interested in Christ
but are not willing to leave that security for an ambiguous
or low status existence in relationship to a literate church.

INJURY TO CHRISTIANS

Another result of the insistence upon the use of literacy
to produce Christian maturity and a knowledge of the Bible
has been the damage done to Christians coming out of an oral
culture. Dr. McGavran tells the story of observing a mature
Nigerian man in church "playing the game" of acting like a
good church member. The elder pretended to studiously find
the page in the hymn book, refused help in finding the page
and then used the book to sing all the words of the hymn,
but failed to realize that he was holding the book upside
down! What must be the inner confusion and loss of self-
esteem of a mature man who feels motivated to play such a
charade. How inwardly debilitating must be the sense of not
actually having skill for the role he feels he ought to play
but cannot. It is, furthermore, a great devaluation of such
a man's memory skill to feel it necessary to sing the hymn
hiding behind a mask of false literacy.

Such men and women have all the potential for genuine
Bible knowledge and Christian maturity if literacy were not
considered the only gateway to it. Perhaps the elder was
already very mature in his Christian character. But the
church literacy standard prevents him from realizing it, and
debars him from exercising his birthright as a member of the
Christian community. From him is withheld the recognition
that could encourage him to stand boldly in his community as
an example of a Christian man. It is impossible to know how
many other Christians in Africa have been humiliated for
their inability to read well when they should have been
encouraged to memorize the Word and display the Christian
gifts they had already attained as mature, ministering mem-
bers of the body of Christ in good standing.

A second idea in the passage quoted from Grimley is that
many students who learn Christianity in the schools return
to non-reading, non-Christian communities and proceed to
give up both literacy and the forms of Christianity depen-
dent upon it.

If the loss of literacy is a very widespread phenomenon
due to the social pressures of the non-reading adults and
peers, then it is not strange that young people should revert
also from forms of Christianity that are largely dependent
upon the use of written communication, and identified very
much with it.

If, however, young Christians were sustained in their
Christianity by a combination of written and more indigenous
types of Christian communication, the loss or diminishing of
literacy skills would not do as much damage to their Chris-
tian identity or means of gaining further instruction. On
the contrary, they would continue to use the indigenous
forms of Christian communication, and minimize the offen-
siveness of the culturally foreign means of communication.
It is also possible that any support from a young Christian's
oral devotional life would promote Bible reading and thereby
help to maintain literacy skills.

LOSS OF INDIGENOUS LEADERS

The heavy dependence upon literate communication by the
church as the primary method of teaching Bible knowledge,
has greatly distorted the patterns of social organization
and communal leadership. Western education and literacy has
generally threatened indigenous leadership structures inside
and outside the church. In oral systems of communication

honor was given to those with age, retentive memories, skill
in using the proverbs of the tribe, and the power to make
forceful presentations before a gathered audience.

With the introduction of literacy, recognition and power
were given to the young people who did well in school work
where reading is all-important. Often, however, the young
people came back from school not knowing the stories and
oral art of their people. They lacked many of the tradi-
tional requirements for leadership. Yet in the modern
scheme of things, the young were frequently given positions
of administrative authority over their elders since the
latter could not read.

The painful effects of this reversal of the traditional
leadership patterns have been as evident in the mission-
sponsored churches as in any part of African society. It is
usually the young men who have the "academic" requirements
to be sent to school who become pastors. The older men who
are the natural leaders in the indigenous scheme of things
are then unhappily left to hold subsidiary roles and even to
face embarrassment if they cannot manage to read well in
public. Young pastors are expected to read to their elders
and are expected to teach them. Young men are expected to
lead elders twice their age.

Missionary education with its emphasis on written communi-
cation ordinarily ignores the oral skills that the elders
have invested years of effort to master and rewards a com-
pletely different set of skills and people. For an elder to
accept the training that comes via the written word, he must
leave behind all the advantages conferred by his status, and
his ability to spontaneously excel in the verbal arts. If
the elder attempts to use the newer and foreign communica-
tive mode, he starts to compete in a game at which the young
men will soon become his superior.

The result of these policies is that mission churches use
not only a foreign mode of communication, thereby repudiat-
ing oral communication, but also end up enforcing the use of
a foreign pattern of leadership that is attractive only to
the young or those on the margins of the society. The result
of these factors is that mission-related churches have an
exceedingly foreign image in the community.

AFRICAN INDEPENDENT CHURCHES

One of the more disturbing reactions to the foreignness
of churches dependent upon the teaching of Christian truth

through written communication, is the establishment of independent African churches. These independent churches are often perceived by Africans as more vitally related to their concerns not only because they focus on those aspects of the Christian message that are more relevant to Africans but also because they employ more indigenous means of communicating the message.

David Barrett's work on the development of African independent churches is the most comprehensive study of this religious phenomenon in Africa (1968). Barrett finds that only a few missions have been characterized by a sympatheric approach to the central institutions of African culture. The negative attitude on the part of the missionaries toward these institutions was interpreted by the local people as a "direct attack on the tribe, its traditions..and on the heart of its social structures, its homes" (ibid p. 154). Among the areas attacked by mission policy were community structure, tribal law, religious leadership, ritual for rites of passage, and "...the vernacular language itself in which was enshrined the tribe's soul, together with vernacular songs, histories and traditions" (ibid p. 266f). Barrett recognizes that "language" is at the very heart of the indigenous culture, and frequently comments on the power of the vernacular as a medium of religious expression (ibid p. 102,131, 133,267,274). He sees the entire phenomenon of independency as a defense of the indigenous cultural institutions that the missionary enterprise has attacked. But he does not see the importance of the modes of communication (and in this case oral communication) for the structuring and identification of the culture system as do Pride (1971:6), Gumperz and Hymes (1972:1-10) and Bernstein (1966:427:427ff). These studies together seem to indicate that the comparatively smaller use of written communication and comparatively greater use of oral and non-verbal communication by these churches are important aspects of their popular appeal to the masses of Africa's peoples who do not identify themselves with written communication.

Although the independent churches are usually related to the publication of the Scriptures in the vernacular languages, and usually have literate leaders who use Scriptures to justify their position, they do not necessarily attract a literary congregation. On the contrary, they are attractive to the non-literary masses because they are adapted in their direction.

While in Nigeria I shared in the training of a few pastors from independent churches of the Aladura tradition, and

shared in the worship of several of their churches. Western theological schooling for these pastors was something of a denominational innovation. Although the entire Aladura movement was originally founded as a society of Bible study and prayer by well-schooled business people (Peel 1968:65, 85), in recent years most of its growth has been among the laboring masses.

The American principal of a new training school for pastors of one of these denominations feels that there is a definite lack of the use of the written Word of God in the churches. He sees a certain semi-magical use of some Scripture passages to promote healing, and to obtain help in a variety of personal problems. For these purposes the passages are not necessarily read or read for comprehension in the western way (Hofsteter 1974:1). The place of the exegesis of the written Word of God has largely been taken by oral revelations, visions, healings, prayer, and direct ministries to the personal problems of the people. Indeed, the prophetic leader of some congregations may not be able to read at all. Such leaders maintain their positions through the exercise of other spiritual gifts recognized by their followers as more important than literacy to the well-functioning of the church. Robinson, Turner and Peel agree that the popular appeal of such groups has little to do with whether or not their leadership is literate (Turner quoted in Grimley and Robinson 1966:312ff, Peel 1968:296ff).

The success of these independent churches appears to be directly related to their use and defense of the traditional culture within a Christian context. This emphasis, of course, implies a diminished focus on and display of literate communication, both for those who attend and for those who attain status as spiritual leaders within the group. This allows those who have the more traditional qualities of "spiritual" charismatic leadership to continue to exercise it quite apart from the question of academic attainments. This enables such denominations to realize a better relationship with the rest of the indigenous community leadership and communal structures. Such emphases are attractive both to those who have not attained functional literacy and to schooled people who are interested in defending the values of the oral community.

I have read the assessments of independent churches by several authors such as Peel (1968), Turner (1967), Webster (1964) and Barrett (1968). I have trained pastors from these churches and preached, taught and visited with the

people in some of these churches. An independent church
leader, trained in a mission school, discussed with me at
length the reasons he had for breaking away from mission
control. He wanted to be an effective leader of his own
people. I am convinced that a genuine desire to communicate
the gospel to the people is among the central motives for
the establishment of these independent churches (cf. Barrett
1968:156). In my judgment the dependence of missions upon
modes of communication and teaching that are foreign to much
of Africa has greatly contributed to the desire of Africans
to break away from mission-related churches.

Because of the very complex nature of communicating the
gospel to the non-reading African community, and because of
the serious consequences of the strategy uniting the church
with literacy, I have studied a similar situation for further
insight.

First Century Palestine consisted of social and communi-
cational complexities similar to our African situation. The
ministry of Jesus was a response to this and gives us a
fresh look at our problem.

Part II

First Century Palestinian Society: A Parallel Situation

6

Social Complexity
in First Century Palestine

At the time of Christ the socio-cultural (and consequent communication) diversity was in many ways quite parallel to that in contemporary Africa. There were ethnic divisions among the Semitic peoples of Palestine, North Africa and Mesopotamia each with its own rich cultural heritage. There was also an invasion of non-Semitic culture and military power to which various parts of the population were reacting in different ways.

By the time of Jesus the Jews had developed two contradictory attitudes toward other ethnic groups near them. After centuries of bitter warfare there was intense suspicion and even resentment of everything foreign. These attitudes were supported by a religious code that required separation. There was also, however, a tradition of hospitality and respect for the "foreigner that is within thy gates" (Deut. 24:11) and a hope of reconciliation with the nations (Isaiah 55:5). In this chapter we shall present some of the major ethnic divisions among the people living in first century Palestine.

1) Jews. The largest single group was the Jewish people. Of the original 12 tribes of Israel, the leaders of ten were taken captive by Assyria in 722 B.C. and never returned. The survivors of the tribes of Judah and Benjamin were taken captive to Babylon in 586 B.C. There as slaves they were required to speak Aramaic. This became their mother tongue.

In the fifth century B.C. some of these Jews were repatriated to Palestine using Aramaic as their mother tongue. Only the religious leaders could speak Hebrew or read the Old Testament Scriptures.

Among the priests and the Pharisaic leaders the knowledge of the law was very important for social and religious status. Among most of the Aramaic-speaking Jews a central social concern was purity of descent, the avoidance of any Gentile lineage. This kind of purity enhanced their chances of upward social mobility by marriage into Levitical or priestly family (Jeremias 1969:270).

2) Levites. Among the Jewish population the tribe of Levi with its Aaronic priestly leaders stands out as a distinct subdivision. The Levites were separated from the rest of the people by their tribal origin and, at least for part of the year, by their special religious employment. They also had the right of certain forms of support from the people for these services. Jeremias estimates that in Christ's time there were 7,200 priests entitled to offer sacrifices and another 9,600 Levites who helped in the services of the temple (1969:147ff). They were arranged in 24 "courses," each of which served one week from Sabbath to Sabbath and did not serve again in the temple until their course was due.

The priests were supposed to help teach the people concerning the law (Malachi 2:7ff), and therefore must have studied it. Even the Levites who worked in the temple must have had some advantages in learning Hebrew due to their contact with the services. The priests and Levites kept careful genealogies. The preference was to marry into a priestly family, or at least into a Levite family, although wives from other tribes were acceptable if they were of purely Jewish descent. Most of the people were careful to preserve their genealogies.

3) Samaritans. A sharp division in the land was caused by the presence of the Samaritans. The Assyrians had forceably settled non-Israelite people in Samaria after the Northern Kingdom of Israel was taken captive in 721 B.C. (I Kings 17:24f). These foreigners intermarried with the Hebrews who remained and adopted a form of Judaism. They did not however cease their pagan sacrifices (II Kings 17:41). They erected a temple on Mount Gerizim with the help of a renegade Jewish priest around 490 B.C. and used a limited canon of Scriptures containing only the five books of Moses,

adjusted for their own purposes. They claimed that their temple was better and that their scriptures were more authoritative than those of the Jews. Animosity over these issues became so sharp that in 130 B.C. John Hyrcanus, the Hasmonian ruler of the Jews, destroyed the Samaritan temple. At the time of Christ the Samaritans had been in the land for over 700 years. But they remained a very distinct and separate group, speaking their own dialect of Aramaic.

4) Foreigners. We cannot estimate the number of "diaspora Jews" who returned to Palestine from foreign lands and were considered "foreign." But there were many Gentile proselytes, Romans, Greeks (John 12:20), Ethiopians (Acts 8:28), and other foreigners called "God-fearers" living in Palestine or regularly visiting Jerusalem for religious purposes. In addition to these there were Gentile slaves working in the homes of wealthy Jews (Jeremias 1969:345ff).

These ethnic groupings constituted "horizontal" social divisions among the people of first century Palestine similar to the "horizontal" tribal divisions of Africa. Figure 3 depicts the first century Palestinian horizontal ethnic divisions.

FIGURE 3

HORIZONTAL SEGMENTATION IN PALESTINE

VERTIGAL SEGMENTATION

Within each of these horizontal divisions, and perhaps across all of them existed a "vertical" segmentation along economic, political, educational or religious lines. The

various social groups or parties within Palestine competed
for various kinds of economic, social and political power
within the limits imposed by the Roman occupation.

1) Romans. Officially the Romans were at the top of the
social order. Pompey had conquered Jerusalem for Rome in 63
B.C. and a Roman garrison was stationed in Jerusalem under a
tribune after 6 A.D. This does not, however, mean that the
soldiers, or even the officers would be Roman in a procura-
torial province (Acts 22:28 and Jeremias 1969:63). The
procurator's residence was at Caesarea, where the "Italian
Cohort" of Acts 10:1 was located, and this may have consti-
tuted all or most of the Romans among the occupational
troops.

2) Hellenistic Jews. As a result of various military
disasters and a shortage of good farm land many Jewish
people were dispersed from Palestine into various parts of
the Hellenized Mediterranean world. Large numbers lived in
Syria, Alexandria, Cyrenaica and Rome (Lane 1971b:10). One
particular group of these people were called the "Freedmen."
They had been taken captive in Pompey's conquest in 63 B.C.
and were taken to Rome where they were later released. In
Christ's day only a portion of these men had returned to
Palestine, leaving a large Jewish community in Rome. Here
as in other parts of the Roman Empire, the international
language of trade was Greek.

These and a large number of other Jews were known as
Hellenistic Jews because they had adopted the Greek language
as their mother tongue. Because of their fluency in Greek
they were able to participate in much of the cultural life
of the lands in which they lived. They did not usually
struggle to learn Hebrew for Bible reading. They had a
translation of the Old Testament in Greek, the Septuagint
(LXX). The Greek orthography (since it included vowels) was
more efficient than that of Hebrew. It was, therefore,
easier to read the Greek text correctly without memorization.
It was a mark of the religious and social prestige of the
Hellenistic Jews that they were permitted to use written
copies of the Scriptures in their mother tongue, Greek.

The pharisaic regulations were memorized in Hebrew and
were probably not directly available to the ordinary Hellen-
istic Jews who did not attend special religious studies.
But the people did not surrender their distinctively Jewish
identity. They kept certain aspects of the Jewish law, care-
fully maintained their ethnic identity by practicing

circumcision, observing the Sabbath, taking part in the monthly feasts, ritual washing and, when possible, making the pilgrimage to Jerusalem (Lane 1971b:12 from Trypho Dial 46:2).

The community of Hellenistic Jews outside of Palestine within the Roman Empire is estimated to have been from four to four and one-half million people, several times the total number of all the Jews in Palestine (ibid p. 11). The community of all Jews within Palestine has been estimated at from one and one-half million (ibid p. 12) down to slightly more than half of one million (Jeremias 1969:205). The great mass of four million Hellenistic Jews undoubtedly exercised great commercial and cultural influence. But it is doubtful if very many of them could have qualified for acceptance by the Pharisees.

At the time of Christ large numbers of these Hellenistic Jewish Pilgrims returned to Jerusalem for the Passover, helping to swell Jerusalem to more than five times its normal size for the celebration. From time to time some of those who had migrated or had been taken away as prisoners returned to Palestine to live. Jeremias is of the opinion that these Greek-speaking Hellenistic Jews from various lands would group together and form Greek-speaking synagogues (Acts 6:9) and conduct their services in their mother tongue, Greek (1969:63f).

3) High Priests, Priests and Sadducees. Within the tribe of Levi the priests were the aristocrats, led by the High Priests. But within the priestly families there were various factions. One small group led the Essenian communities who separated themselves from political and commercial concerns and sought to call the nation to repentance and spiritual purity. The Herodians were alligned with Herod's court and attempted to gain power for themselves by promoting peace with Rome.

It appears that most of the priests and high priestly families were identified with the Sadducees. This priestly hierarchy exercised religious and economic power through the high priestly office and the considerable influence of the temple officers in the regulation of commerce (Jeremias 1969:26-29). It was the chief priests, their close associates in trade and their relatives by marriage who formed the Sadducean commercial and political power block. Their commercial interests kept them generally on the side of peace with Rome, law and order. Their relationship to trade

and commerce would demand a degree of fluency in Greek and provide opportunity for external contact and study.

All indications are that they were a very small but powerful group of men. They had a combination of religious and commercial power protected by kinship ties. At the time of Christ the term Sadducees "...designated all the aristocrats connected with the High Priests by marriage or other social relations..." (Lane 1971a:16).

While they were in control of the Jewish temple, they were "clearly under the impact of Hellenism" (ibid p. 16). In fact they were leaders in the process of Hellenizing the Jews, much to the distress of the ordinary peasants. The High Priest Onias III and others were so enamored of Greek culture that they adopted the Greek language and attempted to make their entire way of life Hellene. Jason, the High Priest in 175 B.C. built a Gymnasium for the study of Greek culture and the wealthy youths studied and exercised nude in accordance with Greek custom. The wealthy trading classes and the priestly aristocracy approved this kind of social advancement for their sons, but the rank and file were greatly distressed (ibid p. 27).

The excessive identification with the Greeks by the ruling priestly group led to the Hasmonean revolt in 167 B.C. This was an attempt to throw off the yoke of the Seleucid Empire and to purify a corrupt priesthood. With the rise of Jonathan in 152 B.C., and Simon, who was made a hereditary High Priest in 141 B.C. there was a renewal of the policy of incorporating Hellenism within Judaism by the very family that was supposed to bring cultural reform. The continued drive of the Jewish power elite to Hellenize the country in the name of "progress" is noted in the use of Greek script for coins and inscriptions and Jannaeus' use of the name Alexander on coins bearing his name (Bickerman 1966:154).

The High Priests of pure descent from the family of Zadok were greatly displeased with the Hasmonian priestly rulers. The Zadokite priests called the people to a pure observance of the Law and of Jewish customs. Lacking political power they retreated to the desert and founded the Essenian communities dedicated to prayer, fasting, discipline and Bible study. They rejected the defiled temple worship and claimed to found communities of the true Israel. They hoped to please God with their purity and that the Messiah whould be sent to them in order to save the people.

As the priesthood became increasingly identified with foreign influences and political intrigue, priestly political power and authority among the common people greatly diminished. Confusion among competing priestly leaders eventually prepared the way for the easy conquest of Jerusalem by the Roman general Pompey in 63 B.C. The priests never again ruled as sovereigns, being more and more forced to share their power with the Pharisees.

4) Hellenizing Jews. For the purposes of this discussion the term "Hellenizing Jews" indicates those Jews whose forefathers had returned from the Babylonian captivity speaking Aramaic, but who were now in the process of learning Greek as a second language. Aramaic was their mother tongue, and they were socially closest to the other Aramaic-speaking Jews. But they were in the process of moving away from Aramaic Judaism toward identification with Greek culture. This gave them certain social advantages in relationship to the Jewish aristocracy and gave them better contact with the Mediterranean world. But they were distinct from those who were raised in wealthy Hellenistic, Greek-speaking homes. They may have imitated Greek attire but they spoke a "broken Greek" and were charged with being "wretched imitations" of the Greeks (Lane 1971a:9).

5) Pharisees. The Pharisees led the popular resistance to the process of Hellenizing among the people. They were mostly tradesmen and artisans from the middle classes of laymen. They were not born into priestly or Levite families and represented the common people. They stood for the purity of the Jewish religion and incidently (even subconsciously perhaps) for the purity of Jewish culture (Jeremias 1969:259). They came from the common people and had a popular identity as a force opposed to the temple authorities. But they were also a power elite. They were a power elite based upon scholarship—a kind of scholarship most of the common people did not attain.

Elias Bickerman states that the Pharisees were a rebellion against the Hellenization of the people, but that the shape this reaction took was conditioned by Greek culture. The Pharisaic concept of reform coming from a community of scholars where scholarship is power comes from the Greeks, according to Bickerman. It is a "Platonic notion that education could so transform the individual" and produce holiness (Bickerman 1966:160). He claims that earlier Jewish reform movements focused hope upon a prophetic vision of deliverance that would come directly from God

as a result of holiness (ibid p. 160). After contact with Greek scholarship the Pharisees stressed a knowledge of the Law as a means of producing holiness. It was this special kind of knowledge of the Law, and separation from the ignorant ones that they felt was required before God would deliver them from Rome.

Bickerman states that both the Hellenistic Maccabees and the Pharasaic reform movement were by-products of Greek culture. Both parties were also minority or elitist phenomena.

Here the character and significance of Maccabean Hellenism is plainly revealed. The reform party wished to assimilate the Torah to Hellenism; the Maccabees wished to incorporate Hellenistic culture into the Torah. The process was like that of the Europeanization of Japan (ibid p. 156).

The specialized kind of knowledge-power of the Pharisees was only for the few who had the particular talent and time to become wise.

Jesus Sirach, a Pharisee, writing in the Wisdom of Sirach asks in disdain of the agricultural masses, "How can he become wise that holdeth the goad" (Bickerman 1966:161)? Most of the working people lacked the leisure for extensive memorization the Pharisaic regulations demanded.

Evidence from Josephus indicates that there may have been 6,000 Pharisees in Christ's day (Jeremias 1969:252). Compared to the 600,000 to a million Jews in Palestine (Lane 1971b:11) this would be something less than one percent of the population. In contrast to the four million Hellenistic Jews outside of Palestine (Jeremias 1969:205) they were an even smaller minority class.

In spite of their minority or elitist status the Pharisees had a popular image and exercised great political power in the Sanhedrin due to their popular following. They were laymen of humble origin. Their ranks were open to any of the common people who had the zeal for the Law, the time, and the intellectual capacity to meet the standards they had set for the study of the Law. Membership was supposedly open to all, but in practice only a minority could meet their scholastic standards and manage to pass through the keyhole to the "spiritual maturity" they had constructed.

The drive for purity of things Jewish and "holy" led them to reject the use of Greek or Aramaic for the study of the Law. They preserved their own teachings in Hebrew, which helped to separate them from the ordinary people who spoke mostly Aramaic. They required their members to maintain strict social separation from ordinary Jews who did not keep their traditions and referred to the unlearned masses as *Am-ha-ares*, "the people of the land." In view of the fact that they were separating themselves from more than 95 percent of the people it is very instructive to notice some of the requirements for becoming a Pharsiee. A man had to pledge himself:

to strict Levitical purity (as strict as the priests in the temple).
to avoidance of close association with the *Am-ha-ares*.
to scrupulous payment of tithes.
to a conscientious regard for vows and for the other person's property (Lane 1971b:14).

The avoidance of close association with ordinary people of the land prevented marriage, contract, and even buying and selling from *Am-ha-ares* who did not keep the traditions of the Pharisees. We shall see below in the study of the Jewish school systems that the study of the Pharisaic traditions or the oral laws was not begun till a student could correctly cantillate or sing the Pentateuch or, in some cases, even the whole Old Testament. Therefore, a person had to display considerable scholastic ability before he could study and comply with the orally transmitted rules for purity. There were many reasons why they remained a numerically small group of respected experts. The respect granted them by ordinary people for their great scholarship gave them considerable influence in the synagogues and in the Sanhedrin.

6) *Am-ha-ares*. The term *Am-ha-ares* was used by the Pharisees as a derisive term for the masses who did not learn to read the written Law in Hebrew or go on to learn or to keep the oral traditions of the Pharisees. The evidence indicates that ninety-five percent or more of the population fell into this category (Martin 1975a:90 and Jeremias 1969: 205). These were the ordinary working people who were not members of any of the official power groups. Information concerning education in first century Palestine given in the next chapter indicates that most of these people were considered to be ignorant and were not considered to be able to read the Jewish Law. The fact that ninety-five percent of

the people were considered to be *Am-ha-ares*, however, does not mean that they were completely ignorant of the traditions of Israel.

The synagogue life used a great deal of chanting of the Scriptures, particularly the Shema' (Deut. 6:4-9; 11:13-21; Numbers 15:37-41) and the Hallel (Psalms 113-118) line by line in unison. The women were not expected to learn to read from the written text, but they were expected to participate enough in synagogue life to be able to teach the Shema' to their children. This was oral learning and teaching.

The three major feasts of the liturgical year provided for ceremonies in the synagogue and in the home where parents were required to tell the children exactly what these symbolic actions meant. There was the dietary code that set the Jews apart as a separate people even when millions of them lived among the foreign nations of the world (Lane 1971b:11). These were considered ordinances of God, given at a time when written communication was exceedingly scarce and nearly all of the communication among the people had to be oral or non-written. Although the Jewish religion was rich in its use of oral and ceremonial communications the scholarly Pharisees had rejected the masses who did not read. The synagogue services did much to preserve the Jewish religion, but as we shall see in the next chapter they were not structured to provide popular literacy at the time of Christ. The great majority of the people did not participate in the Hebrew memorization exercises of the scholarly minority.

7) Zealots. Another important group was the party of the Zealots. These people steadfastly maintained that only God was King. During the reign of Herod the Great a man named Judas organized them as a political force and in 6-7 A.D. led them in a rebellion against the Romans (Jeremias 1969:73). Under the leadership of Hezekiah a faithful band fled to the caves and fortresses of Galilee to fight and die for their convictions. Their work did much to increase the animosity of the Jews toward the Romans. During the life of Jesus they were few in numbers but had the support of many of the people. When later they united with the Pharisees it did much to bring about the crisis resulting in the destruction of Jerusalem in 70 A.D.

8) Essenes. Another segment of the population that abandoned the social and religious life of temple worship

was the Essenes. They rejected the corrupted temple system, the restrictive rules of the Pharisees and the militant fanaticism of the Zealots. They retreated into the deserts where they sought spiritual purity, read and copied holy books. They formed various Essene communities, the best known of which (to us) were the Qumran communities. They felt that the Hasmonian Priesthood was both defiled and illegal. They fled from the defiled Israel under the leadership of Zadokite priestly leaders to form a pure Israel through whom God could send the Messiah to save His people. They gave themselves to prayer, meditation, reading and copying of the sacred scrolls. They were committed to literacy and the holy life, practicing complete separation from sinful society and even normal family life. It appears that their practices were known to the general public, and that John the Baptist may have had some relationship to their communities early in his life. But the general public did not join them in their ascetic practices.

SUMMARY

In contrast to the common people the Pharisees hoped that by their scholarship and purity God would establish His rule among men. The Essene sects hoped that through their greater separation and asceticism God would come to rule through them. The Sadducees may have thought they were God's agents to exercise His rule among men. The Zealots hoped to bring God's rule by force. These groups were all able to exercise various kinds of power and represented various kinds of special interests.

But all of these elitist groups together composed only about five percent of the total Jewish population living in Palestine (Martin 1975a:90). The rest of the people were not members of any of these groups and probably could not meet the requirements to enter most of them. The evidence indicates that ninety-five percent of the people were included in the derogatory term for the common people used by the scholars of the day, *Am-ha-ares*. The literal translation of this term is "people of the land." It was used to refer to the Jewish farmers (Ebner 1956:50 and Dalman 1924:32). The need of the people to work precluded the possibility of finding time for the lengthy memorization that the scholarship of the day required in order to be counted wise. Only very talented, or wealthy or very dedicated young people acquired these skills.

Any attempt to display this social complexity in graphic form is of course an over-simplification. It is virtually

impossible to show the various kinds of social advantages enjoyed by each ethnic, linguistic or special interest group. The following chart may, however, help the reader to better visualize the relationships between the various components. The control of the Roman army is shown by assigning the Romans to a thin strip across the top of the diagram. This strip is connected to the vertical divisions of Romans and Foreigners to show that some of the foreign visitors were closely allied with Roman power and influential Greek traders. Others worked in less respected and even despised trades. The Samaritans are separated from the Jews, but like the Jews are divided into Greek-speaking and Aramaic-speaking segments. The line between the Hellenizing and Aramaic-speaking segments is broken to indicate that the Hellenizing people are mostly Aramaic-speakers in the process of acquiring a second language. The Pharisees, a lay movement mostly among people of non-Levite families, hold a place of leadership primarily among the Aramaic-speakers because they hoped to lead the efforts to resist the Hellenization of the people in the name of Jewish nationalism. Neither the Essenes nor the Zealots are shown since they drew their constituency from various parts of society.

FIGURE 4

HORIZONTAL AND VERTICAL SEGMENTATION

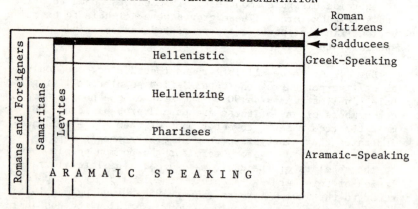

While figure 4 points to the process of Hellenization within Judaism it does not clearly indicate certain important social distinctions such as the extremely small minority of Jews who were in the power elite. The arrangement of the

social divisions in figure 5 comes from Jeremias' analysis of the Jewish social structure at the time of Christ (1969: 270ff). In this analysis he states that among the vast majority of the Jews who did not belong to Levitic families or any of the other special groups (the upper five percent) society was largely "dominated by the fundamental idea of the maintenance of racial purity...Only Israelites of legitimate ancestry formed the pure Israel..." and had the hope of marrying into another socially desirable family. The chances of upward mobility were limited by various kinds of "social blemish" caused by foreign blood, enslavement, or illegitimate birth. Factors related to Hellenization do not appear in this analysis since Hellenization did not seem to constitute a disadvantage to the priestly leaders. The Chief Priests at the very top of the social structure were leaders in the process of Hellenization.

FIGURE 5

JEWISH SOCIAL STRUCTURE AT THE TIME OF CHRIST
(After Jeremias 1969:270ff)

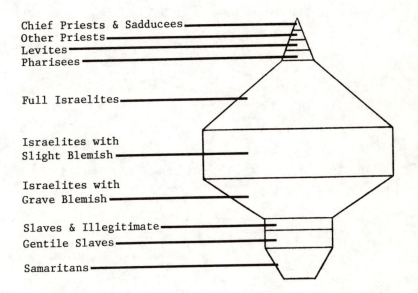

The impact that these social divisions had upon religious communication is considered in the following chapter which is a foundation for understanding the communicational policies employed by our Lord Jesus Christ.

7

Communicational Complexity in First Century Palestine

The communicational complexity of Palestine at the time of
Christ must be understood in terms of the various social,
economic and linguistic divisions among the people. Christ's
choices of language, teaching style and modes of communica-
tion must be seen against the background of the social
meanings these policies had for His listeners. These
choices of methodology did much to shape our Lord's public
identity and the place He took among men. This in turn
helped some segments of the people to accept His message and
scandalized others. Only when we appreciate the social
implications of Christ's communicational policies can we
hope to wisely apply His principles and techniques in parts
of the world where there are similar competing systems of
communication fraught with similar social implications.

THE CLASH OF THREE LANGUAGES

1) Greek. At the time of Christ there was but one inter-
national prestige language--Greek. Alexander succeeded in
military conquest of the Near East. It was, however, Greek
culture rather than Greek political power that took lasting
possession of the imagination of the Middle East. Albright
says that Greek cultural prestige was so great that after
Alexander's conquest Aramaic inscriptions virtually dis-
appeared from most of the Middle East. And there is
absolutely no trace so far of a continuous Aramaic literacy
tradition spanning the interval from the beginning of the
Hellenistic period until the second century (Albright 1965:
155). The Greek language completely displaced Aramaic as a

vehicle for scholarly exchange due to the vast store of
scholarly writing and oral tradition it contained and the
far greater international audience that could be reached
through it.

Greek also had the advantage that it was written with a
script that (unlike Hebrew and Aramaic) represented both
consonants and vowels. Thus written communication could be
effective without a scribal witness to preserve and authori-
tatively state orally the intended meaning of a text. Hence
it was virtually inevitable that Greek should become the
language of written scholarship of the day (Black 1967:15).

Greek was readily accepted by the Hellenistic Jews of the
dispersion and by many of the Hellenizing Jews and High
Priestly rulers of the Jews before and after the Maccabees.
We have already mentioned Janneus' use of the Greek language
and name, Alexander, on his coins. Herod, Archaelaus,
Antipas and the Roman Procurators also used Greek on the
coins they minted (Dalman 1929:2,7).

The translation of the Old Testament into Greek (LXX),
done in Alexandria was easily tolerated even in Jerusalem.
Thus the Scriptures could be read directly in Greek, "emanci-
pating Greek-speaking Jews from the task of learning to read
the original Hebrew" (Moore 1946:322). Hellenistic children
could learn to read the LXX in their mother tongue, Greek.
They had less need to memorize the Hebrew text to make use
of Scripture portions. But it was strictly forbidden to the
Aramaic-speaking Jews to put an Aramaic translation of
Scripture into writing. Greek was the language in which the
Apocrypha was most often read and it is possible that Tobit,
parts of the Wisdom of Solomon, the Letter to Jeremiah, the
Prayer of Manasseh and surely II Maccabees chapters 4-15
were written in that language (Harrison 1969:1209-1268).
The entire Apocrypha was preserved into the third century in
Greek rather than in Hebrew. Dalman states that there were
Greek-speaking synagogues in Palestine for "Alexandrian"
Jews, apparently built by Jews from Rome and other parts of
the empire (Dalman 1929:3). It appears that when Jews
from different places came together, the common tongue was
not Aramaic but Greek.

Dalman goes so far as to suggest that everyone in
Palestine was supposed to have some knowledge of Greek in
order to deal with the authorities, since much of the govern-
ment was conducted in it. This seems unlikely except for a
very few words required for paying taxes or registering

payments. But he may be right that Greek was common in Galilee, and that Jesus spoke directly to Pilate and the Canaanite women in Greek (Mark 9:28; see Dalman 1929:5). Matthew appears to have been quite fluent in it, as well as John Mark, but there is no evidence that any of the other disciples wrote in Greek except John who may have had help. The genuinely Greek names of Andrew and Philip indicate that they may have spoken Greek. This theory is strengthened by the fact that the Greeks approached Jesus in the temple through these men (John 12:20). The policy of Jews having two names was common. One name was for personal identity at home among the Jews. A Greek name was, however, used in commerce and contact with the outside world (Barclay 1966:205).

2) Hebrew. This was the sacred language of the Jews, the language of their Scriptures and the language of rabbinic studies. Although the Law was thought to have been originally given in Hebrew and three other languages including Aramaic, Hebrew was the only language in which many teachers thought it ought to be read. Reading the Law in Greek was tolerated. But the Pharisees strictly prohibited reading or writing of any Scriptures in Aramaic. In the synagogues the Scriptures were read in Hebrew and then translated into Aramaic, for the majority of the people (and virtually all the women) were *Am-ha-ares* who could neither read nor correctly understand the Hebrew (Moore 1946:321). The reader held the Hebrew scroll but the translator was not allowed to have any written Aramaic notes of any kind. He was required to give an oral paraphrase that correctly expressed the meaning of the text, because it was held that a word for word translation would mislead the people.

R. Judah (ben Ila'i) sets a difficult standard for the translator: "He who translates a verse with strict literalness is a falsifier, and he who makes additions to it is a blasphemer" (ibid p. 304 from Tos. Megillah 4,41).

This required that the translator not only know Hebrew, but also understand the meaning and correct understanding of the text he was translating.

Theoretically every boy was supposed to learn to speak Hebrew in his home as soon as he was able to speak. His mother and father were to start teaching him to say the Shema' (Deut. 6:4-9; 11:13-21; Numbers 15:37-41) and the Hallel (Psalms 113-118) (Dalman 1924:33f). These were also

frequently chanted by the congregation in the synagogue.
But this formal and informal system of chanting from memory
hardly produced fluency in Hebrew, the ability to read or
the standards of textual memorization required to become a
Pharisee.

Due to the low level of literacy among the common people,
the Pharisees made a decree that in addition to the disciple-
ship system for training scribes, free schools for children
must be established in Jerusalem to teach children to read
the Scriptures. This decree for free primary education in
Jerusalem came around 70 B.C. (Ebner 1956:47ff). But it was
not till just before the destruction of Jerusalem in 70 A.D.
that another decree was given to establish free primary
schools in the synagogues of the towns and villages of the
land. However, this was probably not implemented until much
later (ibid p. 47f).

When these schools were finally established after 100 A.D.
there were three levels of schooling, reflecting the older
practices of Jerusalem. Only the boys who successfully com-
pleted a lower level could go on to the next higher level.
The first level was the *Mikra*, or Bible School for boys
starting at age 5. In *Mikra* they learned to recite the
Scriptures in the melodious pattern known as "cantillation"
(Rosowsky 1957:1). Herzog calls this a "logogenic" style in
which the words determine the tones, and the tones clarify
the meaning of the words (1972:Vol. II, 1100).

The written text contained only consonants--no vowels.
Only a teacher who had virtually memorized the text with an
approved rabbi in order to assure that he would pronounce
it with the proper vowels could be approved to teach the
children (Moore 1946:320 and Ebner 1956:91).

The text was taught line by line, verse by verse, till
the children could chant the verses by heart with the
correct pronunciation, without the book (Ebner 1956:90ff).
Without the correct cantillation it was "considered neither
beautiful nor good" (Dalman 1924:32). The whole Hebrew Bible
was "read" or cantillated in this manner with appropriate
styles for each division of the canon (Rosowsky 1957:1).
Some rabbis required all of this for graduation from *Mikra*,
others only required successful chanting of the entire
Pentateuch (ibid and Ebner 1956:90ff).

Herzog states that this type of chanting is common to all
other great oral and highly memorized "scriptural" traditions,

such as the Vedic recitation in India or Buddhist recitation in Japan. These countries and others reveal that none is spoken or sung, but they are "cantillated" (Herzog 1972:Vol. II, 1099).

It would appear that this is true as well of the *Ijala* chanters of Nigeria and other Yoruba memory specialists such as the *Ifa* Priests (Babalola 1966:23).

The second level of schooling was for boys of about 10 years of age who had successfully completed *Mikra* and could correctly read or chant the Scriptures. This second level was called *Mishnah* (Ebner 1956:69). This was for the study of the oral traditiona, the *Halakah*. These were the codified rules of the Pharisees and rabbis. They indicated what interpretations of the Law were acceptable. They were learned and transmitted orally during the period from 400 B.C. to 200 A.D. when they were finally written (ibid p. 18ff). *Halakah* was memorized in Hebrew and discussed in Hebrew or a special rabbinic mixture of Hebrew and Aramaic. Such learned discussion and teaching was elevated out of ordinary Aramaic and thus effectively put beyond the reach of the masses.

The third level of schooling was the highest; the cultural equivalent of our Ph.D. This was the study of the *Haggadah*, the non-juristic stories about the previous application of the laws in certain situations, and the sayings of the wise men (Moore 1946:Vol. I:320). Ebner calls it *Talmud*. This too was completely oral and passed from a master to his disciples. This work had the highest prestige.

Moore quotes a *Midrash* that claimed that out of every thousand who begin to recite at the first level only 100 complete the course to go on to the study of the oral law. Then only ten of these complete the second level, and but one out of the thousand completes the entire course (ibid). It was considered desirable for every child to complete the first section. But if the saying above is accurate, it would seem that only a minority completed even the first level with the ability to chant extensive sections of the Bible. One who spoke only Aramaic and did not know enough Hebrew to follow the lectures of the rabbis in Hebrew or to keep the Pharasaic distinctions between clean and unclean was called *bor*, "an ignoramus" (Dalman 1924:32). One who could not recite the oral law of the rabbis and observe its distinctions was called *Am-ha-ares*. This designation also applied to those who studied on their own, without being attached to a recognized expert (ibid 1924:p. 32).

We must note at least three important aspects of this educational system as it related to the use of the Hebrew language and the potential for communicating new information through the use of writing. First, the reading of Hebrew was only pursued in the primary level of schooling and it was not the most cherished skill most students hoped to acquire. The ability to memorize large volumes of material and to pass it on accurately was the major academic skill required from primary school on upward. None of these studies required literacy in the 20th century sense of the term but rather..."an exhaustive and ever ready knowledge of every phrase and word of Scripture" (Moore 1946:320).

Secondly, we are dealing with a completely different definition of reading, involving a different kind of learning than is usually used in our western educational systems. The kind of reading that required the reader to supply the correct vowels and and to sing them correctly does not prepare a person to read large volumes of new information, but only to review material already familiar. The traditions passed on in this fashion were personally mediated through the teacher. Reading was an aid to memory and books were not used in such a way as to replace memorization, or for private critical study. When the Greeks introduced a complete alphabet and students came to privately review old materials without a teacher to guide the process, a new method of learning, a different definition of learning and mental attitude toward learning developed (Goodey 1968: 30-44ff).

We shall see in section III that most indigenous African cultures operate on a definition of learning similar to the ancient Hebrew concept. Both systems depend heavily upon memorization, oral communication, and the role of the teacher who mediates a tradition. Neither system uses writing to replace memorization.

Thirdly, and perhaps most strategically, we must note the predictably high rate of attrition caused by the difficulty of finding time and leisure to do the memorization necessary to complete even the first level, *Mikra*. At the time of Christ the vast majority of the people were not skilled in the use of Hebrew. They had *not* acquired the skill to read, chant or understand extensive portions of the Scriptures for themselves in what was to them a foreign language. To learn Hebrew or to read it was permitted for women but not at all recommended. This attitude alone assures that virtually half of the population could not be effectively reached by a message in Hebrew.

We may suppose that some people could read or chant the Scriptures but few people had books in their homes. Most of the use of Scriptures in the homes was done from memory. Christ could not think of reaching the masses with a new message in His century through books in Hebrew or any language. Barclay estimates that at the beginning of the fourth century the cost of having a scribe make a copy of the four Gospels would be about 91 British pounds (Barclay 1966:45). That is nearly $300. Similar costs in Christ's time would have prevented most people from being able to read our Lord's teachings.

One of the central institutions of learning among the Jews at the time of Jesus was the synagogue, where the Scriptures were read every week. Various estimates of the extent of literacy in the time of Jesus have been made. Writers such as Filson (1964:45) have quoted Moore's work (1946) to prove that all male adults were supposed to be able to read the Scriptures in the synagogue services. But when Moore is consulted it is discovered that the specific reading assigned for a given Sabbath is likely to have been only two or three verses long (Moore 1946:302). It was supposed to be read by one person and translated by someone who knew what it meant.

But Moore suggests that the number of people who actually understood and read Hebrew in Christ's time was so small that in many synagogues the synagogue attendant who served as the school teacher was often the only one who could read and give the meaning in Aramaic (ibid 290,302). The rules for using several readers given in the *Mishnah* were observed only in the larger cities in rabbinical schools (ibid). The minimum standard required by some rabbis for counting a person literate was the ability to read or chant from the text correctly three or four verses during the service. For this, he could have been specifically coached (ibid 302 and Dalman 1924:32). Other teachers required more extensive skills to count a person literate. The bulk of the synagogue service was given to prayer, praise, oral recitation from memory and an optional homily depending on the availability of someone to expound the Scriptures.

All of this evidence fits the conclusion that at the time of Christ the combined efforts of all the educational institutions in Palestine had not succeeded in bringing more than five percent of the populace to the stage that we have defined as functional literacy in Hebrew.

3) Aramaic. Aramaic was the official language of Babylon and much of the Near East prior to the conquest of the area by Alexander in 333 B.C. When the Hebrews came back from Babylon before 444 B.C. they spoke only Aramaic. Only the religious leaders spoke Hebrew. The continued use of Aramaic among the Jews must have been a continual reminder of their years of slavery.

It is extremely difficult to study the Aramaic of Christ's day because of the scarcity of written materials in Aramaic from 333 B.C. to 200 A.D. (Albright 1956:155). The *Mishnah* material from Christ's time was written at the end of this period. When the scribes wrote they avoided the language of the peasants and used Hebrew for religious purposes, or Greek for international trade and scholarship. There was no need to teach the writing of Aramaic in Jewish primary school, and it was not used much in higher schools.

The rabbis used Aramaic only to teach the unlearned, even though it was the mother tongue of most of the Jews of Palestine. Greek was the mother tongue only of those raised outside of Palestine and of a few city folk recently returned from abroad. But there was abundant motivation for those interested in trade or social advancement to take a second name, a Greek name, and begin to speak the trade language.

The scholars and Pharisees escaped the Aramaic identity or a casual attitude by speaking Hebrew. The common people would learn some Hebrew in the synagogue but had a better chance of making socio-economic progress by imitating the other Hellenizing Jews. But the Greek they used in the streets was at best a broken Greek that the Greeks considered a "wretched imitation" (Lane 1971a:43). Usually only the elite managed to learn to use a polished Greek. Hence, at the time of Christ, even for the Hellenizing segment of Palestine, Aramaic remained the language of the home, the language of the country-side and the only language in which the vast majority felt truly at home (Manson 1949:11f).

This division between the language of scholarhip and the language of the heart and home is very similar to the contemporary African situation in which most of the lower and virtually all of the advanced schooling is carried out in French and/or English.

POETIC COMMUNICATION IN ARAMAIC AND HEBREW

In the English-speaking world poetry has usually been
characterized by metre, balanced length of lines and rhyme.
Since Hebrew poetry does not usually concern itself with
these qualities, it has not always been recognized by Bible
scholars that much of the Old Testament is poetic. When the
King James Bible was printed in the 17th century neither the
Psalms nor the poetic parts of the prophetic books were
printed in poetic lines. In the last quarter of the 19th
century Bishop Lowth published one of the first explanations
of the poetic significance of Hebrew parallelism in the Old
Testament and particularly in the prophecy of Isaiah (Burney
1925:15). With the printing of the R.S.V. the poetic
sections of the Hebrew Old Testament and parts of the New
Testament are displayed as lines of poetry.

The major characteristics of classical Hebrew poetry are
parallelism and rhythm. Parallelism is created by placing
two comparatively short sentences one after the other that
are parallel in the thoughts they contain. Parallelism of
thought can be produced by saying the same thing in two
different ways to form synonymous parallelism, or juxtaposing
two opposite thoughts to form antithetic parallelism. If one
line completes or supplements the meaning of the other it may
be called synthetic or constructive parallelism (ibid 15-22).
This parallelism of thought lends itself to translation
because the sound of individual words is not crucial to the
intended poetic structure.

The other characteristic of Hebrew poetry, rhythm, is
created by a balanced number of stressed syllables in the
lines. The number of unstressed syllables in a line does not
affect this sense of rhythm or balance. This permits longer
or shorter lines to be used together as long as the stressed
syllables are balanced.

Rhyme was known, but in most of the Hebrew Old Testament
poetic rhyme was avoided (ibid 148f). It was a device used
in the popular folk songs (ibid 151).

The poetry of the Old Testament was sung or chanted in
the synagogues of Palestine, and would have been well known
to Jesus. Both in His day and today the entire Old Testament
is not just read, but is chanted or cantillated. The chanting
style was a mnemonic device to help the reader remember the
correct pronunciation of the consonantal text. It was to
help the congregation hear the correct meaning and emphasis.

Each section of the canon has its own <u>distinctive</u> style in
which it must be chanted aloud (Rosowsky 1957:1). Thus the
Jews were well aware of the differences between poetic and
prose sections of Scripture. There was also a special style
for chanting parts of the oral law (Gerharddson 1961:167).

When the sayings of Jesus Christ preserved in our Greek
Gospels are translated back into the Aramaic of Palestine it
is clear that they were delivered in the form of Aramaic
poetry (Burney 1925 and Toyotome 1954). But there is a
major difference between Christ's poetry and most of the
poetry found in the Old Testament. The teachings of Jesus
were in an Aramaic poetic style that makes use not only of
parallelism, rhythm and assonance, but also of rhyme. The
Lord's prayer in Matthew (Matthew 7), the parable of the
Good Shepherd (John 10:1) and many other passages make use
of rhyme (Burney 1925:165-175).

The Gospels are unique when compared with the work of
contemporary rabbis for their consistent use of poetic rhyme,
rhythm, parallelism, parables, and "a considerable number of
riddles" (Jeremias 1971:29-35). Nor were these qualities
characteristic of the writings of the early Greek-speaking
churches.

A summarization and visual presentation of the communica-
tional complexity in the Palestine of Jesus' day is presented
in figure 6. This is an attempt to show complexity resulting
from linguistic differences, class divisions, and modes of
communication that were considered appropriate to each
segment.

FIGURE 6

COMMUNICATIONAL COMPLEXITY WITHIN THE SOCIAL
DIVISIONS OF FIRST CENTURY PALESTINE

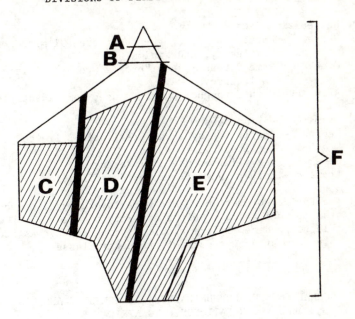

☐ Indicates the part of the population likely to be able to read and write letters in any language.

▨ Indicates the part of the population *not* likely to be able to read or write a letter in any language.

A. Priestly Divisions
 Hebrew – Fluent and literate; proud of oral tradition
 Greek – Leaders fluent & literate; followers less skilled
 Aramaic – Mother tongue of most; mixed identification

B. Pharisees
 Hebrew – Fluent and literate; proud of oral tradition
 Greek – Some fluent
 Aramaic – Mother tongue of most; mixed identification

C. Hellenized Jews
 Hebrew - Very few are fluent and literate
 Greek - Mother tongue; some literacy expected
 Aramaic - Most speak some; limited identification

D. Hellenizing Jews
 Hebrew - Mostly for synagogue recitation; limited
 fluency, and minimal literacy
 Greek - Some fluency; much "broken Greek;" limited
 literacy
 Aramaic - Mother tongue; domestic use; some identification

E. Aramaic-Speaking Jews
 Hebrew - Mostly for synagogue recitation; limited
 literacy
 Greek - Very limited use of literacy
 Aramaic - Mother tongue; strong identification

F. The Entire Population - Most were favorably disposed to
 oral communication. Only a minority of the readers were
 able to read new information. Rhyming poetry was accept-
 able to most except part of the upper classes.

SUMMARY OF THE COMMUNICATIONAL COMPLEXITY AND ITS RELATIONSHIP TO AFRICA

There is a basic parallel between the situation in
Christ's time and many modern African situations. There are
certainly some marked cultural differences, including greater
literacy in today's Africa than in Palestine of old. But
these differences do not obscure the basic parallel of a
common reliance upon oral communication in both societies.
Jeffries and D. K. Smith indicate that in Africa a reading
habit is not socially expected either for communicating or
for leisure time use. Chapter nine of this study stresses
the concept of "oral identity" in Africa, and the socio-
logical factors tending to unite people who cannot or do not
read. It seems that there is a sizeable proportion of
Africa's people who remain committed to oral communication
rather than to written communication.

In both situations the use of literate media would tend
to stimulate a negative reaction from the majority who have
not attained skill in the use of reading and writing. It
certainly prevents the majority who cannot read from becoming
communicators of the written message.

Figure 7 presents a diagram of the proportions of West African society likely to make good use of written communication. This is placed alongside of a diagram of the segments of first century Palestinian society likely to use written materials in daily life.

FIGURE 7

COMPARISON OF MODES OF COMMUNICATION

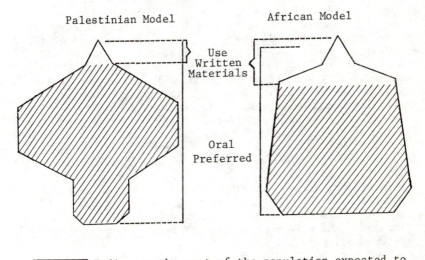

Palestinian Model African Model

Use Written Materials

Oral Preferred

☐ Indicates the part of the population expected to make use of written communication in any language.

▨ Indicates the part of the population *not* likely to be able to read or write a letter in any language.

Brackets: The top bracketing shows the part of the populations likely to be able to use written communications. The lower bracketing indicates that the vast majority of each society, whether literate or not, have a clear preference for oral communication over written.

Figure 7 does not indicate an important factor. In ancient Palestinian society different styles of oral communication were preferred by upper and lower segments. In the following chapters I suggest that Christ's selection of particular oral styles was important for the way various

segments of His audience reacted to Him. In many African
societies, however, there is a more general interest among
all segments of the population in traditional styles. Thus
certain styles of oral communication can be of vital interest
to all segments.

Some scholars may point to higher levels of literacy in
ancient Palestine than is indicated here. In defense of my
position it should be pointed out that 1) literacy was an
ideal of the scholarly elite not actually reached by the
common people, 2) those who did read Hebrew or Aramaic
usually made use of materials with which they already had
some degree of familiarity (i.e., which they had memorized),
and 3) the common people of Palestine did not buy or use
books (or scrolls) in their homes. Books were simply too
expensive. The inability to read would not always be a
stigma among the ordinary people; it may well have been a
badge of group membership. The ability to read may have
marked a person as a non-member of the common people, as an
alien or as a member of "the upper crust."

Having noticed some of the social structures within which
Christ ministered, and their similarity to various parts of
contemporary African situations we will now turn our
attention to the communicative strategy of our Lord. If
His situation was similar to ours, as the data seems to
indicate, there is much in His strategy that we can employ
in communicating His message today.

8

Aspects of the Communicational Strategy of Jesus Christ's Identity as a Teacher

In this chapter we will first consider the nature of the communicative role that Jesus took upon himself as a teacher. Then we will examine His role and the use He made of the media available to Him in terms of four principles of intercultural communication that are known to influence the acceptance or rejection of a message. Our aim is to be able to plan better strategy for missions operating in areas of similar cultural diversity (Kraft 1973b:277-284).

With all the options open to God for His use in communicating to men, it is difficult for us to fathom why God chose to do it in the way He did. Why He chose to become a man and to spend His years among men as a servant, even to the point of dying as an outcast may remain forever a mystery. But an analysis of the communicational aspects of the incarnation is very instructive for the planning of mission strategy.

CHRIST'S IDENTITY AS A TEACHER

One of the contributions to this study is the work of Robert Meye (1968) that documents the disciples' recollection of Jesus as a teacher. Jesus was the Lord, the *Christos* and a prophet. But in addition to these messianic offices, He stands out particularly as a teacher in the recollections of Mark. This was not a title He took for himself but a designation that the people gave to Him in spite of the fact that He was a very different kind of teacher. He lacked accreditation as a disciple of any of

the established rabbinic schools. Many would count Him to
be among the *Am-ha-ares*.

From the very beginning Christ was identified with the
poor in the land by the inability of His parents to be able
to afford a house for His birth, or a lamb for His atonement
sacrifice at the time of Mary's purification (Luke 2:24 and
Lev. 12:2-8). His identification with the trade of a
carpenter was not considered prestigious or compatible with
scholarly ambitions (Matt. 13:54,55). During His ministry
He probably accepted charitable donations from women who
followed Him and "ministered to Him" (Matt. 27:56 and
Lk. 23:55). And He apparently never managed to afford a
house of His own (Matt. 8:20). He does not seem to have
wanted one.

His choice to remain poor plus the fact that He did not
become a disciple of any of the Pharisaic schools or insti-
tutions of His day indicate that He did not take the custom-
ary courses society expected teachers to take. In John
7:15,16 and Matthew 13:43,55 the crowds are clearly surprised
that Jesus takes it upon himself to preach and teach when He
had not studied in one of the approved rabbinic circles. We
must assume if His performance at age 12 is any indication,
that Christ could have performed better than average in the
normal schooling sequence if He had not rejected this kind
of preparation for His work.

Dalman explains that the rabbis would be offended by a
rejection of their training system, since they took great
care to preserve and teach both a unified vocalization of
the consonantal Hebrew Scripture texts and their set oral
interpretations of these texts. This is why they counted
as *Am-ha-ares* anyone who studied on his own and did not
work under the supervision of a recognized master (1924:32).
By failing to "graduate" from one of these institutions
Jesus was sure to alienate the scholarly community and any
institutional claims to being an accredited teacher. He
obviously knew the Scriptures, but took His stand among the
95 percent of the population who did not "make it" in the
religious schools of the day. It is clear that He completely
rejected the curriculum of the *Mishnah*, and make up His own
(*Midrashim*) material to teach.

A major departure from the scholarly, or elite classes of
His day is that Jesus apparently did not teach the common
people through the use of the scholarly languages of the day.
Instead He probably taught in Aramaic. Other teachers

preached in Aramaic in the synagogues, but to teach their
disciples the oral traditions they switched to the Hebrew
which they had memorized (Moore 1946:106ff). Dalman gives
extensive evidence from the traces of Aramaic in the Greek
texts of the Gospels that Jesus probably taught and minis-
tered in the mother tongue of the majority of the common
people (Dalman 1924:7-18 and Black 1967:4ff). Among the
many examples given by Dalman are the word *effatha* (for the
Aramaic *itpattah*, "open yourself") to the deaf and dumb man
in Mark 7:34, and the abusive word *raka* (Aramaic for "silly
fool") from the Sermon on the Mount (1924:12-18).

It is clear from Jesus' use of Aramaic, and the locations
of His ministry that He intended to teach the poor of the
land, the common people. Mary prophesied that this would be
the focus of His ministry in the Magnificat (Luke 1:45-55)
saying in part,

> ...He has scattered the proud in the imagin-
> ation of their hearts,
> He has put down the mighty from their throne,
> and exalted those of low degree;
> He has filled the hungry with good things,
> and the rich He has sent empty away...
> (Luke 1:52f)

He states His own purpose by reading the prophesy of Isaiah
61 and claiming that it applies to Him and His ministry.

> The Spirit of the Lord is upon Me, because
> He has anointed me to preach good news to
> the poor (Luke 4:18ff).

In His choice of location for His teaching, He seems to
have leaned in the direction of informal education. Instead
of setting up a rival school in one of the urban centers, He
had an itinerant ministry out among the peasants (Matt.
3:23; Matt. 9:35), teaching on the sea shore (Matt. 13:1,2),
or on a mountain-side (Matt. 5:1).

Whether Matthew is reporting an actual sermon on a
mountain, or merely reporting the teachings of Jesus, con-
veniently grouped for memorization, Matthew 5 still presents
a remarkable attitude on the part of Jesus toward the common
people, the *Am-har-ares* (John 7:49). He not only declares
that they are blessed as they are, even in their poverty,
but also proclaims that they are the salt of the earth and
the light of the world. This is a completely opposite

attitude from the snobbishness of the learned classes. This
snobbishness was part of the reason that the Pharisees
insisted upon strict social separation from the common
people (Lane 1971b:14).

This brings us to a characteristic of Christ's ministry
that was particularly galling to the Pharisees and other
separatist movements. Instead of observing Levitical dietary
canons (ibid 14) Jesus insisted upon table fellowship with
all kinds of people: tax-collectors, sinners and other
Am-har-ares (Luke 6:1-5; Matt. 9:10; Luke 19:1-10). He thus
did not violate their interpretation of the law, but He
broke the social code by accepting these "unclean" people
as His friends. This could not help but alienate the various
social groupings in the upper five percent of the classes,
and to identify Him firmly as an *Am-ha-ares*, a man of the
people.

There is abundant evidence that His speech clearly identi-
fied Him with the masses. This was true of both His choice
of language and of the distinctive speech styles He used for
His teachings.

Burney was among the first to demonstrate that when the
words of Jesus as recorded in our present Gospels are trans-
lated back into Aramaic, they fall into rather balanced and
rhythmic lines of Aramaic poetry. The lines are complete
with assonance, rhythm, not unfrequently rhyme (1925:147).
The parallelism is still present in much of the Greek text,
although Jeremias feels that when Luke translated into
Greek he had a tendency to reduce the repetitive aspect of
some of the material he took from the Logia or Q source
(1971:17ff). Bultmann and others contend that the church
added the repetitious lines to construct parallelism from
the shorter Aramaic materials (Berclay 1966:74 and Davies
1967:121).

A few other rabbis were known to give some of their say-
ings in rhythmic form, but in the consistent use of poetic
structures, and particularly rhyme and elaborated parables,
the teachings of Jesus are unique (Burney 1925:148;
Jeremias 1971:29). Jeremias is among those scholars who
claim that the use of parables, creative figures of speech
and structures of Hebrew folk culture are distinctive marks
of the work of Jesus, *Ipsissima Vox*, "His very words" (1971:
29; Burney 1925:6f). In this regard he follows Dalman. He
further claims that our Lord, in His role as a rabbi, was
expected to drill His students to memorize His words, so

that they would not pass from memory. (Jeremias 1971:20; Manson 194812ff; V. Taylor 1933:94). When Christ did this in Aramaic oral-poetic style, the common people could participate.[1]

Many writers on the New Testament have attributed the grouping of the materials in the Gospels to the church, or to the Gospel writers, because the various writers record

1. This note is intended to be something of a guide to indicate New Testament scholars who attribute the Hebraic parallelism of the Gospel sayings directly to Jesus himself. The classic work is Burney's *The Poetry of Our Lord* (1925). Burney's findings have been analyzed in the light of current discoveries by Matthes Black in *An Aramaic Approach to the Gospels* (1967). Dalman's *Jesus-Jeshua* supports Burney's view (1929). Manson treats a broad range of issues related to the synoptic problem, and sees the poetic structure as an indication of Christ's influence (1949). Jeremias presents an extended treatment of rabbinic material supporting this position (1971 and 1964:109ff). Meye's doctoral dissertation at Basel evaluates the evidence from Mark indicating that the disciples remembered Jesus among other things as a teacher within the general category of a Jewish rabbi. He supports the position that Jesus would have trained His disciples to memorize His teachings. Gerhardsson represents the Scandinavian rebellion against form criticism, giving evidence that Jesus may have taught the disciples to chant His sayings, and that the memory of the 12 was judged by the larger community for its accuracy in reflecting the actual words of Jesus (1961). Herclots builds a case from an evangelical point of view for oral sources of the Gospels in opposition to the written documentary sources hypothesis. Similar ideas are advanced by Vincent Taylor (1933) and Filson (1938:159ff). Barclay gives abundant evidence for taking this position generally (1966:40-75). Toyotome's dissertation from Union Theological Seminary presents evidence that Jesus had to be a poet in the broader sense of the word simply on the basis of the word pictures and poetic imagery of the Gospels, regardless of the structure of the lines. This is evidence that the poetic devices all come from Jesus rather than from the early church (Toyotome 1953). W. D. Davies is an authority on rabbinic studies who feels that Gerhardsson's position is extreme. He is generally critical of a rejection of a documentary approach, but he does not dispute the evidence given in the positions taken above (1967:120ff; 1962: 1956).

the same sayings but group them in different order (Barclay
1966:47-51, 72-79). Manson (1949:13ff), Dodd (1968:15f) and
Goodspeed (1942:1f) have held that the obvious agreement of
the material was for memorization and catechetical purposes
in the churches.

Barclay gives a helpful discussion on the didactic and
mnemonic purposes for Matthew's arrangement of the genealogy
of Jesus and the stories and the discourses. He considers
it evident that they were organized for oral circulation in
an age without books for the common people (1966:221ff). In
spite of the different arrangements of the material by the
different evangelists, there is a high degree of fixity in
the preservation of the wording, even in their Greek trans-
lation. Yet we have absolutely no traces of any written
Aramaic Gospel portions, although some Galilean Aramaic
fragments of other materials were found. This fact leads
Manson to the conclusion that an Aramaic church would be so
accustomed to oral communication that they would have no
need for written materials (1949:14).

Goodspeed and Barclay both state that the early Christian
communities, even in Hellenized areas, were largely non-
reading due both to the prevalance of memorized literature
and to the lack of scrolls for popular use (Barclay 1961:
43ff; Goodspeed 1943:1f). Barcley points out that even in
the Hellenized church extensive memorization was very common,
and that the memorized Word of God was more highly valued
than the written Word of God.

> ...whenever I met a person who had been a follower of
> the elders I would enquire about the discourses of the
> elders--what was said by Andrew, or by Peter, or by
> Philip, or by Thomas or James..., or any of the other
> of the Lord's disciples...For I did not think that I
> would get so much profit from the contents of books as
> from the utterances of a living and abiding voice
> (Barclay 1966:161 from Eusebius *The Ecclesiastical
> History*; cf. Herclots 1950:90; and Filson 1938:58,98).

Toyotome states that scholars have been blind for almost
2,000 years to the obvious Semitic parallelisms in Christ's
sayings. This, he claims, is because

> ...most of the investigations of the formal literary
> qualities of the Gospels approached the subject from
> the background of Greek rhetoric (1954:7).

By these standards the Gospel sayings were poor rhetoric.
When they are evaluated from an Aramaic perspective, however,
they can be seen as attempts to give very faithful transla-
tions of Aramaic poetry (ibid). While Burney and Manson
(1948:55) and others stress the poetic arrangement of lines
and rhythm, Toyotome stresses the uniquely creative range
of poetic images (including parables as extended metaphors)
that occur throughout the teachings of Jesus.

In addition to this use of poetry, Jesus also employed
ritual, non-verbal symbolizations of essential Christian
truths. He took the existing symbols of water in baptism
and the unleavened bread and wine in the Passover meal and
infused them with new meaning. As they accompany the
preached Word they become vehicles for presenting the Gospel
message via sight, taste and touch.

Such evidence indicates that Jesus consciously broke
socially as well as theologically with the traditions of
the learned community of His day in order to communicate
with the masses in the linguistic and other forms of commu-
nication they understood best. He intentionally structured
His sayings so that those who lacked special training in
the communicational systems of the elite could understand
and remember them. Then oral communicators (including
scholars) could rapidly spread His word across the land.
This recitation of the living Word from memory may have been
part of what was in the mind of our greatest teacher when He
referred to His teachings. He communicated through life,
oral artistry and ritual rather than by writing. He wrote
no books yet He said, "Heaven and earth will pass away, but
My words will not pass away" (Matt. 24:35).

EVALUATION FROM A COMMUNICATIONAL PERSPECTIVE

It is instructive to evaluate these policies of Jesus in
the light of the four principles of effective communication
defined in a series of articles and presentations by Kraft
(1973b, 1973c, 1973d, 1974, 1975).

1. The first principle is the "Frame of Reference Principle."
This principle may be stated, "Communication is most effec-
tive when the communicator, his message and the receptor are
part of a common frame of reference" (Kraft 1975). That is,
ideas are most effectively communicated when the speaker and
the hearer have the same understanding of life, the same
worldview, the same cultural perspectives. A person's
location within a particular sub-culture or position compared

to the larger social structures is an important factor in shaping these cultural perspectives.

When the original frames of reference of communicator and receptor differ, however, the communicator may designate either his or his hearer's frame of reference as the one within which they will interact. If he chooses his own he will first have to train his listeners to understand his general cultural perspective on life before he can impart his message within that frame of reference. Kraft calls this the "extractionist" approach, since it demands that the recipient of the message be extracted from his own way of thinking before he can understand the message correctly.

Alternatively, however, the communicator can choose to present his message in terms of the hearers' frame of reference. This approach may be called "identificational" (Kraft 1975). Employing this approach requires that the communicator understand and empthathize with the recipient of the message. He must then present the message in such a way that it is readily understood within the categories of the recipient.

If we take a sample of the teaching of Jesus, and consider the way it was presented we will see that Jesus rejected the extractionist approach and illustrated an empathizing identificational approach.

In Matthew 5:14-16 we have part of a poem of Jesus. Burney's reconstruction is as follows (1925:130, 131):

> Yé are the líght of the wórld.
> A cíty cannót be híd,
> Which is sét on the tóp of a híll.
> Neíther light they a lámp,
> And sét it beneath a búshel;
> But on the lámp-stand ⟨ they sét it⟩,
> And it líghteth all thóse in the hoúse.
> So shíne your líght before mén,
> That they seé your wórks that are goód,
> And may glórify your fáther who is in heáven.

Appendix A gives another example of the Aramaic poetry of Jesus and a transcript of Yoruba oral poetry. Where various types of Yoruba (Babalola 1966:62; and Buir 1966) and Bantu poetry (Torund 1921:98) are compared to the form of the Aramaic poetic verses (Jeremias 1971:24) there is a striking similarity. These poetic structures seem to use very short

sentences. They were all composed, transmitted and preserved
orally before they were written. It appears to me to be a
style of communication particularly suited to oral trans-
mission.

By teaching in a style suited to popular oral transmission
Christ entered the frame of reference of his hearers in
several ways. As a man speaking a human language He deliv-
ered the address in the vernacular, not in the scholarly
language. He identified himself as an *Am-ha-ares* by the way
He shaped His personal communicative image, and in the very
poetic structure of rhyming Aramaic (see the Aramaic selec-
tion above) for the convenience of His listeners. He
affirmed them as people, declaring them to be at the center
of God's plan for the world as its salt and light. He
chose imagery that was common to the culture and geography
of His hearers, perhaps pointing to a town in the distance
as He spoke.

On the other hand, the Essenes and Pharisees, though per-
haps sincere in their desire to teach the Law to all men,
demanded that the people come to their institutions, learn
their special language, memorize a large corpus of material,
and learn the cantillation style of the teacher all as pre-
requisites for learning their "important" teachings. They
required that the people be extracted from their popular
modes of expression and learn the skills of a special mode
of communication before this new information could become
available. The Pharisees also required certain changes in
conduct prior to learning the message, as well as the will-
ingness to acquire a new identification as non-*Am-ha-ares*.
The Pharisees had to remain laymen because they could not
become Levitical priests. But they took on a new social
identity as a caste of religious specialists, covenanting
among themselves to remain socially separated from the
majority of the people (Lane 1971b:14).

Since the masses were either unable or unwilling to learn
the new communication system or to abandon their loyalty to
the group of "people of the land," the Pharisees pronounced
maledictions against them as if they were unwilling to learn
God's laws. In contrast to the communicative policies of
the scholarly minority, Christ took upon himself the social
identity of the majority. He used their popular system of
oral communication. He accepted their level of knowledge as
sufficient preparation for Him to explain to them the
necessary information to produce spiritual maturity.

2. The second principle used in this analysis is called the
"Credibility of the Communicator Principle" (Kraft 1974 and
1975). The concept is that if the communicator is believ-
able, the receptor is more likely to give the message serious
attention. There are at least two different ways for a
communicator to attempt to achieve credibility. One is to
assume a stereotyped status, an expected position within
the receptors' frame of reference. This has the advantage
of acquiring the authority society usually assigns to this
status, if it is one that is positively valued. But
acceptance of such a status greatly limits the kind and
amount of new information that can be conveyed since the
audience will usually accept only the messages expected
from such a source. If a source is considered relevant to
one segment of society, the other segments may largely
ignore the messenger and the message.

The other option is for the communicator to seek to win
an unstereotyped position as a "human being" among his
hearers. It requires the communicator to earn whatever
position he may attain among human beings rather than to
demand his position on the basis of a stereotyped status to
which prestige is assigned by the culture. Such an approach
to communication forces people to evaluate both the message
and the messenger on the basis of merit rather than on the
basis of reputation. In this way the communicator and the
message achieve their own identity and are accepted or
rejected because they are understood rather than because
they are respected, though misunderstood. The risk involved
in employing this approach is that the would-be communicator
might not win the respect of his hearers.

It is obvious from the previous discussion that Jesus did
not exactly assume the traditional role of a typical Jewish
rabbi. He definitely did not set himself up with His
society's traditional credentials as a teacher. He rather
shaped His own identity as a preacher, teacher, healer and
savior of men. Rather than assuming a stereotyped status,
He ministered, allowing the people to assign to Him various
titles to describe the functions He was performing. A great
deal of unique communication resulted from His ministry
issuing in a great deal of acceptance on the part of those
with whom He identified himself. These same policies
stimulated a great deal of rejection on the part of those
who could not accept Jesus on these terms.

3. The third principle of communication states that it is
most effective "...when the message is understood by the

receptor to be specifically relevant to his own felt needs"
(Kraft 1975). This is not merely a question of the inherent
relevance of the message to the needs of the receptor. It
is a question of the receptor perceiving that the message
applies to him, and that he needs to receive the message.
It appears that the responsibility for the receptor's per-
ception of relevancy must be shared by the communicator and
the receptor, because it is the communicator who selects the
policies that condition the receptors' perception. The
communicator may present his message as it relates to him-
self, or the subject matter, and assume that it is the duty
of the receptors to understand that the message is relevant.
The alternative is to start from the needs and issues the
receptors already feel to be relevant to their situation in
life. Having thus established an initial awareness of need,
the communicator can expand the receptor's awareness of
other needs. These considerations relate to the content of
the message.

There is also the issue of the medium of communication
and the use to which it is put. If the receptors detect an
alien communicative style or a foreign use of media, they
may subconsciously decide that this particular message is
inappropriate to their needs (Pride 1971:9 and Gumperz &
Hymes 1974:14ff). This is where "code switching" and the
use of "restricted codes" versus "elaborated codes" come
into play. "Restricted codes" are culture-specific and
promote accurate perception of the message in one given con-
text. "Elaborated codes" are less specific to any given
cultural group and thus only suited to those who are able
and willing to exert themselves to decode messages from out-
side the community (Bernstein 1972:465ff and 1966:427ff).

In this regard we can see that Jesus used the indigenous
media of the 95 percent who did not use either literate
communication or the elaborated code of the scholars.
Christ's teaching was culture-specific in terms of the use
of oral communication, speech styles related to the folk-
identity of the masses, and imagery from the immediate
milieu.

Christ's teaching was also applied to specific individuals
and specific circumstances. This includes communication
through healing, arguing, teaching, discipling and showing
love in a variety of intelligible ways. He wept over the
masses, touched individuals, taught the twelve day after day,
related warmly to certain women, and was known to have loved
Peter and John in special ways.

4. The fourth principle is the "Receptor Involvement
Principle" (Kraft 1975). This principle focuses on the
receptor's response to the communicator and his message. It
may be summarized in terms of identification and discovery.

Communication is most effective when the receptor is
led to identification with the communicator and dis-
covery of the message (ibid).

The receptor's ability to identify with either the communica-
tor or his message is directly related to the communicator's
stance vis-a-vis the recipient's cultural context. Any
demand on the part of the communicator that his hearers
reject their social identity will ordinarily result in
demoralization and often psychosocial difficulty on the
part of those who respond positively. They can follow the
communicator only by giving up their own identity and imitat-
ing his foreignness. They cannot follow by identifying with
him. In this regard Jesus did not, like the Pharisees,
assume that the *Am-ha-ares* needed to reject their culture or
position in society. Instead He identified himself in many
ways with the culture of the common people so that they
could identify with His message without giving up their
broader cultural identity or social cohesion. The changes
He demanded were primarily spiritual even if they had pro-
found cultural implications.

Jesus' teaching was conducted entirely within the philo-
sophical, cultural and social orbit of the recipients. He
could, therefore, fully state and demonstrate certain parts
of His message, and allow other parts of His essential
message to be discovered by those who were responsive enough
to seek the full meaning of His words. There was an adequate
potential for them to arrive at a correct understanding
through processing the information given in combination with
what they already knew according to their accustomed modes
of thinking. This is illustrated in the way Christ allowed
His followers to "discover" who He really was (Matt. 16:
13ff). It is illustrated in His use of parables that were
only partially understood, and in His use of riddles (Jere-
mias 1971:29-35). It is more broadly shown in the fact that
Jesus left the church to discover (under the leading of the
Holy Spirit) much about the meaning of His life, about how
Gentiles should be incorporated into membership in His
church and about the plethora of other theological issues
that have arisen since Jesus left.

In summary, we have seen that there was in Jesus' day an elite group with specialized methods of communicating religious information. They were convinced that a certain amount of background knowledge and training in the elitest methods of communication were essential to a correct understanding of the information necessary to produce spiritual growth. Jesus, however, rejected the extractionist methods of these elite classes. He found ways to circulate essential Divine truths within the understanding of the common people and within the limits of what was probably a "restricted code." He left His words unwritten, trusting the oral community with His words only in their hearts and minds, with the confidence that they would perpetuate the living word orally. He trusted the church to discover the meaning of His words for a vast variety of situations that He did not discuss with them.

When the sayings of Jesus were written, they were written in Greek for Greek-speakers and readers--including many who were ethnically Hebrew. New Testament writings, even those directed primarily to Hebrew audiences, were written for people living in a Greek cultural context. Goody and others claim that the use of the Greek script allowed for the development of private, critical studies, and a host of "western" intellectual attitudes (Goody, et al. 1968:40ff). These attitudes included a different definition of literacy and a different use of written materials. Hence the writing of Jesus' words in a Greek context did not have the same meaning as it would have had in an Aramaic milieu. This helps to explain why the writing of the Gospels did not apparently begin till many years after Christ's death--not until the church had become primarily associated with literate Greek-speakers rather than with illiterate Aramaic-speakers. Mark, Matthew and Luke were probably not written until perhaps twenty to thirty-five years after the death of our Lord, and John's material may have been circulated orally up to sixty-five years before it was written (Barker, Lane and Michaels 1969:73,251; Barclay 1966:43; Jeremias 1964:2f). It is clear that Jesus communicated orally and did not use the written media available in His day. His communicative strategy has great missiological significance for us today.

SOCIAL DIVISIONS AND DIRECTION OF INFORMATION FLOW

The social divisions of a society have been shown by sociolinguistic study to have implications for the types of language and modes of communication that will be effective

in given situations (Bernstein 1972:465ff and 1966:ff;
Gumperz and Hymes 1972:14ff). Bernstein has shown that
various social groups within a society develop distinctive
linguistic styles with which they identify emotionally.
This para-communication enables a speaker to convey a great
deal of social identity that does much to determine the
acceptance or rejection of the message (Gumperz in Gumperz
and Hymes 1972:16). Within societies socially mobile people
may subconsciously or consciously demonstrate membership or
empathy with various groups by verbal "code switching" from
one language style to another (Pride 6-14ff; Gumperz and
Hymes 1972:18ff).

Bernstein demonstrates that upper socio-economic groups
employ an "elaborated code" which enables them to encode and
decode complex and unpredictable messages with accuracy
(1966:427ff). Certain socio-economic groups, however, depend
entirely upon "restricted codes," which are forms of lin-
guistic expression that reflect the immediate cultural
environment, and limit the complexity of the messages that
can be received (cf Ward, McKinney and Detoni 1971:31ff).
The result of a habitual use of a restricted code is that
messages that are heard in the terminology of the elaborated
code will not usually be given a serious hearing, because
many people refuse to exert themselves to understand a
message that they immediately perceive to be applicable to
a different social group.

Keeping in mind this analysis of communicational inter-
ference across sociological boundaries within a single
large scale society, it is instructive to look at the
analysis of communication within a society given by Eugene
Nida (1960:109).

He notes that small traditional societies are frequently
horizontally segmented into divisions (such as extended
families) within the tribe. This restricts to some extent
the flow of information from group to group. All of the
segments, however, have a relatively good flow of information
between the leaders of the group and their followers, since
they all share the same social milieu within the segment.
There are no class barriers that block communication because
all the people share in rather direct face-to-face communi-
cation. Previous to western contact many African societies
could have been described in this way, as in Figure 8.

FIGURE 8

A FACE-TO-FACE SOCIETY

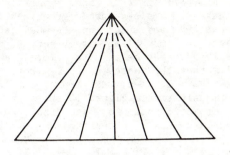

(ibid p. 109)

In figure 8 the lines within the triangle represent hindrances to the flow of good communication. In a face-to-face society these are most likely to be caused by family, clan or dialect boundaries. The leaders or elders of the society (here depicted at the apex of the triangle) may meet more frequently. They are the ones responsible to unite the society to face external challenges.

In figure 9 heavy arrows have been added to show the predominant direction of communication within such a society. Of course there is some communication between the segments especially among the leaders (see the horizontal arrow). But the vertical arrows represent the most important information flow in such societies.

FIGURE 9

FLOW OF INFORMATION IN A FACE-TO-FACE SOCIETY

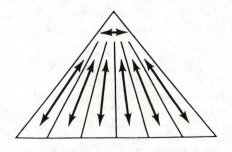

This situation is in contrast to the major patterns of
the flow of information in a modern large-scale society.
Not only are there modern mass media, but there are a new
set of horizontal barriers that produce vertical class seg-
mentation. These are socio-economic groupings in which the
powerful and wealthy socialize among themselves and the
laboring classes have much less direct access to their
leaders. The leaders may be able to afford communicational
media or skills that the masses do not. These social or
economic divisions will have great impact upon determining
patterns of communication. Figure 10 shows two different
distributions of socio-economic class structure that are
possible among large-scale societies.

FIGURE 10

NIDA'S DIAGRAM OF CLASS STRUCTURE

(Nida 1960:98)

In figure 10 there is a much larger middle class in
Society B than in Society A. Society A has a much larger
proportion of its population in the lower classes of workers
or peasants. From the information available it would seem
that the society of Christ's day would be much closer to
Society A than to Society B.

Nida also points out that the introduction of socio-
economic divisions into a small-scale society, or uniting
its members with another large-scale society produced defin-
ite changes in patterns of communication. The easy flow of
information vertically to and from the leaders from and to
all of the followers or workers is altered. Nida summarizes
the communicational patterns that result from these vertical
class structures as follows:

1. People communicate more with people of their own class; that is, interpersonal communication of a reciprocal nature is essentially horizontal and

2. Prestigeful communication descends from the upper classes to the lower classes and tends to be limited to adjacent groups (1960:99).

It would, therefore, be possible to redraw Nida's diagram to approximate ancient Palestinian or modern African conditions and to supply arrows that indicate the major patterns of communication. In figure 11 the social structure is divided into upper, middle and lower divisions. The upper and middle classes are small in comparison to the laboring or agricultural sector.

FIGURE 11

FLOW OF INFORMATION IN A COMPLEX SOCIETY

The heavy arrows in figure 11 indicate the predominately horizontal flow of reciprocal information, while the lighter arrows show that lesser amounts of information do flow between the classes. If there is a high degree of authority exercised by members of the upper class, it may be appropriate to darken the arrow coming down from the upper class a bit. But one should note that only certain types of information--those relating to the exercise of authority--would be likely to be regularly communicated in this direction. Note also that interclass communication is much less likely to be reciprocal than intraclass communication. This fact is indicated by the single direction of some vertical arrows on the diagram.

Nida stresses the importance of these social class divi-
sions for evangelism and the preaching of the Gospel due to
the fact that it appears that communication across class
lines is resisted. It is as if, when people hear a message
coming from the members of another class (especially a lower
class), the message is resisted out of loyalty to the group
to which they belong. The reaction of people to the preach-
ing of the Gospel frequently reflects a

> social situation, even more than a religious conviction
> ...Opposition to the communication of the Christian
> message may be in many instances more social than
> religious...Effective communication follows the patterns
> of social structure...A relevant witness will incorpor-
> ate valid indigenous social structure (Nida 1960:132).

Jesus knew this and worked in terms of this horizontal
flow of information within a single segment of society. But
those who belonged to the elite groups made more of an
attempt to communicate across social boundaries. They were,
however, effective only with respect to authoritarian types
of messages, except with those who agreed to be extracted
from their original social class. Their elitist methods of
communication constantly class-labeled all their material as
relevant to the upper classes.

If we compare various communicative modes used in mission-
ary education and strategies for gaining mature church
members, we find similar elitist presuppositions. Western
missionaries have too easily assumed that methods appropriate
for one segment of society (the westernized elite) are appro-
priate to all segments. If we are among those committed to
the communication of the Gospel in contemporary African
society, we must learn from the approach that Jesus took in
the similarly complex situation in first century Palestine.
He used the oral media of the masses. These insights into
the ways in which information flows effectively in complex
societies would suggest the following diagrammatic analysis
of first century communication paralleled by a similar
strategy for Africa.

Figure 12 diagrams my interpretation of Christ's communi-
cative strategy concerning His choice of oral rather than
written media. The heavy arrow on the Palestinian diagram
is intended to indicate the horizontal and reciprocal
approach Jesus chose by selecting the oral media or the
masses. While this contributed to His effectiveness among
the masses who heard Him gladly, it must also have contributed
to His tension with the upper classes.

FIGURE 12

COMPARISON OF COMMUNICATIVE STRATEGIES

Christ's Palestinian
Strategy

Traditional Mission
Strategy in Africa

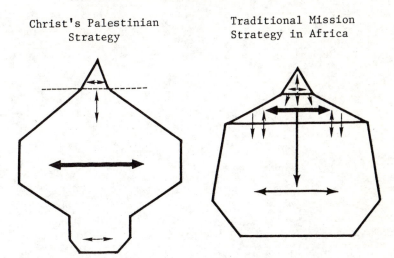

The horizontal arrows at the top of the African Strategy
indicate the actual results of a communicative policy depen-
dent upon literacy. Those who become literate have consti-
tuted a new elite. They have been able to profit from the
use of Christian literature. But Bible knowledge and Chris-
tian education have not succeeded in being extensively
communicated among the non-reading masses of the people.

I am contending that what is missing from modern mission
strategy are presentations of the Gospel and Bible content
that are styled to suit the oral media of the masses of (W.S.)
Africa. Materials prepared for oral memorization in harmony
with traditional oral styles would be shown in the diagram
above by a heavy arrow in the lower African section. In
order to relate to memorized African teaching it is essential
to determine something of the scope, general characteristics
and social importance of memorized oral communication in
West Africa today. This is the topic of the following
section.

Part III

Indigenous African Communication

9

The Vitality
of the Oral System

THE EARLY MISSIONARIES MISCALCULATED

As pointed out above, the early "civilize in order to evan-
gelize" theory of missionary strategy was based on a false
evaluation of African culture. There was often no awareness
of indigenous African alternatives to written communication.
The assumption seemed to be that there was nothing of value
in the minds and hearts of Africans. The missionaries'
task, therefore, was understood to be extractionist--first
to teach Africans how to receive the missionaries and then
how to accept Christ.

Missionary and governmental efforts to westernize Africans
have now been applied with some intensity in many areas for
nearly a century. In many urban areas such efforts have led
to cultural demoralization. This means that many aspects of
tribal culture, including traditional communicational
patterns, have been seriously weakened. But for the most
part, often with a degree of adaptation, oral communicational
patterns have retained a place of prominence in traditional
African societies. This is true with the vast majority of
both rural and urban people whether or not they can read.

One of the important marks of the so-called "traditional"
segment of society is that the people do not read. They
appear to be either unable to read or to be intentionally
resisting literacy. The concept of resistance to literacy
has come as a surprise to me. Missionaries have noticed
certain resistance to literacy and western "education" but

have often interpreted it as stubbornness, ignorance or as resistance to Christianity (e.g., E. Smith 1972:153). It is, however, probable that a large percentage of those who resist are not merely backward, but that, consciously or sub-consciously, they are simply defending indigenous communicative structures, indigenous social structures, the identity of indigenous social groups and the very heart of indigenous culture. Cyril Burt has stated that it is a social disaster to treat educational "backwardness" as a disease without a careful analysis of the causes. It is only a symptom whose root cause must be discovered and treated at the root (Burt 1946:5,120).

In my readings on literacy and mission policy I have found no systematic treatment of the concept of resistance to literacy which has attempted to deal with the social conflicts caused by a choice of western over indigenous communicational techniques. That resistance to literacy could be caused by a conscious or sub-conscious preference for oral communication seems to be missing from most mission thinking. Only rarely in mission writings does one find mention of indigenous oral communication and its sociological implications (Nida 1967:127ff). The greater emphasis has been the urgent need for literacy for all people and the apparent necessity of literacy for planting Christian churches (Rex 1967:1-3; E. Smith 1972:62,236). This is in spite of the fact that some writers have noted that in parts of West Africa they sense a definite resistance to literacy and western education (Cole 1971:43; E. Smith 1972:153). There have been few hints that perhaps African people ought to be reached via oral communication (Crawford 1914:58).

The importance of oral communication and African oral arts for the social structures of African communities has only recently been discovered by western observers (Dorson 1972:3ff; Herskovits 1972:167). The concept of sociological causes for resistance to literacy has likewise just begun to surface in the writings of anthropologists and educators (Finnegan 1968:8,44; 1970:1-10; Howard 1972:115; Flower 1972:19). But I have found no developed theory to explain indigenous resistance to literacy in societies of oral communicators. This chapter attempts to speak to this issue.

It is my conviction that it is neither loving, respectful, nor constructive to view indigenous resistance to western education or literacy merely as a problem or a disease to be cured (Barrett 1968:269ff). It is far wiser and more

fruitful to attempt to empathize with the positive reasons
people may have for preferring indigenous oral communica-
tions. It is my goal to come to appreciate the positive
reasons for the persistence of the oral system that is
present at the very heart of indigenous oral societies.

This chapter is intended to demonstrate sociological
reasons for the continuing vitality of oral communication
in contrast to literacy. This chapter introduces a dis-
cussion of vital characteristics of the oral system and the
likelihood that it shall continue to be a crucial factor in
Africa in the future.

Dorson writes concerning the western slowness to recog-
nize the existence and importance of oral communication
generally (1972:3ff). He speaks of it as a development of
scholarly self-consciousness about communicating through
books, and the development of awareness that there was a
different learned tradition around them that did not depend
upon books. He contends that the conditions for discovering
the scholarship and didactic qualities of that tradition
were not favorable until recently (cf. Herskovits 1972:167).

African folk-tales have been collected for some time
(Torrend 1921:1; Koelle 1854:1). But western universities
have only recently (since 1960) systematically studied them
as "oral literature" or "oral art" in relation to their
social setting (Dorson 1972:2,4). There is now a rapidly
growing body of literature on oral art from Africa and
around the world.[1]

The assumption, held by many, that African people did not
value knowledge was also wrong. Knowledge was not only
greatly valued, it was among the central values of the
community. It was just that many African peoples did not
express their high regard for knowledge in the manner
expected by European observers (i.e., via books and schools),
and the content of their knowledge was different from that
of the west.

[1] See, for examples, Babalola 1966; Beier 1966 and
1970; Deng 1973; Dorson 1961 and 1972; Finnegan 1967 and
1970; Herskovits 1958 and 1961; Ijimere 1966; Lomax 1970;
Morris 1964; Thompson 1946; Torrend 1921; Vansina 1961;
Whiteley 1964.

Cole's writing indicates that the Kpelle of Liberia prize knowledge very highly, and that knowledge is a controlling force in the entire social structure (1971:45-55). But because traditionally knowledge has been greatly valued, it has been kept a guarded secret. He indicates that this combination of knowledge as an important value and the idea of keeping it a secret as the culturally expected way of cherishing it is a widespread African trait (ibid). This attitude was also found among first century Gnostics and Essenes and is even prominent today in modern industry. In many small-scale societies knowledge is traditionally secret because it is considered a valuable tool whereby the elders personally (orally) exercised religious authority in the context of the local ancestral religions.

SOCIAL COHESION AND THE REJECTION OF LITERACY

Among many peoples of Africa, including the Limba of Ghana and the Kpelle of Liberia, the women work to singing and drumming. They may dance as they weed the crops. The singing, harvesting contests, and the religious ceremonies for good crops are all important occasions for oral art. The content of the evening stories and the values expressed in them all relate to the agricultural life of the community. A large investment of time in all these activities is required for one to gain an accurate knowledge of the folk-literature appropriate to these situations and thus to become marked as a loyal member of the local culture. The community defines itself both by these shared activities and by the ability to use the oral arts associated with them. The songs, stories and proverbs become emblems of the economic foundations of the society, its recreation and its finest art.

Oral art thus becomes an important aspect of the "ethnic cohesion" of African traditional societies. Tippett writes:

> I define *ethnic cohesion* as an endemic force which represents to a given ethnic group its entity, its solidarity and its security in the face of the outside world, and its physical, mental and spiritual satisfaction within itself. I believe this is the dominant factor which determines acceptance or rejection of innovative change (Tippett 1974:3).

He elaborates further on this,

> The ethnic group has a power to 'discriminate' between aspects of proposed innovations, 'selecting' and/or

'discarding' in the light of its entity, solidarity
and security and satisfaction...

The cohesion of the ethnic group depends on intracon-
figurational relationships, which are involved in each
other. Their orientation must be culturally approved
(ibid).

He is writing on the need people have for identity or
"entity" and a sense of security in belonging to a group in
order to survive in a world which is potentially hostile to
individuals not protected by a larger group. These communal
needs for identity may take precedence in determining the
cultural changes people will make when there are options
between personal advancement and maintaining identification
with the community. Preserving unity and group identity may
be valued more than obvious financial gain. He feels that
preservation of the ethnic identity is central to the
acceptance or rejection of change.

SOCIO-ECONOMIC ROLES

The verbal art of the people is performed and impressed
on the memories of the people in a variety of social
occasions. Many of these occasions, vital to the survival
of the oral system itself, are related to the seasonal
dimensions of the economic life of the tribal community.

Among the Kpelle, rice farming is the heart of the economy
and the shared social life. It is not strange that verbal
art flourishes on the farms where the ceremonial, religious
and social life of the community is focused. Cole writes
about the rice farming,

Highland farms are communal affairs where work is
done with singers and drummers and contests complete
with community awards...(Cole and Gay 1971:420; cf.
Finnegan 1967:8).

These awards are both for farming skills and for performing
skills.

In Nigeria, in spite of the increase of schooling, even
in the prosperous Midwestern State, more than 80 percent of
the adults are directly involved in farming (Obedei 1975:26;
Daily Times, Monday, Feb. 3, 1975).

Another indication of the interaction between farming
and oral communication comes from the Limba people of Ghana

who consciously define themselves as a farming and oral
community. Informants have said,

> Rice farming is the destiny of the Limba given them
> by Kanu (God) in contrast to the books and money given
> to the white men or the Koranic knowledge of the Fulas.

> Rice farming for the Limba is more than merely an
> economic or chronological matter. Each agricultural
> phase has its own associations of cooperation between
> family and kin, the characteristic songs, speeches,
> drums and dances that accompany it. People sing in
> the farms, even when they are alone because, "we are
> happy there. There is work. That is our books, our
> food" (Finnegan 1967:8).

> "Farming and hoeing is our book...Our hoes are our
> books" (ibid p. 44).

This oral identification of the people may strike us as
a "sour grapes" repudiation of something that is merely too
difficult to obtain. But the fact that the songs, stories,
ceremonies and proverbs of the people all focus on the
agricultural life of the community would seem to indicate
that this is rather a considered reluctance to give up
either farming or the oral communication system. Farming
and oral literature hang together for the Limba as a single
basic cultural institution, intimately related to their
sense of identity as a people.

Ethelyn Orso's article "Folklore and Identity" points to
the strategic role of folklore or oral art in building,
preserving and enhancing a people's ethnic identity, the
basis of ethnic cohesion (Orso 1974:24ff). The gist of her
argument may be indicated by the following quote:

> In the narrower sense, cultural identity is a kind of
> ethnocentrism. Anthropologists are well aware that
> ethnocentrism has a positive function to fulfill in
> maintaining *social solidarity and group survival* (Orso
> 1974:25, my emphasis).

Her article goes on to document from a wide range of
anthropologists the growing recognition of the way tradi-
tional communities make use of proverbs, folksongs and
other forms of indigenous verbal art forms to build a sense
of identity that is distinct from that of other groups.
Language styles and skills strengthen social control within

the social structure and maintain boundaries between other groups (ibid p. 35).

In his search for universals of song and music, Lomax has determined that song style symbolizes and rein- forces some important elements of social structure in all cultures (ibid p. 35 referring to Lomax 1968: vii-viii).

Such statements indicate that anthropologists have begun to see how important the oral art of a culture is in deter- mining its identity and potential for unity. And the way the distinctive art forms are used is as vital as the verbal content of the material itself in the process of creating and maintaining the sense of identity.

The survival of the memorized and informal oral arts is therefore vital to the survival of the group identity. While it is possible for us to separate conceptually the art form from the specific content of a song, poem or story, both the content and the form of the art are potential vehicles for signifying ethnic identity and group solidarity.

V. Turner, and many other anthropologists see religion and the general ritual process as central to a people's understanding of the world, central to their core values. It is important in motivating and directing the conduct of the community (V. Turner 1969:6). The close intertwining of oral communicational forms with this religious-ritual core of society means that any threat to the communicational forms constitutes a threat to the cohesion of the society as a whole.

AN EXAMPLE OF ETHNIC COHESION

A pointed work on the concept of cultural resistance to outside influences such as schooling has been done by Alan Howard. He has done extensive research with Hawaiian school children who attend schools managed by teachers representing more traditional American middle-class values (in Kimball 1973:115-131). The students he worked with came from a community that had a social identity not quite the same as that of the school system. The parents held relatively low status blue collar jobs in the cash economy. The school administrators were, however, intent on stressing more middle class values related to professional standards in order to "provide the students the basis for socioeconomic advancement."

Among the children studied there was a higher value placed
on "sociability and affiliation than on personal achievement."
There was a greater concern for "social regards" among the
peer group than for meeting standards of performance deter-
mined by the teacher or the educational system. The students
showed a drive to accumulate "...social capital (i.e., an
expanded network of interpersonal commitment) rather than
material resources..." or the development of individual
skills such as good reading speed.

The students, then, paid more attention to each other
than to the teacher. And the more effective teachers were
those who stimulated group interaction with the lessons,
rather than those who attempted to have students relate
primarily to the teacher. Attempts to motivate students by
means of the challenge to develop distinctive personal skill
for later life were usually very unsuccessful. Teachers
were frustrated by this lack of interest in education dis-
played by the students, and evaluated it as anything from
youthful foolishness to maliciousness.

Howard analyzes the non-productivity of the school in
this instance as a kind of passive evasion of the values of
the school by the children. The children were already well
along in the process of acquiring the culture of their par-
ents and families before attending a school with its dis-
tinctly different cultural values. The students' resistance
to and evasion of education is seen by Howard as a defense
of the values they had acquired from their parents. Teachers
who attempted to structure the class in terms of individual
achievement and individual interactions with the teacher
against the grain of the peer structure were usually dis-
appointed by the results. Those best able to obtain cooper-
ation and participation from the students were the few
teachers who worked with the group structure and allowed
the students to interact with the material among themselves
in multi-directional discussions, rather than demanding
that each student respond to the teacher (Howard 1973:128).

Howard uses the word "hero" to describe the attitude of
the group toward the resistant students. He sees their
non-performance of "dislexia" as an expression of their
attempt to preserve the cohesion of their culture.

...the Hawaiian-American children we have observed
might rightfully be labeled as "heroes," for they are
defending the core values of their culture against
the onslaughts of an alien group. Even though they

cannot verbalize it, their behavior may well be inter-
preted as a communicative statement to the effect that
"it isn't worth it; we will not give up our basic
commitments to peers, to affiliation, to our general
lifestyle, for what you are offering" (ibid p. 128).

Howard's thesis is that the children were defending the
cultural values of their homes because these cultural
values conflicted with those taught in the schools. Yet
these cultural differences were between groups within a
literate cash economy. If such value conflicts caused rejec-
tion of schooling, then we should expect even greater tension
and difficulty from those whose communities are at greater
cultural distance from those operating the schools.

In much of West Africa it is not just a question of suit-
able schools for minority groups. It is only the highly
westernized minority for whom the schools are at all suit-
able. There is a great cultural distance between this
minority of literates and the majority of the community.
The schools are related to the cash economy, the larger
national community and the international arena beyond.
Members of small-scale, face-to-face societies of oral
communicators have their unique group identity to defend
and preserve against such a vastly different system. We
should not be surprised if literacy meets with great passive
resistance, evasion or determined rejection among the
majority of non-reading communities of Africa. Rather, in
view of all the ways literacy and western education work
against local group identity, we should be surprised that
there is not more open opposition to the way conversion to
literacy attacks the social structure of many communities.

PRIDE IN VERBAL SKILLS

Oral language arts are close to the heart of perhaps the
majority of African peoples. They take great pride in ver-
bal skills. Cole shows how language arts are central social
values of the Kpelle of Liberia.

Kpelle parents take great care to teach their children
to use the language well. The ability to speak well
is a prerequisite to political power, and verbal
skills, whether in telling a story or pleading a case
in court, are greatly admired (Cole and Gay 1971:42
from Gibbs 1965:209).

Skill in performing or telling stories, a person's age
and closeness to the traditions are important, not only for

the sake of the art, but also because the person power of the ancestors is embodied in the living elders who know the power of the past (Cole and Gay 1971:43). Cole reports that among the Gola of western Liberia

> An elder with a poor memory "whose old people told him nothing" is a "small boy" among the elders, and might well be looked upon with contempt by younger persons (ibid 1971:112).

Among the Limba of Ghana, Finnegan indicates that the term for items of oral art is a broad general term, *mbora*, which revolves around the "old people" and the things they have orally passed on to their descendants. The term means "Limba things" (Finnegan 1967:46f). It applies to all the categories of oral art: stories, proverbs, songs and secret knowledge. These things do so much to help form the group identity and focus of communal pride that they are the "Limba things" (ibid pp. 25-50).

The pride in "Limba things" is such that a Limba person is willing to say, "When we hear something we put it in our hearts; our hearts are our books' (ibid p. 44). This reference is specifically to Limba sayings which came from the elders in their own language.

B. Walter writes concerning the high value Yoruba people place upon proverbs. He recognizes that among the Yoruba:

> ...the storehouse of culture and history is oral literature--traditions, poems, proverbs, and stories. Only recently have Western scholars begun to realize and appreciate the range, complexity and variety of information available from oral sources (Lindfors and Owomoyela 1973:v).

Professor Owomoyela speaks with pride of Yoruba proverbs as the "repository of the collective wisdom of the tribe" (idib p. 1).

As honored custodians of the tribal identity, elders are given the right to dispense wisdom and to make social use of the treasure of the ancestors. The younger people are expected to learn these arts, skills and sayings, but to use one with an elder would be a breach of etiquette.

Among the Yoruba, proverbs and other signs of creative language skills are important social markers. Proverbs are

of particular importance because they are so closely inte-
grated with the rest of the oral literature. Proverbs are
brief, pithy statements. They frequently refer to, repeat
one key line of, or sum up the lesson taught by a whole
story (Finnegan 1970:390f). Thus the words themselves may
not say much. They are frequently not meaningful when trans-
lated by themselves apart from their context. The entire
context from which they come needs to be explained. Only an
outsider who knows the stories, only someone who has spent
time sitting and listening to the stories of the elders will
understand the deep meaning of the proverbs of the wise.
These sayings are at once the property of insiders and the
summarization of the great oral teachings. It is very
logical then that great cultural pride should be attached to
the proverbs.

Proverbs and colorful figures of speech are highly prized
for their wit and beauty. They are also valued for social
reasons because a well chosen proverb can show that the user
has a control of the inventory of oral tradition. In one
sense their use can count as much or more than the other
information contained in a discussion or argument (ibid
p. 395). In any oral event it soon becomes obvious who has
the best command of the culture by the figures of speech
and proverbs a person can muster for his cause. Speech
patterns become cultural emblems that show a man's loyalties
and how he has spent his time.

This kind of identification through the use of traditional
art is so highly prized by African groups that skillful use
of proverbs and metaphor can count more than a detailed dis-
cussion of the facts in a court case. Such use of oral
skills is regarded as valid evidence and a logical form of
argument. It would seem that careful use of these figures
and proverbs by an outsider would create a most favorable
climate for his message to be heard with interest. To be
without them is to be hopelessly marked as a foreigner who
has no interest in the culture of the land.

Poetry and singing too are prized both for their own sake
and for the way they provide avenues for the expression of
the group's identity. The group participates with the per-
former not simply as a matter of politeness, but in a
spirit of communal interaction. Dorson reports concerning
a poetic presentation from Zaire:

It is music, rhythm, song, dance, movement, _dramatic_
entertainment. It is feasting and gift-giving...

It is group solidarity and mass participation...
(Dorson 1972:41).

It is more than group telling the speaker what they like, it
is the group sharing with each other what they like and do
not like. It is a sharing in many directions at once.

The poet or singer is stimulating and encouraging group
solidarity through the distinctive color of his presentation.
He brings forth the treasures of the community's past
around which the contemporary group can interact. This
function of the artist is the topic of Whiteley's introduc-
tion to African oral presentation,

> If much of the traditional material serves to rein-
> force the solidarity of the group, then the group
> must clearly be present on *occasions when the reciter
> is the medium between the past and the present*
> (Whiteley 1964:6, my emphasis).

One person may be featured at a time, but the group has come
to interact and express themselves to each other during the
progress of the presentation.

There are several ways oral literature strengthens group
cohesion beside the distinctive art quality which is a
culture symbol. Dorson shows how the Mande epics tell of
the origins of the people and ancient heroes who symbolize
the Mande state. The tales represent the people and their
chosen status with the gods for the very purpose of restor-
ing the state to grandeur worthy of the gods. "The strength
of the culture is fully reflected in the exploits of its
epic hero" (Dorson 1972:290). The hunters' tales also serve
a similar purpose, but since they celebrate only hunting
heroes, they serve to promote unity and cohesion among the
hunters but not among other groups (ibid).

The same phenomenon can be seen in the Yoruba reverence
for *Obatala* with poems, songs and drama. *Obatala* is a
national figure and promotes at least regional unity among
the Yorubas. The cult of Ogun was originally for black-
smiths and hunters. Now it includes soldiers, taxicab
drivers and other people in trades using mechanical things
made from metal. The celebration of values related to any
in the brotherhood helps to increase a sense of identity and
group loyalty. It is not just the words and ideas celebrated,
but also the impact of the methods of celebration which feed
this sense of social cohesion, common among small face-to-
face communities.

I have experimented with employing African folktales as sermon illustrations while preaching in Nigeria. The effect on the congregation is usually instant. Attention is immediately increased, even when the story is well known, or especially when it is well known. There are smiles and murmurs of approval characteristic of a Nigerian audience enjoying themselves. It seems to be a pleasure beyond the value of the story itself. I believe it comes from a communal pleasure in seeing a visitor enjoy making use of Nigerian culture.

My interest in African stories developed while teaching English in Nigeria in 1967. The students were patient and dedicated, but some of the high school students were not overly interested. We were required to have oral recitation and practice of English for the students. Particularly when the weaker students recited, it was painful for teacher and class alike. Having noticed story telling at parties, I assigned the students to tell indigenous folktales in English. These became hilarious and exciting lessons for all of us. Some of the slowest students exerted themselves to a greater extent than ever before and their performing talents surfaced even in English. One boy who was consistently failing caught fire and moved up toward the top of his class in English that year. It was largely a matter of motivation and delight in expressing cultural pride. One boy had been a general discipline problem in the school, but that term he became my friend and improved in all of his studies. I believe it was giving this boy the chance to tell an African story in class that started him off. He was a natural story teller but had felt restricted in a largely reading and writing situation.

Having discussed the existence and vitality of the African oral system, let us turn to some of the characteristics of that system.

10

Characteristics of Oral Communication

THE SYSTEMIC NATURE OF ORAL COMMUNICATION

Contrasting literary communication with oral communication in African cultures is not a matter of contrasting a systematic approach to communication with an unsystematic approach. Nonliterate communicational techniques are carefully and systematically integrated into the cultures of which they form a part. They are employed quite obviously in each of the major subsystems of a culture (e.g., political, economic, religious, educational, etc.).

Coming from a literate part of the west, it is difficult for us to think of societies run virtually without the aid of written communication. But there is an abundance of evidence that, as Ted Ward has said, a "whole society" can be organized around aural communication" (Sgaard 1975:6). Ruth Finnegan reports:

> It has been well said that oral poetry takes the place of newspapers among nonliterate peoples. Songs can be used to report and comment on current affairs, for political pressure, for propaganda and to reflect and mould public opinion (Finnegan 1970:272).

It appears that there are completely different ways of fulfilling the purposes which the west associates with writing and technically sophisticated extending media.

There are techniques of remembering and repeating the ancient traditions and current gossip, which when blended together in a largely non-reading community justify being thought of as systematic. They serve the purpose of keeping the people informed and aware of traditions and current events both inside and outside of the local community.

There are issues of life-style, recreation and education involved. There is intense artistic effort, but the structuring for the occasion is very different from most western approaches to poetic readings, concerts or "cultural" events. There is a completely different arrangement of social conventions that we are used to in modern times. For some of us "cultural events" are often at the periphery of life. But various forms of oral art have been at the very center of African life. We must not, therefore, think of this system as merely a matter of oral art, poems, or stories as these are now employed in our culture. It is a system for preserving traditions, rewarding group loyalty, expressing communal pride, spreading news, gaining social approval and enjoying a good time with friends--all wrapped up in one (ibid p. 272-500). This chapter is intended to focus on certain of the major characteristics of that system.

A COMPLEX CONCERN FOR ART

There are a number of distinctive attitudes toward oral literature and spoken art that ought to be considered. These factors may not be universally applicable, but are likely to apply in a general way in many African cultures. We have demonstrated that westerners have frequently misjudged the traditional African interest in intellectual pursuits, partly due to a lack of familiarity with the local languages. Michael Cole has shown how an intellectual pride in oral virtuosity, verbal creativity and eloquence are an important part of community life among the Kpelle of Liberia (Cole and Gay 1971:42). The ability to memorize and perform is very widely prized (ibid p. 111f). These verbal skills are an intellectual focus of attention at the center of the social life of the community, a means of upward social mobility within the society, and a badge of cultural identity.

The result of this artistic interest in language is that many communicators have dual motives which may be in conflict as they speak. One desire is to be understood or to convey information about some subject being discussed. At the same

time the speaker knows he is sending messages about himself
--his scholarship, his cultural identity and his position in
the society. Adults are aware that regardless of the topic
they are broadcasting messages about themselves and they
desire to make a favorable impression. Dorson shows this
from Akan society.

> A mature participant in a dialogue or public dis-
> cussion always strives to use vivid language because
> his audience is *continually making folk-literary*
> *analyses of his speech*. The importance attached to
> brilliance and imaginativeness in public speech leads
> those who aspire to enter traditional public life and
> hope to exert influence, especially in the courts and
> in politics, to cultivate the use of striking images.
> It is not unusual for courtiers in the course of
> their training and education to be attached to foreign
> courts in order to practice the techniques of public
> speech, in which the witty use of striking metaphor
> and imagery is an important ingredient (Dorson 1972:
> 186, my emphasis).

While this love of artistic speech describes the Akan
people specifically, anyone who has attempted to teach
English composition or journalism in Africa, as I have in
Nigeria, would have to admit noticing a general love of
florid phrases even where we may feel they complicate
clarity. I was speaking with a journalist in Lagos who had
helped to edit a Christian publication for several years.
He said that the writers he knew of had an extreme reluc-
tance to write simple English when they were capable of a
more high-sounding style. The American journalist had no
emotional problems simplifying eloquent style for new
readers. But the Nigerian editorial staff had far too much
sympathy for a writer to lower the academic or artistic
level of a brother's work. The journalist could teach
editing, but it produced a cultural conflict to ask a
Nigerian editor to strike down or simplify a brother's art.

During my stay in Nigeria, a variety of speaking assign-
ments were thrust upon me in a wide range of situations
including sermonizing and recreational debates. It soon
became obvious that just running together a string of
adjectives or simply using fancy words in English was
enough to bring murmurs of approval or applause. For a
contrived verbal gymnastic with a culminating peroration
the students would cheer and celebrate in a way that, from
my point of view, was completely out of proportion to what

was said. People from all over Nigeria derive intense
pleasure from verbal displays. If Nigerians cheer for a
visitor's skill in English, it stands to reason that reach-
ing a similar level of performance in the local languages
would meet with even greater approval and interest. Regard-
less of which languages we work in we will have to live with
the concept of artistic expression counting very heavily
alongside of the content of the message. This cultural
value is probably one of the factors that causes many trans-
lations done by indigenous personnel to be written at such
high academic levels that the common people have difficulty
reading and understanding.

WORDS HAVE POWER

Robin Horton has attempted to ascertain the crucial
differences between traditional African mental attitudes and
western thought patterns. One of the pivotal attitudes he
mentions as a central difference is the view of words. In
western scientific thought words are merely phonological
symbols. They are arbitrary markers for ideas. Words have
no power in themselves, except that a group of people agree
upon what objects or thoughts these sounds represent. In
themselves they are not thought to control matter or the
course of events. But, according to Horton, there is a very
general African

> assumption about the power of words, uttered under
> appropriate circumstances, to bring into being the
> events or states they stand for (Horton 1967:157).

For this reason many people are reluctant to tell
strangers their real names, since knowing a name is thought
to give power to exercise some degree of authority over the
thing named. Euphemisms are used for death or dangerous
diseases lest the mere naming of them bring them to reality
where they are not wanted. Horton suggests that the "pre-
scientific" ideas have survived in the west occasionally
under the headings of nominalism, solipsism and idealism
which holds that "mind sustains and has power over matter"
(Horton 1967:160). There are a large number of different
African groups that feel that words, spirits and men have
"force enabling one thing to create another" (Beier 1966:43).
This force of words is related to spirit forces behind
nature. They are thought to be manipulable by men even if
the words are spoken by accident or by carelessness.

One of the evidences that this attitude exists in Yoruba-
land is the interest people have in blessings. Even Muslim

leaders who are opposed to Christianity are very happy to have a Christian or a missionary pray a blessing on their homes. But to ask an interested inquirer, "If you were to have an accident today (may God forbid) and die, how would you know you were going to heaven," would be enough to end the conversation and threaten your safety. It is a view of the power of words about events to cause them to happen that brings strong aversion to even mentioning evil events. It is a magical view of power in words.

PRAISE

The oral arts are frequently used to praise the founders of the tribe, relatives who have gone to be with the ancestors, or people living on earth. Praises can be sung by friends, relatives, professional praise-singers, or sometimes by the person praised himself. It does not detract from the value of these praises that a singer is paid to sing the praises of his patron, and it is a comparatively minor thing that the patron displays his wealth by being able to pay a singer. The central issue is that the public praise and the use of special praise-names is thought to affirm, strengthen the spiritual force and enhance the power to endure of the person praised. It affirms and enhances the vital force of the person named (Tempels 1959; Adegbola 1969:116-225).

One of the more frequently quoted works on African Philosophy is by Placide Tempels, entitled *Bantu Philosophy* (1959). He holds that one of the central values of African life is the quest for ontological power to exist, to be something great, to endure beyond the grave. In Yoruba thought this mystic power is directly related to a person's virtue *iwa* (Adegbola 1969:116-225). But it can be injured by every insult spoken against the person, so that any kind of slander can be considered an attack against the survival of the spiritual, inner man. On the other hand, public praise affirms a man's spiritual force and increases his chances of being remembered favorably in the community. "Eternal life" or favorable existence after death is directly related to being remembered and cared about after a person leaves this world.

The peoples of Africa have a very strong belief in life after death that Mbiti indicates by his use of the term, the "living dead" (Mbiti 1970:83f, 149f; Idowu 1962:189f). For those who "go home," to use a Yoruba euphemism, remembrance by the living and appropriate "funeral" rites are very

important. When a person who has died is memorialized by
his children, it is usually a celebration of life with
praises to God for what He has given. Western peoples cele-
brate the birthdays of people while they live. In Nigeria,
people do not usually celebrate birthdays, but people strive
to have the anniversary celebrated by their descendants and
the community after they have passed away. To fail to have
such celebrations that preserve one's memory "evergreen" in
the memory of the tribe is to perish or die the second death.
In the celebrations of life and remembrances of the departed,
praises and praise songs called *oríkì* among the Yoruba are
very important.

The Yoruba *oríkì* is an interesting kind of praise song.
It contains the important praise-names of the person
involved, and those of his ancestors. Important ancestors
in the geneology will have many of their praise names pre-
served, and lesser characters will have fewer names pre-
served. The praise names reflect the personal qualities or
past accomplishments of the person concerned. They are
given to him by friends or professional singers to commemor-
ate special events, so that a string of names in the praise
song will give a brief and glorified biographical sketch of
a person's life. The *oríkì* of a person's ancestors is a
sketch of the history of the family tree, to which the
individual hopes to add a few glorious lines of his own.

The recitation of a person's *oríkì* can be a public cele-
bration of his place in the community, sung by a bard. It
can be sung to please the ancestors, or it can be done
merely as a matter of honor to the founders of the clan. A
person may sing part of it privately to give him strength
and courage to face a crisis situation. From a psychologi-
cal point of view it seems very well suited for helping a
person to build a positive self-image. On public occasions
it helps to build the individual's ego, displays his wealth
and reminds the entire community of its historic roots.
This strengthens the identity of the group and supports
ethnic solidarity.

The professional praise singers are aware that they are
enhancing the life-force of the person they celebrate, and
that they are also establishing their own reputations as
performers as they display their virtuosity with words.
These celebrations are potentially patriotic, social and
religious. They are considered to bring a blessing upon
the entire group.

The biographic and geneological *orîkî* of the Yoruba
people may be distinctively Yoruba. I would like to know
how widespread it is, and the devices for remembering gene-
ologies in other oral societies. But the institution of
praise singers and artistically contrived praise-names is
very widespread in Africa. The name *omo ekùn* means the
child of the leopard and refers to the fierce couragenousness
of the person remembered (Babalola 1963:51). Another name
is translated "He-Who-Has-Killed-All-The-Baboons-In-A-Wood-
land-Tract" (ibid p. 218). Another is translated "He-Who-
Has-Killed-An-Unsociable-Elephant-On-His-Farm" (ibid). From
Bantu country we have "He-Who-Does-Not-Slacken" which means
the one who is steadfast in battle, and "He-Who-Has-Not-Got-
Elephantiasis," meaning the agile one (Morris 1964:25f).
One of the singer's jobs is to praise the traditional actions
and values of the tribe through new and catchy titles to
bestow on his patrons. Some of these expressions are paid
for, coined, heard and forgotten as the vibrations fade
away. Others are picked up and repeated, to be brought out
as a badge of honor at future celebrations. When the people
gather to celebrate their accomplishments and their great
communal values, the poets with their verbal artistry are
the focus of attention.

Most Yoruba people would be expected to be able to per-
form their own personal *orîkî* and that of their family.
Specialists in the tribe would be expected to perform
various other types of poetry or songs such as *ìverè Ifá* of
the *Ifá* diviner priests, the *Ìjálá* of the hunters who
praise *Ògun*, and the *ewì* or *ògbèrè* of the masquerade dancers
(Babalola 1966:23).

These songs, hymns and chants are all poetic. Rhyme,
however, plays no great part in the Yoruba definition of
poetry. Yoruba poetry is more like Hebrew poetry in that
it consists of a series of comparatively short lines of
relatively parallel thoughts. Rhythm is important since the
poems may be sung or chanted to the accompaniment of drums
and/or dancing. The most important characteristics are
considered to be the thought content, the display of tradi-
tional Yoruba wisdom, sparkling metaphor and the correct
"sound" of rhythm and voice freedom (ibid p. 46-50). This
freedom of poetic form would give a Christian poet consider-
able freedom to prepare teaching materials for memorization
and poetic performance in Yoruba. The use of short sen-
tences intrigued me because I was helping to test a trans-
lation of the book of Hebrews that used short sentences.
This prompted me to seek Yoruba musician-poets who could

attempt to set our translation to Yoruba music for perform-
ance in a traditional Yoruba style.

TONE AND ART

We have already developed the argument of Yoruba as a
tonal language in chapter 3. There are special considera-
tions of tone for the structure of oral art. Two Nigerian
writers who deal authoritatively with this subject are
Beier, 1966 and 1970, and Babalola, 1963. In Babalola's
Appendix A he gives the characteristics of Yoruba tone,
rhythm and stress as they are used in Yoruba poetic work.
It is essential for any Yoruba poetry to control both the
rhythm and the tone patterns of the words.

The choice of word, of course, determines the tone with
which it must be pronounced, and the rhythm of speech. In
many nouns the stress will be on the high tone. The ends
of poetic lines must be composed to control the patterns of
syllabic emphasis and the final tones of each line. The
rules are flexible for tone patterning, but they must be
artistically arranged (ibid p. 344-346).

Poetry is a very complex art. The translation of western
hymns into Yoruba invariably violates many of the indigenous
rules for tone and rhythm. The care for meaning in the
translation may produce an intelligible product only if it
is read, not if it is sung. Even indigenous songs can
rarely be sung to other Yoruba tunes since the tone patterns
are usually unique and the tune follows the tone patterns
of the words. If Yoruba words are sung to a foreign or
European hymn tune, the tones of the Yoruba are distorted
beyond recognition. Vowels are extended in an arbitrary
way instead of in a meaningful way. Rising and falling tone
get bent flat and the other tones are randomly redistributed,
obliterating most of the critical tonal distinctions with an
alien seven note scale. Those who have been carefully
initiated into the meaning of such "secret chants," or can
read them from the book before they are sung, may come to
enjoy them. But many people are at a loss to figure out
what words are being sung.

A senior pastor has told me that he has been bringing his
mother to church for years. She listens to the hymns but
thinks that they use some kind of Yoruba with a secret mean-
ing she cannot comprehend. Even though some of the words
sound smutty once in a while, she accepts these songs as a
religious mystery. But they never explain the Gospel to her.

Many of those who can read well appreciate the translated
hymns and know they are intended to have only pure meanings.
It would seem that the majority of people are, however, just
as confused as this old lady concerning the intended mean-
ings of translated hymns. ʔ

On the other hand, many of the choir presentations I
heard in Yorubaland were conceived and composed in Yoruba.
They are considered beautiful and rhythmic. They are readily
intelligible to those who hear them. This indicates that it
would be wiser to sacrifice the international uniformity of
church hymnology (that helps missionaries to feel at home)
for the sake of using indigenous native hymns. Indigenous
hymns have the possibility of being evangelistically and
theologically useful among the masses who do not yet under-
stand the Christian message, because the tunes help the
words to be understood.

FLEXIBILITY AND ARTISTIC CREATIVITY

A vital characteristic of African oral art is that it is
flexible. It is expected that some stories and poems will
be different each time they are repeated. Finnegan feels it
is a western assumption that a given tale has to be told the
same way every time. This attitude comes from the fact that
western literature is "frozen" in printed form (1970:334).
It is the western expectation of fixity that prevents a more
accurate appreciation of what oral presentations are all
about. She has shown that in Limba story-telling there is
no fixed content to any one given story. Elements of
character and plot may be used again and again, but the form,
embellishments and illustrations of casual stories are in
constant flux (Finnegan 1967:7,31). Even when essentially
the same plot is repeated, different narrators [Evangelists] may include
or exclude a moral teaching as part of the presentation. A
dilemma question may be added to provoke a lively group
debate. Explanations, aeteological endings or moralizing
conclusions vary with the individual teller, the occasion
and the audience (ibid p. 31). Even the same narrator when
he attempts to tell the same story does not come close to
keeping the same wording, since this was never his objective
(ibid p. 94).

This is partly because the artist is telling old tales
that are well known. The artist is concerned to show how
well he can creatively rearrange and restate in more graphic
and picturesque imagery the essentials of his people's
traditions. The result of each new performance among the
Limba is a fresh literary creation (ibid p. 98).

One of the prime skills of a performer is his ability to lead his audience to interact with him to recreate the story. As the audience interaction varies, so too must a given performance. As the social occasions differ, the stories are adapted to suit the themes of the festivities. They are also adjusted to suit the social status of the audience vis-a-vis that of the performer (Finnegan 1970:374). Finnegan concludes that the concept of word for word memorization does not occur at any level of Limba society because it is contrary to the objectives of the performance.

The characteristic urge to display creativity freely, even in a controlled situation, is vital to the social drives that contribute to the performance of oral literature. Our own literary expectations of what we ought to find have obscured our view of what these presentations are really all about. For

the crucial way in which such narratives in fact really are different - their oral quality - is scarcely taken serious account of at all...

There is still too general an acceptance of such questionable concepts as verbal fixity, dominating significance of subject matter, lack of native imagination or inventiveness, handing down narratives unchanged through the generations, or the basically pragmatic role of African stories (Finnegan 1970:334).

Finnegan has shown that the majority of story themes, general styles and plots are ancient, but..."everything which makes it a truly aesthetic product comes from the contemporary teller and his audience and not from the remote past" (1970:319). She believes this is true for a wide range of African cultures.

Speaking in a general sense of African oral art, Dorson says that in contrast to the west, which expects fixed poetry, plays with set lines and word for word memorization, an African "...reciter, singer or chanter continually varies his words" (Dorson 1972:11). He does not elaborate on the social dynamic behind this constant variation, but recognizes that it is a widespread characteristic.

The Yoruba attitude is very interesting. On the one hand, some stories can be as fluid in form as those of the Limba. But certain songs and stories related to the origins of the tribe contain religious elements that tend to keep

the material concerning Oduduwa and Oreluere and other great ancestral spirits of the tribe more fixed in form. The priests have a vested interest in keeping the threads of the historic tales more constant (Idowu 1962:19-30).

The *Ìjálá* chanters, common throughout Yorubaland, take great pride in keeping genealogies and their historic content quite accurately by using poetic structure as a memory aid. Babalola tells of the social institutions that jealously guard the accuracy of these traditions. The poems are chanted at friendly get-togethers that frequently take the form of a contest among the hunters (1966:50f). Superficially the comparative reputations of the chanters are at stake. One person is allowed to have the floor and begins to chant. He is judged for the pungency of his idiom, his wisdom, control of the repertoire of his group and his singing ability. As he goes along, any of the gathered experts can extemporaneously compose a verse of poetry to make a correction or swing into a debate conducted in extemporaneous verse chanted to the rhythm of the drums. If the gathered experts feel the errors of the first chanter were significant, he must surrender the floor to the challenger. It is a great honor to be recognized as having a superior ability to recite the standard *oríkì orílè* poems of the tribe, or the *oríkì* of the local dignitaries. These poems contain the history and glory of the community. The chanter may also sing about himself or a wide variety of local issues. But the tribal and honorific *oríkì* must be performed according to set forms.

> The ijala artists believe that the *oriki orile* texts should be preserved undisturbed as they have been for generations and should be handed down intact by each succeeding generation (Babalola 1966:50).

The fixedness of some of the crucial passages is increased because they may be changed by the group in unison. However, this degree of fixity should not lead us to the false conclusion that word for word identity is sought or achieved.

> Although no two minstrels would give the *oriki* of a particular progenitor in exactly the same words, yet there is a hard core of constantly reoccurring information in such *oriki* no matter by what expert minstrel they are performed (ibid p. 25).

Concerning the chants he has recorded, Babalola says:

On another occasion the same *ijala*-chanter may add
more to this text, or fall short of it, according to
his ability to recollect the salute on that occasion
...from some other typical *ijala*-chanter, slight
differences might appear both in the wording and in
the length of each piece, depending on how detailed
or extensive was the tuition...(ibid p. 86).

Babalola explains some of the reasons for variation among
the artists. It is my impression that central among these
reasons for allowing reasonable variation in form while main-
taining identity of substance is the necessity of allowing
for artistic expression that is vital to the performing
artists.

A Yoruba pastor complained to me about how dull we
Europeans were because we had no variety, because we always
wanted to "freeze" things in exactly the same words every
time--when we read from books or when we memorized. He
thought word-for-word memorization was a terrible way to
memorize or repeat things, and that the missionary's stand-
ards in this regard inhibited more extensive Bible memoriza-
tion among the people who would tend to use a more African
definition of memorization. Finnegan, Babalola and most of
the other authors consulted agree that there is a hard core
of repeated information in African performances, but it is
virtually impossible to get word-for-word identity from even
the same performer.

This quality of controlled variation for the sake of
artistic expression and relevance to particular situations
is a culture pattern that will have an impact on any wide-
spread program of Scripture memorization in West Africa.
It suggests a need for an authoritative witness to an
accurate translation of the Bible recorded for the masses
and written for those who read. The practice of evaluating
and setting limits for tastefully chosen expressions of
ijala poem seems to be an indigenous structure for Bible
studies that lead to group discussions of the meaning of the
text. These are culture patterns that present great pastoral
opportunities for popularizing Bible knowledge.

IDEOPHONES

One of the delightful devices of most African performers
is a wide range of expressive utterances called "ideophones"
that are not necessarily conventional words, but seem to
describe special kinds of actions. Ideophones exist in

profusion in African languages. Three thousand or more have
been counted in African languages. Three thousand or more
have been counted in Gbeye (Welmers 1973:461). They are,
like all words, part of the community-accepted lexicon of
arbitrary associations between sound and meaning (ibid p.
464). Yet it is not simply the words or the phonic element
of these utterances that give them meaning but the accompany-
ing expression and the forceful body movements with which
these ideophones are spoken. When a Yoruba describes a
smashing blow with a spear or fist it does not go "Bang" or
"Baam" or "Boom"--it is more likely to go "VVIVVIVVIM" or
"VVLIDUUMMM." A bell would ring "Gbererererere." A lion
doesn't just run, it goes "baka-tak...bakatak...," and goes
off to hide in the tall reeds, "MekMek Med" (Dorson 1972:75).
Among the Zulu the tortoise may struggle to move himself and
his shell "khwanya-khwanya-khwanya!" and a butterfly flits
around "pha-pha-pha" (Finnegan 1970:65).

It is not only what is said in these sounds, but how they
are said and the posturing that goes with them that carry
the audience. They are a pause in the verbal flow to allow
time for more emotional communication via other non-verbal
symbol systems. These sounds flow freely and creatively
from the speaker as part of the overflow of emotion that
carries him on. They are so important to Bantu presentation
on all occasions that A. Burbridge (*Bantu Studies* 12, 1938)
is quoted as saying,

> In descriptive narration in which emotions are highly
> wrought upon...*the human appeal* is made and the depths
> of pathos are stirred by this medium of expression of
> intensely-wrought emotion without parallel...The
> ideophone is the key to Native descriptive oratory.
> I can't imagine a Native speaking in public with
> intense feeling without it (Finnegan 1970:66, my
> emphasis).

Among the Yoruba, ideophones are a crucial spice that
allows the speaker to show the feeling that belongs with
actions taking place.

A presentation that lacks them is hardly a natural product
of the traditional society, or a forceful presentation. They
are distinct badges of cultural identity that (if they are
present) mark the message as indigenous or (if they are
missing) as foreign, and signify the level of dynamic charge
that ought to be associated with the message. This may
suggest a special problem for translators or public Bible

readers who seek to achieve dynamic equivalence impact for African audiences.

A SHIFT FROM VOCABULARY

One important effect of the rich profusion of non-verbal communication in these events is to lessen greatly the dependency upon individual vocabulary items to sustain the meaning of a given message. Narrators can add "subtlety and drama, pathos or humor, characterization or detached comment by the way they speak as much as by the words themselves" (Finnegan 1970:383). Finnegan notes that some of the complex relationships that we would indicate by subordinate clauses and grammatical devices, Limba people would convey with a variety of signs and gestures, plus reduplication.

Complicated concepts are not necessarily shown by complex sentences. Ellis states that the Yoruba do not have sub-ordinating conjunctions although it is possible to construct complex sentences in other ways. Perhaps their dependence on oral multi-systemic communication has made such grammatical structures unnecessary. The fact remains that the sentence structure of all the transcriptions I have seen are very simple. There is a pattern of short sentences of four, occasionally eight or more words. (See appendix A for a comparison of Aramaic and African poetry).

The presence of so much non-verbal communication in these close face-to-face situations is bound to have an effect on the amount of attention that is given to the purely verbal content of the message. There is considerable evidence to support this position.

Finnegan feels that the western literacy tradition has biased the study of African oral arts and literature. A westerner brought up reading his information from books assumes the meaning is in the words. Words are the major symbol system employed in many books. Speaking of the western practice of focusing on the words she says,

This model leads us to think of the *written* element as the primary and thus somehow the most fundamental material in every kind of literature, a concentration on the *words* to the exclusion of the vital and essential aspect of performance...This insidious model is a profoundly misleading one in the case of oral literature (Finnegan 1970:3).

There is also another factor. Even if a person retells
his own story and preserves the same basic structure each
time, neither prose nor poetry would repeat identical word-
ing (ibid p. 334; and Babalola 1963:25). Even in the case
of genealogical *oriki*, no identity of words would occur
between different performances (Babalola 1966:25), because
the focus of attention is not on reproducing words for them-
selves. The attention of the audience is on "...the artistry
of a particular individual performance rather than on any
verbal 'correctness' of rendering" (Finnegan 1967:101). The
artist will be praised for his creativity and the force of
his particular delivery rather than for exact memory (ibid
p. 101).

Two anthropologists who have studied the cognitive varia-
tions between so-called traditional or illiterate societies
in comparison to western societies are Robin Horton and
Jack Goody. From different perspectives they agree that
one of the most fundamental differences between the two
types of social structure and mental attitudes is rooted in
the radically different attitude toward the place of words
in communication.

RICHNESS OF METAPHOR

One of the shared characteristics of most African oral
art is the richness of poetic imagery. Dorson indicates
that there is an especially great desire to be picturesque
and pungent.

> I contend that the different reactions from a mature
> native speaker are determined not by the truth-value
> of proverbs, but the quality of the imagination or
> poetry that has gone into them...[they] must reflect
> native culture and circumstance (Dorson 1972:191).

He feels that a speaker will use proverbs and poetic meta-
phors not only for the truth or logic content, but also to

> embellish or elevate his message with a poetic dimen-
> sion, or demonstrate to his opponent his superior
> sophistication, education, eloquence, or sensitivity
> in the use of his language. These goals need not be
> moral or didactic (ibid p. 184).

This seems to be particularly important in Akan society
since the people seem to be constantly making "folk-literary

analyses" of everyone's speech, so that the issue of folk-
identity is constantly behind the choice of indigenous
imagery.

This pleasure in identification through distinctively
local culture displayed in oral speech is indicated by the
way Limba people come to accept new stories. Most of the
people enjoy traditional culture and value "Limba things."
But new stories, even stories about mdoern times, are accept-
able if they are properly identified as "Limba" by the
language arts used to present the new stories. It is in the
manner of telling them that they are so identified. The
cultural identity of these is sustained by the personality
of the performer and the more of presentation rather than
in the specific content.

One new story is about the way dogs chase the wheels of
"lorries." It is explained as being due to the fact that
African dogs originally owned the wheel. The white men
stole the invention and put them on their machines. When
the dogs see how their wheels have been used they chase the
trucks and bark in an effort to get their wheels back. The
story is fantastic and delightful even in print. It is
presented with this comment:

> New stories are often found particularly attractive
> by listeners; they are not to be disregarded as
> "unLimba" once they have been told by a story-teller
> in a characteristic Limba manner and according to
> Limba literary conventions (Finnegan 1967:100).

The problem of the identification of the material with Limba
culture may be helped by the humorous slant of the story,
and the theme of European exploitation of Africa. But
according to Finnegan it has been "Limbaized" primarily
because it was presented in traditional Limba style.

It must, therefore, be suspected that the use of tradi-
tional forms of oral art would help many West African
audiences to hear and study Bible portions. This raises the
questions concerning the various kinds of oral art that are
available, the way it is performed and the patterns of
audience response. These are the issues considered in the
following three chapters.

11

Varieties of Oral Art

It is difficult to classify the different types of African oral art because the categories of our culture are not parallel to most African approaches to classifying. From the western perspective there are prose tales, proverbs, short poems, hymns, work songs, funeral dirges, disputing songs, epic songs, poetic contests, myths and songs of praise (Whitely 1964:2,3; Finnegan 1970:xiii-xv). But in a given performance there is very likely to occur a mixture of several types all at the same time.

In Yoruba society the designation of a given oral art style will likely depend on the style of voice production, rhythm, or particular deity or social grouping with whom a given style is usually associated.

In attempting to interpret African oral art to westerners it is helpful to begin by discussing the characteristic mixing of genres. We will then discuss the forms and informal uses to which these art forms are put.

MIXED GENRE

One of the most striking characteristics of a Yoruba-speaking performance is the speaker's freedom to break out into song and sing a solo, even if he has but minimal talent as a singer. Such singing, immediately claims attention because it is a shift in the method of presentation. There

are different emotional qualities expressible via song that
do not come across as well by the spoken word. Emotion and
expressiveness may count more than voice quality. This
seems to have been fully appreciated by African bards from
antiquity. It is characteristic of the performances that in
the midst of a story, and carefully woven into the plot and
theme, are chants and songs that provide the opportunity for
the leader and the "audience" to join in singing. The people
may move about, dancing if they choose, and in general enjoy
a change of pace.

Among the *Bantu* there are very special reasons for includ-
ing songs and poems in the stories. Torrend felt that songs
are central to the story to the extent that the story is
primarily a "frame" for the song, a setting in which to sing
the song (1921:1-5). On the one hand the story explains the
song and gives it meaning. On the other hand the song
repeats, emphasizes and drives home the main idea by having
the performer and the audience sing and chant it over and
over again. The song is the part everyone ends up memoriz-
ing. He feels that these songs imbedded in stories are
basically educational structures very parallel to "that of
the morning lessons in Latin rites of the Catholic Church" X
(ibid p. 5,6).

Dorson states that this "multifunctional, multigenre com-
bination of stories, songs, dances and poetry is a very pan-
African characteristic of oral art" (1972:41f). Songs can
be introduced and sung in a wide variety of ways. One way
is for a poet or storyteller to break into song--singing the
verses with the group supplying a chorus. Another way is
for a friend or an appointed "answerer" to completely take
over leading the singing for the raconteur while he catches
his breath and gets his thoughts together (Babalola 1963:
66f; Finnegan 1967:17).

There are several virtues in this kind of mixed presenta-
tion. It helps loosen up the audience to interact with the
performer. It helps the performer to get a break and gauge
his audience response. It allows the people to move and
express themselves, to share in the performance, showing
what they know. This, in turn, improves their ability to
remain receptive to further teaching and entertainment. The
songs help to provide associative structures to facilitate
informal memorization of the material that the bard selects
to emphasize by putting it into the form of a song (Torrent
1921:1-10). In the Yoruba *òdù* corpus these songs or verses
also serve as important devices for stimulating recall of

the plot of the story itself. In discussions, few snatches of the song can serve as a brief reference to the entire story.

FORMAL CELEBRATION

The language arts and the performing arts of Africa are great shining symbols of African culture. At various semi-political western functions I have observed in Nigeria the oral arts have been present, but occupied a dubious status. At the opening of the post office at Igbaja in 1971, all the local dignitaries were present in their finest robes for speeches and general merrymaking. The speeches were in English or translated into English. But the praise singers worked completely in Yoruba. They circulated in and out of the center of attention, singing the praises of the town and the dignitaries as each one began to speak. The common folks who couldn't follow the English seemed to enjoy the colorful and boisterous performance of the singers who unofficially burst into the dignified ceremony. The advanced students, officials and teachers merely appeared to tolerate this with a show of mild irritation. Some tried to ignore the whole thing. A few dared to speak openly against the singers. The singers seemed, however, to have permission to fill in the dull spots in the program. But they did not seem to me to have been intentionally included as part of the program.

They seemed to be tolerated as voices from the past and provided semi-comic relief for a serious ceremony. However, I do not think they would play such a marginal role in a similar ceremony today.

Yoruba traditional culture is now in center stage, the focus of attention. Nigeria is now engaged in a vigorous attempt to recover her "glorious cultural past" (Awo 1974 a:8). A cultural revival is under way. The breezes of cultural revival have been blowing for some time (Mendelsohn 1962:20ff) but are now gaining rapidly in force. One Nigerian says,

Whatever one might say, the stark reality must be faced--the wind of cultural renaissance is blowing across the continent of Africa. It is blowing in Nigeria and we must exploit the occasion to reawaken our glorious past (ibid p. 8).

Nigeria had planned to host the Second World Black and African Arts Festival in November of 1975, at Kaduna, but it

was cancelled because of the July 1975 coup. The whole
country teemed with local competitions in every type of
African art in order to select the best possible candidates
to represent Nigeria in the international festivities. The
newspapers were full of stories on the practice of every
kind of traditional art, and the article quoted above repre-
sents the Governor of the state as supporting the cultural
revival (ibid).

A country's cultural heritage and its contemporary
artistic achievements are, both in material and histor-
ical terms, as important in defining a nation's history
and character as its political and economic development
(ibid p. 8).

The article goes on to extol the virtues of Haruna
Ishola's excellent proverbs moulded into beautiful and
meaningful songs. The main purpose of the article was to
call for a more complete study of the culture and its oral
arts, alongside of modern technical development. Many of
the newspapers I read in Nigeria in December of 1974 con-
tained similar articles on the revival, highlighting the
importance of the coming festival and local performances of
various arts in preparation for the big event.

Traditionally, in West Africa the praise singers played
important social and communicative roles. With the progress
of westernization, modern mass media may replace some of
their functions, but they are still much in demand for
celebrations of many kinds.

Even before the cultural revival struck Nigeria in full
force, it was not usually possible to hold an important
political event in Yorubaland without attracting praise-
singers and traditional performers. Now modern government
leaders give an important place to traditional praise-
singers. Finnegan reports that court poetry is one of the
most developed genres of oral art in Africa. One of the
steps the new military Governor of Kwara State did to con-
solidate his position in the area in 1971 was to elevate
and give official staffs of office to several of the local
hereditary chiefs who rule in local matters alongside of
the modern military government. The staff of office was
presented with pomp and ceremony in Igbaja. This was
Yorubaland, but there were Hausa chiefs and Yoruba chiefs
present. They all had with them official court poets, and
there was no attempt to keep away large numbers of free
lance poets, drummers and dancers.

Among the Yoruba there are two types of professional storytellers. The one who travels about telling stories as a traveling bard and praise singer is called an *apalo*, one who makes stories or other kinds of verbal art (Ellis 1964: 243). He is paid as he performs or by those who admire his work. But there is also an *akorin* or official narrator of the national tales. There is a community of these in Yorubaland, with different poets attached to the courts of the leading chiefs. Their leader or chief historian is called *ologbo*, one who possesses old times (ibid). He is an official of the court on government salary. He serves a formal apprenticeship, and has far greater dignity and status than those who are paid as they sing. The pattern is similar to that of other African groups such as the Hausa.

Only a few of the more expert or official performers were allowed before the governor during the presentation itself. There was an official English reading of the *oriki*, a genealogical praise poem of the chief indicating his glorious ancestors and his right to his chieftancy. All of the dignitaries were officially praised by selected bards who competed for large denomination currency notes to be placed on their heads as a tribute to their skill (and also an immediate demonstration of the wealth of the giver).

There was an official presentation of the staff of office and a day of feasting and dancing afterwards. During most of this, there was a skillful blending of official English military pomp, speechmaking and traditional Yoruba proclamation for the masses to understand. The chief's speech was read to the crowd by heralds—one was read in English and one in Yoruba. Then the chief himself gave a few words in Yoruba. The old chief did not seem to be able to read.

The Yorubas do not have as extensive a development of officially maintained court poets as the Hausa, or the Senegal and Mali memory specialists called Griots (Finnegan 1967:90-120). I cannot, however, conceive of any major political or social function progressing without *akorin* present to review the glories of the tribe, the previous chiefs and the incumbent. In addition, numerous other bards (*apalo*) would certainly be present to "work" the occasion, receiving cash payments as they perform.

Finnegan believes that in the Hausa courts and in the courts of Senegambia, the bards who sing the praises of the chiefs actually serve as mediators between the chief and the people. They sing concerning the commands of the chief to

the people, but also convey criticism of the chief by faintly singing his praises on issues that are not popular with the people. They wax eloquent over issues which the people favor. They are attuned to the will of the people, and express their opinion in a way that the chief and his elders can understand (Finnegan 1967:90-120).

In a less official capacity the Yoruba bard fills a role as an opinion leader. As part of his chores at a social gathering he will be asked to sing the praises of sundry guests, to "...recount his personal experiences, exalt kindness, hospitality or courage and to comment on current affairs" (Finnegan 1967:100). While he is judged on the basis of his poetic skill, he speaks concerning a wide range of issues, including politics. Since he is frequently working for cash, and is paid song by song according to the pleasure of his audience, it is likely that he will be a shrewd judge of what the audience wants to hear. If his phrases are pungent they can be repeated and carried far and wide, even to the rulers concerned. I believe, therefore, that the Yoruba bard can still be regarded as performing important political functions, including the role of an "oral newspaper" (ibid p. 272).

The most well known groups specifically renowned for their memory work among the Yoruba are the *Ijala* singers and the *Ifa* priests. Ijala singers undergo an apprenticeship, but the selection for professional work is on the basis of skill. Financial support for training Ijala singers is ordinarily given informally by the community. There may be help from the chiefs as a reward for superior performances on various occasions. The Ifa priests do most of their memory work in connection with the divination system. Inasmuch as they record many of the gods' *orisa* doings, they deal with important historic material. These men are supported mainly by their clients. The chief could be the only client or a major client of a diviner priest.

These two groups of singers have definite political functions because they support and influence various community leaders. But from a western perspective they may appear to be religious. We now turn to religious uses of oral art.

RELIGIOUS EVENTS

Professor Idowu of Ibadan has characterized the Yoruba as pervasively religious. His slogan for this concept is

"In all things...Religious" (Idowu 1962:1). Hence, the quest for political power or stability is a religious experience. Religion is a major manifestation of the widespread African pursuit of "life-force," or "vital force," the power to be (Adebola 1969:117). This is the power to accomplish things that will benefit the clan and result in the perpetuation of a person's memory by his descendants after he passes away (Tempels 1959:65f; Sidham 1969:10).

This power to be, to endure, is nourished at the horizontal level by one's success in life and every good word spoken about a person during his life. At the vertical level the spirits and ancestors who have life are in a position to increase or diminish a person's ability to accomplish good (Idowu 1962:1-10). A man's children must perpetuate his memory among the living after he is gone to be with the ancestors. Religion for the Yoruba man is a matter of reverencing the spirit powers, and seeking to obtain from them the means of a successful life. If he "sins" it is the spirit powers who will punish him. This fear provides some of the major social controls in the community (ibid p. 202-215).

There are two major focuses of these religious activities. The home, the family and the ancestral village are one primary focus, because these are the institutions through which a person relates most directly (via his ancestors) to the ultimate source of his being, God himself. Each head of house serves priestly functions for his children and is religiously obligated to the chief as a communal representative of the ancestors. Thus the chief cannot really separate his religious functions from his political control because he is head of the extended family and is a superior "priest" to the head of each house. It is in his relation to the ancestors that the people believe strongly "in the power of the chief to secure the beneficence of cosmic forces for the people..." (Forde 1954:xiii).

The other major focus of attention is the cults of deities who govern different aspects of life. Among the Yoruba, Ògún grants success in hunting and war. Sàngó controls lightning and other punishments from the gods. Sòponná controls smallpox. The Ifa priest serves Òrunmìlà who knows future events and can give personal guidance (Idowu 1962:71-100).

So it is a family matter for the chief to be sure his ancestors are properly honored, and he has priestly

obligations for his family and the village under his care.
He also owes it to the community to have a leading role in
propitiating the deities the community reverences communally.
In Igbaja town a man chosen to be chief because of his
inheritance happened to be a Christian. But he fled town
for his life. As a Christian he did not want to have to
perform the priestly functions in traditional rites. But as
a chief he did not dare to disrupt or insult the cults
practiced in the town.

Yoruba tradition expects a devotee of a deity to rise
while it is still dark, around five in the morning, and to
greet the *òrisa* ancestor or deity, before speaking to any
other person (ibid p. 111). Various hymns of praise may be
sung to the deities, pledging service or loyalty (ibid
p. 114). Or a segment of *oríkì* can be said for the ancestors.
Children awaken and bow very low to their parents with formal
greetings perhaps including *oríkì* or praise names. There
are also weekly and annual celebrations for each major
divinity.

Another major religious institution revolves around the
Ifa priest of divination. He is called *Babaláwo* or father
of mysteries. He is supposed to be able to help people and
promote healing and is, therefore, sometimes unfortunately
called "witchdoctor" by outsiders. Divination is done from
a board with sixteen squares or "houses" which are further
subdivided to yield a total of sixteen times sixteen, or
256. To each of these squares is assigned a number of poems
or songs which the diviner must be able to chant accurately.
Then for each of these 256 songs or poems there are a large
number of stories (*esè*) called "paths," "roads" or "feet."

To go into practice a beginner should have learned four
stories or myths per *odù* (song) which would mean a minimum
of 1,000 stories. An ideal number of stories for each song
would be sixteen which would mean a total of 4,096 tales to
recite (Finnegan 1970:194). Professor Idowu reports a
claim that there are more, up to 1,680 myths for each of
the 256 *odù*. This would yield 430,080 set stories (Idowu
1962:8). This number of stories seems fantastic for even a
community of priests to maintain, and I doubt that they do.
However, practicing priests do have thousands of them at
their command. They may not be told word for word each
time, but the contents must be accurately preserved for the
ritual to be effective.

The *Ifá* corpus then is a system built upon sixteen basic
memory cues which in turn cue 256 chants or poems. These

in turn are mnemonic keys to thousands of symbolic stories
and myths. It is a fixed and elaborate system, perpetuated
by an apprenticeship system (Finnegan 1970:190-200). These
songs and stories are not performed openly in public per-
formance, but can be heard by the clients who pay for the
diviner's services. They are symbolic story texts from which
the diviner will deduce the correct sacrifice or course of
action for his client to take. The effectiveness and spiri-
tual power of the diviner is thought to be related to his
knowledge of the memorized material.

There are other religious occasions for oral art. Four
of the five days of the Yoruba week are each dedicated to a
Yoruba divinity. The first day is a day of rest and market-
ing for all the people. The other days are dedicated to
Ifa, Ogun, Shango, and Obatala respectively (Ellis 1964:145).
On the day of each deity the worshipers of the god rest from
farming and perform acts of worship. Praise songs are sung.

In addition to this, every major god also has an annual
celebration which usually involves processions, masquerades,
dancing, feasting and sacrificing (Idowu 1962:111-115). On
these occasions set hymns are sung publicly. The singing,
recitation and poetry for the masquerades is called *esa*, or
ewi, depending upon the deity and the ceremony. Here again,
it is the identity of the performers, the deity being
honored, the voice type employed and the occasion which
indicates the correct title, rather than whether it is sing-
ing or chanting or prose (Babalola 1966:23).

INFORMAL OBSERVANCES

In the discussion of the occasions when oral traditions
are formally presented for ceremonial reasons it should be
noted that 1) alongside the formal presentations there is a
good deal of less formal use of the arts before, during and
after the formal ceremonies and that 2) the distinction
between formal and informal is not a clean one. Finnegan
makes a useful, but not consistently valid distinction
between daytime and nighttime uses of oral art (Finnegan
1967:5-15).

During the day many ceremonies take place. But apart
from these, at the informal level, it is possible to hear
stories, songs and proverbs during the day. Many people
sing as they work. There may be a dispute to settle, a
court case to try, a bargain to be driven in the market.
A child may need to be corrected or a friend may need advice.

In these practical, useful situations there is likely to be some careful use of stories and pungent metaphor. A parable or proverb referring to the meaning of a long story can win an agrument or powerfully warn a young person of the error of his ways. Stories may be told, but if so, they have a specific persuasive purpose.

In these crucial junctures of social interaction the elders or citizens with graceful speech shine as leaders or settlers of disputes (Cole 1971:42f) because they know how to tell stories, jokes and parables to gently and tactfully move an audience (Finnegan 1967:30). On special occasions alongside of rites of passage and other celebrations, it is possible to find people casually passing the time of day with some of the oral arts. But the major celebrations will usually get into full swing well after the sun goes down.

During the evening hours people relax and want to enjoy themselves. The traditional form of relaxation is to sit and tell riddles, jokes, and stories or to sing songs, which are likely to involve drumming and dancing. Someone simply starts a song or story, and someone else starts up a drum and soon people begin to gather (Babalola 1963:48). The storytellers will see who can tell the best stories and sing the best songs (ibid p. 50f), so that there can be an element of competition. But with or without competition the people will generally have decided who are their best performers. Some storytellers will include specific moral teaching but others may tell the same stories and completely fail to draw any moralizing conclusions (Finnegan 1967:31). The main point outwardly seems to be to entertain and to have a good time. But at the same time the traditions and values of the tribe are extolled and discussed (Torrend 1921:6f).

The greatest amount of informal storytelling and singing occurs, however, in the evenings and at the times of formal celebrations. All the political and religious occasions have their cultic elements with accompanying ritual. But in addition to these, for hours and days the people will sit around in random and informal groups and entertain themselves. One after another, people just get up and perform, unless more skilled talent is present. If a guest is good enough at singing or dancing, someone will press some coins against his forehead (which he will take and keep) and instantly turn him into a semi-professional. His hopes of turning completely professional are just a question of how much cash crosses his forehead in comparison to his other forms of income.

Ìjálá chanters, Ifá priests and others serve apprentice-
ships playing the instruments for their masters, but the
question of going on and becoming professional is decided
gradually along the way and only signifies a level of involve-
ment rather than a basic decision about being involved at all
(Babalola 1963:40f). Everyone has to take part in some way
at some time or other since participation is an essential
part of belonging to the group.

More common occasions are not planned. They just happen.
A few friends may gather and happen to get into a story.
This is natural since story telling is "an act of sociability
rather than an organized artistic ceremony" (Finnegan 1967:
65).

Word goes around the village that so-and-so is telling
a story and the people gradually gather to listen...
Frequently it ends up in a contest...(ibid p. 65).

It is the same way in Yorubaland for stories and for Ìjálá
chanting (Babalola 1963:51 and Dorson 1972:265). People
hear the drum or the singing and they just come around.
Invitations are not considered necessary, because most of
these events are not planned. The story, the song or the
strumming of an instrument is something like a national
sport, or recreation. On a big occasion you may call in
the professionals, but on a quiet evening around the village
informal "pick-up" games can start anywhere. "Invariably,
the narration of oral texts draws a participating crowd in
the African communities" (Dorson 1972:262). The performers
are pleased to see visitors, strangers and neighbors join
in, especially if there is another session nearby. In that
case one's presence is regarded as a tribute to the skill of
the group one has chosen to join. Coming around and joining
in is a sign of approval and belonging; staying away is a
sign of disapproval and not belonging.

At Igbaja I asked a friend to invite me to some of the
gatherings. He just laughed. "You white people give
invitations and have set times," he said. "We Africans just
come to each others' houses." So in the middle of the
night, when I heard the drums throbbing away, I would get
up and go to town to join the fun. Sometimes it was a
funeral, or an anniversary of someone's graduation to
ancestor status, or a wedding party. It is not a question
of who is invited, or of holding small intimate socials, it
is a question of how many people can be attracted to parti-
cipate. To attend as a welcomed guest one only needs to

bring a few coins to contribute to the performers or to the
celebrating family. If it is a rite of passage, the more
who are involved the greater the affirmation of being for
the people involved. Only foreigners and enemies stay away.
If it is just some friends having fun, the performers
wouldn't dream of limiting the audience as long as the
visitors show approval and support the performance.

For several years I had wanted to know how to get to
attend some of these affairs, and watched from a distance.
But once I got the idea, it was thrilling to just join in.
I tried at first to be unobtrusive by being very quiet, but
this did not really meet with cordiality or openness. Then
I read that participation and identification were central
ideas. So I began to take a small part. Just a little
shuffle with the group to the rhythm of the drums caused
cheers from all sides. Just a few coins to a performer and
a praise singer would do a number about me, and the whole
crowd would cheer him on. A good seat would be opened up
in a good spot, some refreshments might be brought. There
was an instant and cordial welcome. It did not matter
whether I was only slightly known or a complete stranger.
Attending some of these informal and semi-formal occasions
were among the more delightful and exciting times I had in
Nigeria.

Several Nigerians have told me they thought it was great
to see a missionary spend some unnecessary, casual, fun
time with his people doing some of the African things. He
seemed to be saying that some visitors or missionaries
"love" us and help, but not as many enjoy us. It seems the
people of Africa are saying, "Love me, love my art."

CONCLUSION

During the years ahead we may expect that the number of
occasions at which the traditional arts will be performed
as prominent parts of the program will greatly increase.
There will be increasing pressure for the church to partici-
pate and take a positive stand. It is my view that truly
Christian content can be circulated through traditional
forms. This would greatly improve the image of the Church
as something good for Africa.

Currently, all too many evangelical churches in Nigeria
are too close to being carbon copies of American evangelical
churches. Many an American has felt at home in an African
church because the hymns often have familiar tunes. The

Bible may have the same kind of cover as in America. The
Bible passages may be read through only once and in the same
manner as in America. The congregation may listen in quiet-
ness and only sing or speak when requested to do so. The
man in the pulpit may be young and he may even give an
English summary of the sermon. Many a supporting institution
in the United States has understood these factors as indica-
tions that such churches are genuinely evangelical churches,
faithfully perpetuating authentic Christianity in Africa.

But this dependence upon western modes of communication
is but an example of ethnocentrism in mission work. Would
it not bring greater blessings to the Christian church in
Africa to use the wonderful indigenous memory systems to
circulate the Bible? Then on the occasions when African
culture is usually transmitted the Gospel could be presented
and non-readers could participate even as leaders. Would it
not be a blessing to use the indigenous talents of the
praise singers, the story-tellers and the speechmakers to
lead their people into the Christian life? Would it not be
a strong Christian influence to have the elders who can
memorize the messages from the Bible teach their people in
dignity? This would be better than having a young student,
who is regarded as but a boy within the adult community,
attempting to teach his elders from a book.

As the Church responds to the cultural revival, it is my
hope that ministers in the Church will respond in love--
love for the people and love for African oral artistry.

12

The Performer's Resources

One of the special values of using indigenous styles of
communication is the force and power these presentations
frequently have. H. R. Weber has noted that non-readers
have special ways of performing and listening (1957:41).
In this chapter and the next we shall explore some of the
distinctive characteristics of indigenous oral communicative
events that contribute to the effectiveness of these presen-
tations. In this chapter we shall analyze the ways indig-
enous performers make good use of the full range of human
sensory systems to put across their messages.

ELEVEN CHANNEL COMMUNICATION

Anthropologists and other communication specialists have
become aware of the fact that only a part of the total inter-
personal communication process occurs at the conscious level
(Hall 1959:38f). Much of the process occurs at the subcon-
scious level. People may focus conscious attention on words
or certain gestures, but other cues are perceived and inter-
preted below the level of consciousness. These subliminally
perceived signals do much to help the receiver form an
opinion concerning the accuracy and realibility of the
verbal content or other easily manipulated parts of the
message.

A mother may not be able to tell you exactly what
characteristics of her child's voice or gestures tell her
if her child is lying or telling the truth. But she may

very accurately form an opinion on the subject. She is
judging from subconsciously observed details.

The use and interpretation of subconscious communicational
systems are learned as a language is learned. A given body
signal may have opposite meanings in different cultures. In
the west we expect a person to look you in the eyes when he
makes an important statement. Looking away is considered a
sign of deviousness or inattention. It can be considered
impolite. A child shows attention and sincerity by looking
directly into the eyes of an adult.

In Nigeria, among the Yoruba, a child who focuses his
eyes on another's face is showing anger, lack of respect and
great insult. He shows respect by looking at the ground and
keeping his eyes generally cast down. The Yoruba have a
saying, "My eyes cast me down," which indicates that respect
for a person simply forces a young person's or a woman's
eyes to look down.

Several missionary teachers have complained to me of
devious students who lack the moral courage to look them in
the eyes as they talk. They felt that only a few of the
students had this kind of moral rectitude, not knowing that
the few students who did look them straight in the eyes were
probably the ones most likely to deceive them. The students
with the down-cast eyes were only trying to show respect as
they had been taught to do at home.

At least two major factors concerning the performer's non-
verbal systems are involved in this illustration. First,
the truthfulness and reliability of messages are frequently
determined by the para-communication--the supposedly inci-
dental signals given off by the communicator. In many situa-
tions these can be the most critical signals sent, since
they can either win acceptance of the message or convince
the recipients of the unreliability of the messenger or the
message.

Secondly, a given set of signals, such as hand gestures
or facial expressions, can have completely opposite meanings
from culture to culture, and language to language. They
are culture-specific and are learned just as surely as verbal
language is learned. The natural assumption is that body
movements mean the same things to all men in all cultures,
but they do not. When a visitor says one thing with his
body gestures and something different with his mount he
appears to be lying. He could simply be confused, but then

he is still not to be trusted. Since the whole process may
be subconsciously signaled and subliminally perceived, it
may not be open to discussion. Unfortunate gestures may
simply create an atmosphere of discomfort and distrust. An
indigenous artist who has completely mastered the culture
of his people will make very effective use of all these
signal systems.

D. K. Smith has written an article on this subject
entitled, "Your Hands Are Deceiving Me" (1971a). It
focuses on a variety of kinesic signals that may have com-
pletely opposite meanings from culture to culture. In this
article and his lectures he enumerates a total of eleven
different signal systems or methods of communication. They
are: verbal, written, pictorial, audio, kinestic, tactile,
spatial, temporal, artifactual, optical and olfactory. The
signal systems at the beginning of the list are those most
consciously used and carry the most explicit and detailed
types of communication. The first three--verbal, written
and pictorial--are the most explicit and can carry very
detailed information. But because they are so consciously
used they can most easily be manipulated to convey false
information.

The signal systems toward the end of the list typically
carry less detailed and explicit information. They also
less frequently rise to the level of conscious perception on
the part of the communicator or the receptor. Signals sent
or received through these less specific signal systems may
be harder to manipulate, or at least are less frequently
maniuplated to intentionally deceive. For this reason the
subtler signals are read with a higher level of credibility
than the more obvious signals. Effective liars and good
actors achieve their expertise by learning to manipulate
well these communicational systems, especially those at the
bottom of the list. They may not be able to state any set
of rules for the minor adjustments in the use of the eleven
symbol systems they use to create the intended emotional
signals. Nor can they usually explain how they are all
interpreted, since the complete range of the signal system
is not ordinarily perceived at the conscious level even by
those who use them.

When in a cross-cultural situation, the recipients have
learned and subconsciously employed different communicational
patterns than those of the communicators. It may be very
difficult for either the communicator or the recipient of
the message to discover the source of the discrepancy.

In African oral art nearly all of the eleven symbol systems (usually excepting writing and pictorial) may be artistically employed in any given peformance. African communicators often skillfully coordinate the use of all the systems to create an emotionally rich sensory experience. The interaction of all eleven symbol systems works to give an emotionally moving and convincing performance. As stated above, attempting to represent such performances via writing saps the life from them.

For example, in a single performance an African bard will ordinarily make elaborate use of gestures and bodily movement (the kinesic system) as adjuncts to his use of the oral and audio systems. Furthermore, his role-playing may take him around and among his listeners in subtle and effective use of the spatial system. He combines with these, expert use of clothing and a variety of implements (artifactual communication). As he whirls about among his listeners he may be waving artifacts such as a spear or a handful of money. He also touches people (tactile communication) as he performs, timing his utterances and other activities expertly in recognition of the existence of the temporal structuring of communication. His audience, of course, hears changes in the timbre of his voice (audio). They also touch (tactile), and smell (olfactory) the performer. This is a warm, personal, human encounter. It exploits all the symbol systems and stimulates two-way or multi-directional communication with tremendous emotive impact. This is lively art.

PERSONAL COMMUNICATION--AFRICAN USE

One of the difficulties encountered in scholarly presentations concerning African oral art is that they are usually written and thus focus only upon the verbal aspects of the presentation. The verbal part may not, however, be the most important part of the presentation at all. A written account cannot re-create the personality of the performer, or the use he makes of non-verbal communication channels. (Note how difficult it is to visualize the kind of performance described above if all one has is a written description of it). Writing is a rather severely limited medium. For

...what in literate culture must be written, explicitly or implicitly into the text can in orally delivered forms be conveyed by more visible means--by the speaker's gestures, expressions, and mimicry. A particular, atmosphere--whether of dignity for a king's official poet,...enjoyment...grief...--can be conveyed...

by the dress, accoutrements, or observed bearing of
the performer...In these cases the verbal content now
represents only one element in an opera-like perform-
ance which combines words, music, and dance...and even
in cases where the verbal elements seem to predominate
(sometimes in coordination with music), the actual
delivery and movement of the performer may partake
something of the element of dancing in a way which to
both performer and audience enhances the aesthetic
effectiveness of the occasion (Finnegan 1970:5; cf.,
Bauman 1975:290f).

These intangible overtones which support and give meaning
to a live performance are virtually impossible to record on
paper. Written transcriptions of these lively performances
must be understood to be very partial representations of
what was communicated in the events themselves. The person
of the performer, that which gives life to the traditions,
is almost completely left behind.

Goody and Horton have attempted to analyze the differences
in cognitive patterns between western cultures and radically
different oral cultures of the world. From different per-
spectives they have reached the same conclusion that perhaps
the most fundamental difference between western and tradi-
tional cultures is the question of personal (oral) versus
impersonal (written) transmission of culture (Goody 1968:
29ff; Horton 1969:162, 180ff). They point out that the per-
sonality of the oral communicator is a vital element in
determining what is transmitted and how it is received. The
separate studies of Goody and Cole also point in West Africa
to a widespread preference for memorized, personally pre-
sented material, even when writing is present (Goody 1968:
82, 167-225; Cole and Gay 1971:43). From East Africa it is
reported that even a voice on a cassette player "carries a
higher credibility rating than the same message read from
the printed page" (Howat 1974:450).

The personal element is important for the way a man
mediates the message to maintain the unity of the community
in the face of changing situations. Jacobs writes that in
the transmission of Hebrew texts, the scribes were aware of
the personal quality of oral transmission that made it
possible to maintain the purity of the tradition and at the
same time keep it applicable to new situations (Jacobs 1964:
1f; Ebner 1956:47f). The personality and adaptive qualities
of the performer are crucial as he deals with audiences of
various social levels and constantly adjusts for maximum
acceptability (Finnegan 1967:92f).

Our written records or even recorded tapes of African performances are virtually deaf to many crucial aspects of the performer's personality. Yet these adjustments may determine the meaning, the reception and the emotional impact of the performance. It is, therefore, vital to any understanding of African oral art that we understand something of the social dynamics of the performances and the non-verbal resources at the disposal of the performers.

VARIETY AND ACTION

The narrator gives life to presentations that might otherwise be lifeless. He changes voices, roles and postures to act out as much of the lively conversations as possible (Dorson 1972:107f; Finnegan 1967:92). He dramatically jumps from role to role as part of the show. Performers are free to change the mood from heavy seriousness to comic relief, from stark brevity to ponderous repetition, from cautious understatement to hilarious exaggeration.

Concerning the Limba storyteller's use of visual and vocal signals, Finnegan writes,

...every muscle of face and body spoke, a swift gesture often supplying the place of a whole sentence... The animals spoke each in its own tone...It was all good to listen to--impossible to put on paper (Finnegan 1970:383).

The skilled raconteur moves his audience with more than just the logical content of his words. He relives the events and dramatizes them with all the vividness and creativity at his command. He fires the imagination of the audience to relive the events themselves. He tries his best to pass on the experiences of the ancestors who have gone before.

ECSTASY

We have been documenting the case that African oral art presentations are emotionally rich, multi-channel communication experiences. The net effect is communal and very moving. This is frequently enhanced by the level of excitement of the performers themselves. It is true that some performances demand that the performer remain aloof and unmoved by the force of his own presentation (Finnegan 1970:5). But there are also occasions when a Yoruba or Zulu poet may be expected to become more than excited, bringing himself and his audience into an ecstatic mood.

The poetic literature is frequently recited in a high voice, and spoken rapidly. Breaths come at the end of poetic lines.

The lines are short and rhythmic. After a Yoruba *igala*-chanter begins to get worked into the mood, he begins to rhythmically gulp in large breaths and rapidly recite a line per breath to the rhythm of his drum. As he gets excited or "carried away, as he often is, by ecstasy or the desire to show dexterity" he may skip a breath, pause and race on for two or more lines in one breath (Babalola 1963:345). This feat of strength and endurance adds to the sense of exertion and the general tempo of the presentation.

The reciter is not alone in his ecstasy, for he does not reach this degree of fervor through his own powers alone. The audience may gather around him, clapping or swaying to the rhythm, cheering his better efforts and urging him to greater heights. When one person is spent and can go no further he knows that others have been waiting to take their turn. They take over and so the party goes on.

IMPLICATIONS FOR THE CHURCH

In an indigenous performance the expectation on the part of both audience and performer is that the latter will utilize nine or more of the eleven symbol systems to provide his audience with a wealth of stimuli of which the so-called intellectual or verbal element is only a part. Formal church services after the western pattern ordinarily overlook both the existence of these expectations and the powerful resources of indigenous modes of communication. The habit of standing in one place, reading from a book and speaking calmly as the people sit quietly in rows, is deadly—as if words were the only worthwhile part of the message. It fills the atmosphere with foreignness, stiltedness and deadness, since it allows only a limited use of the symbol systems. Such a communicational event is comparatively stimulus-poor in an area where the expectations concerning the use of communicational stimuli are high.

Messages that will catch the attention of the masses will have to be as rich in the use of the symbol systems as is traditional face-to-face communication. While books and recorded messages have a vital part to play in the popularization of Bible knowledge, these techniques remain stimulus-poor in comparison to live and living performance by native speakers who are experts in the indigenous use of a multiplicity of symbol systems. The church needs to learn to

employ such indigenous techniques and to encourage Christians who are expert in such communication to employ their talents for Christ. These need not be people exposed to the conditioning of western book learning at all. They do not have to be literate, though literacy might be useful if it did not cramp their oral style. Following Jesus' example would seem to demand that such oral techniques and technicians be the primary vehicles of His message in traditional African societies.

We turn now to consider the kind of interaction with an audience that this great emotive force is likely to engender, and the way African culture tends to direct this response.

13

Audience Participation

THE AUDIENCE MUST RESPOND

When in African communities someone starts a tale or starts
drumming, it typically "draws a participating crowd" of the
neighbors who come around to join in the fun (Dorson 1972:
262). They don't come to sit and listen in the western sense,
but to take part, because they expect that the songs and
stories will lead to a good deal of social interaction (ibid
p. 262). This is a different kind of listening from that
which ordinarily occurs in the west (Weber 1957:40-52). The
West generally assumes that an audience will listen rather
passively for most of the performance, and let the speaker
do his thing. A speaker can rehearse his speech or his story
without the audience. But these assumptions are not quite as
true in African gatherings. In an African situation there is
likely to be a variety of more or less formal and informal
customs which support general interaction among the members
of the group and the performers.

THE ANSWERER

Among the Limba people one of the institutions for stimu-
lating response from the gathered group is the answerer.
When someone takes a turn telling a story he will appoint a
friend to act as his answerer. His job is to help the per-
former and to lead the audience (Finnegan 1967:93f). As the
speaker moves through a story there are places where he may
want the audience to ask some questions. The answerer makes
sure he or someone else keeps asking the right questions.

He reminds the speaker if he leaves something out. He can ask questions to have the performer clarify a point, he can interrupt to explain something himself, or he can fill a gap. He may lead the people in a song. He keeps the speaker loose and encourages him with a running series of comments. This encourages him with a running series of comments.

His other job is to lead or orchestrate the audience response. If something is funny he supports the laugh. If the people should get angry at or afraid of the villain, he leads the cries of anger or fear. When the villain gets his just reward, he leads the cheers, and in general promotes a lively atmosphere (ibid p. 93f).

When I first preached in a small Nigerian church, I noticed an elder who sat in front of the pulpit facing the congregation. Whenever I made a point he would give out a loud "Amen" and others in the congregation would echo him with all kinds of comments. At first it disturbed me, but after a while it was fun and a real help. He and the audience were a guide to me about what was actually getting through and what was "off target" for that particular group. For silence indicated either that I had said nothing worthwhile or that I had offended them. The weak or casual "amens" indicated that they had heard me but were just being polite. In the larger town churches this kind of thing was greatly reduced but still present.

ENCOURAGEMENT IS GOOD MANNERS

Dorson indicates that this general type of audience response is rather pan-African and is very parallel to what is found in many American Negro churches in the "shouting" tradition. In these churches the congregation can interject a "Yes Lord!" or "You're sayin' it!" as an accepted part of the sermon (Dorson 1961:167f). This has been my experience in New York City also. He states that there is a general African concept of polite listening that expects the audience to respond aloud to the speaker. It is rude to allow a performer to speak into a void of silence. Hence the affirmations by the audience as the story unfolds are essential to the telling of a tale.

One of my students was quite a singer and was part of a group that performed in schools and churches in many large cities of Nigeria, including Lagos and Ibadan. However, one week he performed for a Baptist church of comparatively

wealthy business men who listened "quietly and respectfully" in the western sense. Perhaps they did not like my friend's youthful performance. At any rate, my friend was incensed and swore never to go back to that church again. They were quiet. They let him sing into a void of silence and he was quite insulted. I used to be disturbed by a "noisy" audience but now I, too, look forward to being able to hear what the audience thinks of each part of the presentation as we go along. It is indeed a different concept of politeness. And in Africa it contributes to a better context for effective communication.

This custom may, however, have its limitations even in Africa. It is possible that it is really fitting in small face-to-face groups where everyone can be heard but that in groups of 500 or so it can become just too confusing. It may become unmanageable in a mass audience. Perhaps when the crowds become large this custom needs to be modified.

ANTIPHONAL SONGS

Another planned device for getting the audience to participate is antiphonal singing. We have already shown how any performer, storyteller or poet can break into singing when he chooses. Song is often built into the structure of the story or epic, but it provides a time for general celebration and participation.

Sometimes the leader will sing a line and the group will continue to answer with one set reply as the leader keeps singing verses and the group will answer with a chorus which is repeated (Finnegan 1970:259). In many groups the characteristic form of singing is for the leader to sing a line that the audience sings after him. In the case of the *ijala*-chanter, he may simply start a song which the audience will sing for him while he gets his thoughts together to continue (Babalola 1963:55f). The songs and choruses sung by the group tend to remain fixed, keeping the same words. A soloist, however, has the option of modifying as he goes along.

MOVEMENT

Whatever the structure of the song, the audience is usually free to join in the singing and frequently takes the opportunity to dance, sway or make other rhythmic bodily movements. If we take a narrow definition of dancing (moving the whole body while in a standing position) then it

occurs only at some performances. Sometimes people do get up
and dance around the area during these songs. It is not
usually done by couples as is "ballroom" dancing, but by
individuals making expressive body movements to show excite-
ment and involvement. There are also a variety of movements
more like swaying, nodding or keeping time with your knees
or feet that would be appropriate or expected at any time
during any rhythmic presentation at all. These occur in
most musical situations.

Both the singing and the dancing are forms of group
communication, since they are means by which every individual
can signal his reaction to the presentation. Most forms of
participation would indicate some level of approval, while
silence or immobility would be likely to indicate strong
disapproval.

Compared to western meetings, these African performances
are comparatively free, active and long. The freedom of
movement is part of the reason people can enjoy staying for
hours at a time. People move around during the performance
and are expected to come and go as they need to. At an
"all night" anniversary of a funeral or at an "outing" or
wedding, guests are expected to drift in and out of the
festivities.

THE AUDIENCE SINGS

African poetry and literature is never far from song and
the audience is often expected to provide some of the sing-
ing. In some cases, songs are sung by characters in the
story as they contemplate evil plans or celebrate victories.
The performer may introduce the song and the audience join
in the singing, or often just in the choruses. In a story,
a Yoruba hero may sing his *oriki*--a review of victories in
his and his ancestors' lives, to prepare him to face a
crisis. The leader may start the *oriki* and the audience act
as a choir singing the refrain. During these "breaks,"
which are really part of the story, the artist can catch
his breath and his listeners can participate by getting up
to move around or dance.

There is a happy atmosphere to these gatherings in which
people enjoy each other. The artist is serious, but not in
a way that prevents anyone from having a good time. There
are moments of rapt attention, but there is also opportunity
for everyone to join in. Many of the songs are started by
the artist, but they become antiphonal, providing structured

responses from the audience. Without the willing response
of the audience and their pleasure in their participation
these performances would be much less enjoyable.

REPETITION

Another notable difference between an African performance
and a western presentation is the idea of repetition. The
stories and songs which are told are oft-repeated tales.
This does not mean that the event becomes a dull, intellec-
tually unstimulating thing. For in the first place, the
focus of attention may not really be on the plot of the
story, but on the vividness and artistic creativity exer-
cised by the individual performers. After all, traditionally
African value systems say "old is good, new is unreliable
or dangerous." In the case of the Yoruba *ijálá*-chanter it
is a matter of seeing who knows the best traditional poems,
who can present them the most accurately, who can perform
the best, with the most creative treatment of the tradi-
tional themes. Producing new numbers is possible, but
hardly a major objective (Babalola 1963:50f). Too large a
repertoire is also a threat to oral communicators. For the
Limba stories it is the performer's ability to do an expected
job uncommonly well that is desired. The story is there,
but the focus of the audience is on the

> artistry of a particular individual performance...
> they more often praise a narrator for the verve or
> drama of his delivery than for the content of the
> plot itself or his clear memory of it (Finnegan 1967:
> 102).

No one is distressed when stories are repeated. Repeti-
tion is expected and enjoyed. It is the verbal, linguistic
gymnastics in a controlled and disciplined setting that is
the focus of attention. This can be very intellectually
challenging for the artist and his critical audience.

Secondly, although the story or the poem is repeated over
and over again it seldom comes out exactly the same way twice
(ibid p. 93). That is because the individual performer can
change the parts around within certain limits. In a story
told for fun the freedom is great. In an *oríkì orílè* praise
poem there are stricter limits, and the experts sitting
around will challenge any great liberties taken with the
text (Babalola 1963:51f).

However, in a non-reading society where the text of the
people's traditions is not on a shelf for easy reference,

there is a certain necessity to maintain the traditions by
repeating them and a certain pleasure in airing the same
treasures again and again.

PARTICIPATION INTERNALIZES THE MESSAGE

Gatherings of non-reading people are a different kind of
communication event than that typical in the West, producing
a different kind of learning.

It is part of the communal life-style of illiterate people
to narrate and listen in this free-wheeling, multi-directional
way.

For in the world of illiterates such narrating and
listening is not a simple but a highly complicated
process which implicitly comprises all ways of commu-
nication, and even all typical elements of the "primi-
tive" world. Only an "unspoilt" illiterate is able to
narrate and listen in such fashion (Weber 1957:41).

Weber clearly recognizes the communal nature of what
happens when members of these groups get together to inter-
act around a traditional presentation. He notes the active
aspect of this listening which results in the listeners united
either identifying with the message or rejecting it.

The freedom for anyone to call out, to praise the singer,
to dance with him or to question him means that listeners
must constantly declare themselves in relation to the message
by words or gestures. Weber labels this communal listening
"partnership in communication" and "authentic communication"
which a non-reading community does well to maintain rather
than to forfeit (ibid p. 41f).

PARTICIPATION IS REQUIRED

We have shown that an African presentation not only permits
comments from the group; it *requires* active listening because
it is participatory in its structure. This quality means
everyone, or most of the people, will know the reaction of
most of the other people present. Silence, refusal to sway
if everyone else if swaying to the music, or other forms of
non-participation will ordinarily be interpreted as dis-
approval. Not only is it possible to take part, but polite-
ness requires that each person take part--unless one wants to
cast his vote against the proceedings in progress. This is
why my friend was insulted by a "silent audience."

I was in Nigeria during the time when Tommy Titcombe, the great pioneer of Christian mission in Egbe, Nigeria, passed away in Canada. The local churches got together to praise God for the message of life they had received through their dear brother and "father," Tommy. To show their love for him they held preaching services around the town, walking from place to place. Since it was a glorious celebration of thanks, the leader asked that we really show the people of the town how thankful we were to God for Tommy by dancing as we proceeded. We were a fine crowd of perhaps 500 people spread out along the road, attracting the attention of the whole town.

Some of the students were horrified at the idea of dancing for a missionary's funeral, others thought it was great to celebrate such a fine man in this truly African fashion. But there was no way to hide one's opinion. One either participated or he didn't. People either took part and registered approval, or they marched solemnly and put a damper on everyone around. Those who were merely tolerant walked with a swagger or with a jaunty step, while those who approved moved their arms and shoulders with enthusiasm. The issues of participation and identity were clearcut and open for everyone to see.

Finnegan has written about Limba funerals. Everyone in town is expected to attend. All the women are expected to take part in the lamentation, by singing and dancing. To refuse to participate is to take a stand against the person who died, insulting him and probably the community. To fail to dance is to face severe criticism and suspicion of complicity in the death (Nketia 1955:18 in Finnegan 1970:102).

One evening I asked one of the church elders what a certain drumming in the town meant. He told me it was the Apostolic Church people praising God. I was baffled by this but had recently read Psalms 149 and 150 which say "Let them praise his name with dancing" (Ps. 149:3), and "Praise him with timbrel and dance; praise him with strings and pipe" (Ps. 150:4). So I asked an elder of the E.C.W.A. Church if he ever went. Slowly he admitted that he attended--once, twice, well, perhaps three times a week. That stunned me. Now I had discovered both an unrescinded command of Scripture and an elder of a mission-related church who praises God by dancing as the Bible commands. I thought it would be good to see this strange thing of praising God with bodily movements.

The elder, with fear and trembling, led me to the place. There in a small, one room building with a dirt floor, a table and a few chairs at the front, was a group of mature men and women proceeding around the room with shaking, shuffling steps. They were singing hymns and crying out an occasional, "Hallelujah!" The elder and I stepped into the doorway and someone got a glimpse of me and froze in his steps. The whole room stood still except for one drummer who had his eyes closed. He kept drumming. Everyone else kept looking at me to see what I would do.

I had no choice. To condemn the proceedings would have stopped them without my seeing them. I had to act for or against their actions. I chose to follow my elder African brother who came often. I smiled and nodded to the music. Everyone gave a huge sigh of relief and burst into relieved laughter. The other drummers went back to work with broad grins on their faces and the circle began to move again with genuine delight. The pastor ran to greet me, perspiring freely. I shuffled around the room a few times to see what was happening and they applauded. They gave me a shaker to play and we had a marvelous time. They couldn't believe that a white man had joined them in an African way of praising God. They thanked me profusely for coming and not condemning them in their customs.

I had come to observe how they were praising God but found that in a participatory group, where everyone knows what everyone else is doing, I had to participate or put a stop to the whole thing. It was a question of identity by participation. They told me that I was becoming African because I joined them. A brief philosophical discussion of the importance of participation to African community and family life and Christian theology has been written by Vincent Mulago (1969:158).

CONCLUSION

When we survey the lively level of audience participation in a traditional African audience it reveals a very healthy and multi-directional flow of communication. Signals are sent by the performer to the audience. Immediately the audience begins visually and audibly to share their reactions with each other and with the performer. This can be to draw his best efforts from him or to correct him. These communicational events are joint efforts.

When this multi-directional flow of authentic communication in a traditional social setting is compared to the

communication flow in a western church, it is obvious that
it is very different. The western church may be organized
to facilitate good listening in a very large group, but most
of the communication is one-way. The seating faces one way.
For much of the service one person speaks to many who cannot
express themselves individually. Only a small part of a
western service promotes multi-directional reaction of the
audience around the message. Comparatively few western
structures make good use of this sharing of knowledge and
encouragement that is natural for audiences in African and
other non-western culture areas. Figure 13 gives a
pictorial representation of the process.

FIGURE 13

UNI-LATERAL COMMUNICATION
VS. MULTI-DIRECTIONAL COMMUNICATION

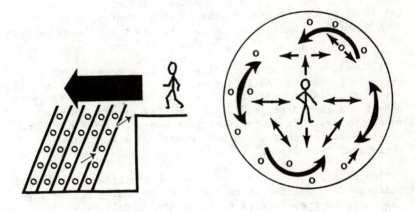

A. Unilateral
Communication

B. Multidirectional
Communication

The heavy arrow in diagram A of figure 13 represents
information from a lecturer or preacher on a platform to a
group seated in rows. This is the predominant flow of infor-
mation. The people respond in a limited way. But by large
they simply take in "whatever the leader 'dishes out'."
Disgram B represents an African communicational event in
which the leader starts a celebration. He communicates
information. Then group members pick it up and react. They
communicate in various ways with each other and with the

leader. The leader is shown at the center, but he may be
anywhere. The people are likely to be arranged to face each
other.

The people of God in more ancient times made good use of
communal exercises and group singing. God commanded Moses
to prepare a song that would serve to remind the people of
Israel for many generations of His mighty acts among them
(Deut. 31:19-22). And the people were taught to sing the
song. The *Hallel* and the *Shema'* (p. 52) were extended
portions of Scripture that the people were expected to sing
from memory. And the people were expected to take part in
the singing of the great antiphonal Psalms such as Psalm 136
(Moore 1946; Martin 1964:54ff).

An excellent example of church use of an indigenous
communicational technique in group catechetical learning was
reported by Dr. A. R. Tippett from his Fiji experience. He
says the Fijian people had a fairly rhythmical catechism
which the ladies of the church would chant or sing regularly
before services. In the course of this chanting most of
them memorized their catechisms. This is not printed as part
of the hymn book.

It would seem that multi-directional, communal, public,
rhythmic praise to God is one of the aspects of African oral
art that would be most useful in the African church today to
make the rather "foreign" message of Jesus more indigenous
to the masses. It is instructive to note that many African
independent churches are making great and effective use of
these oral techniques.

The possible usefulness of somewhat traditional styles of
indigenous communication in the churches could, however, be
cut short if these styles fall out of general use. The
following section deals with the future of African oral art
and an experiment designed to evaluate its usefulness.

Part IV

Toward More Effective Communication of the Gospel in Africa

14

The Future of
Oral Literature in Africa

THE ORAL SYSTEM WILL CONTINUE

A variety of substantial reasons lead one to predict that oral communication will continue to shape the direction of African life and cultural development. In our analysis of the structures that support oral communication it has become apparent that oral communication is at the very heart of traditional African culture and the decision-making processes of the vast majority of people (Vansina 1962:2; Finnegan 1970:280ff). The most fundamental reason why this situation will not soon shift is that for some time to come the vast majority of the people will not be able to read, or at least, to read well enough to make it an enjoyable and natural way to get information for making vital decisions (Jeffries 1967:32,97). The UNESCO information indicates that "60 to 70 percent of all adult illiterates have no desire whatever to learn how to read" (Paul Smith 1975:3).

Non-reading communities sense the dangers of a society divided by "education" and the use of different communicational systems (Majh 1965:36ff). Those who return from schools to live in such communities are under great pressure to solve this problem by abandoning the communicational system of the westernizing minority (Nasution 1972:36). Hence, Jeffries does not believe that within the 20th century the total number of non-readers will be reduced below the one billion mark. It has been demonstrated over the centuries that African indigenous communicational systems are capable of providing the people with information.

By rejecting the foreign communicational techniques, the community may appear to be taking a stand against other innovations as well. This is not necessarily the case, however. Such communities are merely attempting to preserve their own "identity" in the face of pressure to westernize, a process that they may quite rightly see as destructive to their well-being. New ideas can, however, be communicated via traditional communicational techniques. And we must not shrink in horror at the prospect of people gaining enough knowledge to adjust to the modern world without first learning to read (Mahu 1965:31ff).

This dissertation has suggested that it is more constructive to view the perseverance of the oral communicational system not as a retreat from literacy or resistance to literacy, but as an indication of the vitality of an indigenous communicational system that lies at the heart of African culture. Which communicational system a society employs is very much a matter of cultural identity, a matter of choosing which communicational community one wants to belong to.

The agony of being extracted out of traditional modes of communication is expressed poignantly in a poem by p'Bitek expressing the lament of an African wife concerning her husband's education.

> My husband has read much
> He has read extensively and deeply
> He has read among whiteman
> And he is clever like whitemen
> And the reading has killed my man
> In the ways of his people
> He has become a stump...
>
> The deadly vengeance ghosts
> of the writers
> Will capture your head
> and like my husband
> You will become a walking corpse
>
> For all our young men
> Were finished in the forest
> Their manhood was finished
> In the classrooms
> Their testicles were smashed
> with large books. (Rubadiri 1971:153f from Song
> of Iawino by Okot p'Bitek

Writers such as p'Bitek have, as it were, one foot in each communicational world. They ordinarily still speak their native languages and have a feel for the value of the oral system. They seem to sense that any breakdown of that system signals a breakdown of the society as a whole. They are, however, (like the rest of us) more able to identify such demoralization and its causes than they are to come up with a remedy for it.

Meanwhile, they write wistfully--as if they feel they have lost more than they have gained by the loss of their integration in the oral communicational systems of their ancestral communities. They sense that it is involvement in the world of written communication that has damaged their African identity and especially that of the large numbers of their countrymen who have not "made it" in the western system. They long for the complete and secure identity afforded by the traditional system. The new system has offered most of their people at best a partial foreign identity that effectively separates them from traditional society but never quite admits them to western society. In this light the pressure for literacy in place of oral communication is perceived as another subtle attack on African culture at its very roots. Many of these westernized writers have, therefore, pledged themselves to encourage a reexamination of and return to what they see as the richness of their traditional African heritage.

We observe two trends: 1. Traditional communicational techniques persist at the unwesternized end of the sociocultural spectrum. The masses are still not literate and the number of non-readers is still growing, and 2. A positive attitude toward traditional culture is emerging among many highly westernized opinion leaders. Both of these factors support the current cultural revival. These factors lead one to predict a long future for oral communication systems in Africa.

CURRENT USE OF THE ORAL ARTS

There is in Africa a group of leaders for whom the recognition that the majority of the people have resented the deculturizing quality of literacy communication is absolutely crucial. These are the politicians. Political leaders have long since recognized that the masses continue to cling to their traditional oral methods of communicating, including songs and poems. Jemo Kenyata is an astute observer of cultural realities. As a politician he was faced with the

task of winning the support of the people of Kenya quickly. He therefore designed a program that used songs as orally memorized propaganda for oral communicators. These songs were written, and sometimes spread, by literate leaders, but they were popularized and learned quickly among the masses through oral methods (Finnegan 1970:248-286 from L.S.S. Leakey 1954). The songs through which Sekou Toure rose to power in French Guinea around 1954 probably never did appear in writing, but became well known throughout Guinea (ibid p. 290). As a result of the obvious success of oral communication for leaders whose job it is to know their own people, various kinds of praise songs and taunts are an accepted part of the modern political life in modern Africa.

Songs are now accepted by African political parties as a vehicle for communication, propaganda, political pressure and political education. Their exact nature and purpose vary, but they have in common the face of being *oral* rather than visual propaganda (Finnegan 1970:284, author's emphasis).

Urgent political messages cannot wait for the population to gain a new method of communication, so some political leaders use the traditional structures. The result is that even very westernized politicians thereby gain a degree of identification with the common people.

The tradition of communicating through poetry is an ancient art in Africa. The Chopi of Mozambique have used the poetry of the common people to make suggestions and corrections indirectly to leaders they could not otherwise confront (Finnegan 1970:273f). By chanting as they dance, the people share their opinions with each other and can be sure that the leaders concerned will eventually get the message. If a ruler they would not otherwise confront gets out of line by trying to seduce a very young girl, it is in poetic verse and song that the Chopi women chide him (ibid p. 277). It is culturally appropriate in many African cultures that when political leaders run contrary to public opinion, the people use this indirect means of communication to express their feelings. And woe be to the politician who refuses to heed such opinion!

Employees in a copperbelt mine spread dissatisfaction about the working conditions and advocated support of one of the unions through the use of songs and dances (Finnegan 1970:277). Workers on a plantation who dared not directly ask for improved working conditions are not prevented from

putting the same message into entertaining forms of communal singing and dancing (ibid p. 275).

In similar ways the Yoruba people and the Igbo people of Nigeria correct each other, insult and apply social pressure through the use of improvised songs and taunts (ibid p. 278f). These informal uses of songs seem very likely to endure regardless of the use or non-use of written communication. Finnegan is of the opinion that many forms of oral communication in traditional art forms will continue to be vitally useful in the maintenance of African life and culture, even if written communication is increasingly used in scholastic and commercial situations. She concludes that since Africa has a rich tradition of oral art to which all segments of society are accustomed, the coming years of modernization in the continent may not (as assumed in the west) lead to a greater dependence upon the printed page. On the contrary, the more natural way for the mass media to extend communication would be through "greater dependence upon auditory forms (the radio in particular) at the expense of the visual (the written word)" (Finnegan 1970:520).

It is not a question of whether oral communication is more or less efficient than written communication. Writing obviously seems to do some jobs better, such as the preservation of business records. But it is largely a question of identity, and of acculturating the people to a new system. In some kinds of mass communication the spoken literal translations of Africa may be needed to promote the distinctive non-western image of the emerging new Africa. Hence, "this reliance on the spoken word and thus on oral forms of expression may well increase rather than decrease in Africa in the future" (ibid p. 521).

We cannot conclude from Finnegan's remarks that there is no need for more interest in literacy in Africa. She has, however, pointed out that African peoples show considerable pride in oral forms of communication, and considerable resistance to literacy. She has seen the vitality of the African oral communication system, the central part it plays in maintaining the identity of African culture, and the pride that is invested in the use of the oral arts.

The insistence upon the use of literate communication in some social settings, therefore, constitutes another attack upon central institutions of African culture. Barrett would interpret this continued attack upon the central formal and informal institutions of African life as a lack of love

for the people and their quest for identity (1968:156f, 269f). Rather than insisting upon written communication in a way contrary to the oral ministry of our Lord, it would seem that we need to show love for Africans by accepting and endorsing their tradition of sending important messages orally. We could thus harness for Christianity the positive values that accrue to messages that are memorized and *become part of African culture.*

THE CULTURAL REVIVAL

Across Africa today, there is a growing cultural revival that is clearly a reaction to the impact of western culture upon African life and culture. In honor of this drive to establish and celebrate the dignity of traditional life, the Eastern State of Nigeria has named its newspaper *The Renaissance*. The paper gives extensive coverage to various cultural events affirming the positive contributions to community life made by these celebrations. In this tumult of ideas, some Africans point out the way the church has contributed to the erosion of the "glorious past" (Mendelsohn 1962:184-238). Many writers realize, however, that the past was not all glorious. Yet they are caught between such things as the desire for a truly authentic reproduction of traditional dances, and aversion to what is now considered excessive nakedness unsuited to a modern situation (Awo 1974a:6).

It must be noted that the cultural revival is not a phenomenon of the non-reading masses who have never really departed far fr-m the traditional way of doing things. The cultural "Renaissance," as the very title seems to signal, is a product of the westernized elite. They have discovered that in the process of gaining a western literary education they have lost many connections with the culture of their fathers. It is the western-educated leaders who are promoting the traditional performers to the center of national attention even if these performers are not literary scholars. These are the people who feel a need to find an identification that blends elements of ancient arts with aspects of the modern world. It is those with the most western education who feel the greatest need to find an identity in touch with the traditions of the past.

There is, thus, pressure from both segments of Africa's divided society for a positive attitude toward traditional modes of communication. The great majority of the people have never attended school and have, therefore, never left

the sphere of oral communication. They want self-respect even without literacy. Many of the new elite who have entered the world of western literacy education are, however, now seeking ways of participating with the larger majority in some of the traditions of the past. They seek to achieve a degree of social solidarity with the non-westernized masses.

A CHRISTIAN POSTURE IN AN AFRICAN SOCIETY

According to Kraft's analysis of the communication process (1973:1974, a,b) there are at least three different factors that work together to decide the potential for acceptance or rejection of the message. In this discussion we will focus primarily on the needs of the majority who are resisting westernization.

The crucial factors are the *media*, the *style*, and the *content*. When all three factors are from an indigenous source, the potential for acceptance is excellent. The potential decreases, however, if any of the factors are foreign. When all three factors are foreign the potential for acceptance is very poor.

An indigenous ceremony (the medium) using African oral art (the style) and dealing with the greatness of the past (the content) is highly acceptable. On the other hand, if a sermon (the medium) concerning Jesus (the content) is presented via three point American-type sermon (the style), it will have an exceedingly foreign impact on the tradition-oriented masses.

It is difficult to consider Christianity a foreign religion in Africa. Much of North Africa was once Christian. Christianity has, furthermore, been present in Africa south of the Sahara for over 200 years, and millions of Africans have been born into Christian homes. For many, however, the Christian church and its message still have a pervasive air or foreignness that needs to be counteracted if they are ever to have a more indigenously acceptable impact.

In agreement with Kraft's principles of communication in the media, Dr. Soladoye, former Commissioner of Trade and Industry, urges the church to work at establishing a distinctively African identity by using African forms of art. He feels that the Christian message has a great opportunity to make a healthy contribution to the development of modern African culture, surviving the test of cultural revival, and spreading rapidly among the people if it is presented with

African music and art forms. But if the church retreats
into its western identity, in the face of the challenge of
the revival of African culture it would be fortunate to sur-
vive at all (Soladoye 1974:3).

In this regard, Soladoye finds there are many traditional
cultural values and art forms that can be endorsed and cele-
brated by Christians. This will not only strengthen their
own sense of identity as Christians, but also improve their
chances of communicating the Gospel to their countrymen who
are seeking an identity that is compatible with both modern
technical advantages and some aspects of African tradition.
Soladoye points to the traditional value placed upon personal
character as being superior to personal wealth. Sharing was
praised, especially among members of the extended family.
Respect for authority was demanded. Chastity in men and
women was highly praised as an ideal. As an integral part
of the system, African oral art plays a part in supporting
such values. Such use of oral art is particularly suited to
Christian purposes.

This kind of use of African oral art, solidly identifying
Christianity with traditional African culture, is admirably
suited to spreading the Word of God among people who either
do not read or do not care to read. The next section is a
report of an experiment that attempts to assess the value of
using African oral art styles to communicate the Scriptures.

15

An Experiment in Oral Communication

THE EXPERIMENT

In the previous sections we have seen that in Africa Christianity has suffered from having a very western image. This is due in no small part to the policy of insisting upon western modes of communication in all areas of the life of the church. The masses cannot or will not take this path to church membership or Christian maturity, partly because it seems to involve so much separation from the rest of the oral communicative life of the community. They have been turned away from membership or held at arm's length when they ought to have been embraced and taught the Scriptures in their own way.

The experiment here reported was part of an effort to imitate the policies of Jesus Christ by using the indigenous culture systems to communicate and teach the Word of God. We hope to see emerge a more African definition of Christian maturity that does not revolve around the mastery of foreign communicational techniques, but around more distinctly spiritual issues. One of the first steps in this process is the development of indigenous methods of mastering the Bible.

Having determined that the Yoruba people are proud of their folk music and have a great sense of enjoyment in singing in a variety of social situations, it was decided to experiment with an instructional technique that would involve singing in a Yoruba way. It was hoped that such an experiment would provide evidence that oral communication of

Scripture materials in contemporary African society is indeed a viable option. An experiment in oral communication of a portion of Scripture through singing was constructed.

The first purpose of the oral communication experiment was to prove or to disprove the possibility of communicating Bible knowledge without depending upon literacy. The second purpose was to evaluate the difference between the amount of factual information communicated and retained when the text was communicated via traditional book and lecture methods versus that communicated and retained when oral methods of presenting the text were used. The nul hypothesis tested states: Whether Hebrews chapters one to six is circulated in written form or oral form there is no difference in the amount of information retained.

For the purposes of this experiment we chose the Book of Hebrews. It is not one of the simplest New Testament books but it does contain a number of themes that we felt were theologically relevant to those possessing an African world-view. It opens with a discussion of the messenger spirits of God who in the past brought messages from God (Hebrews 1:6,14; see Gal. 4:8 and Acts 7:38). It recognizes previous communications from God which must be completely set aside since God has now spoken through the Lord Jesus Christ. It contains an explanation of the atonement through the death of Jesus Christ which alone completely atones for all sin. It stresses the supremacy of Jesus Christ as Lord.

It clearly warns about the dangers of falling into a sinful way of life. It speaks rather directly to issues that are vital to the life of the church in Africa and in terms of concepts that are theologically relevant to Nigerian understandings of sacrifice and atonement, but which are at the same time distinctly Christian.

For the purposes of this experiment we used a paraphrastic translation of the book of Hebrews. It was designed so that a woman of childbearing age who knew only her own culture could easily understand the message if it was read to her in her own language. It was prepared in written form in mimeographed booklets in a special type of page arrangement called maximum-readability layout. This presents the text in short, easy to read statements. It was prepared in association with Living Bibles International.

After the text had been carefully translated and tested for theological accuracy, comprehension, and ease of reading,

we sought Nigerian composers to set the text to music. The arrangements for locating composers and performers were made by Rev. Enoch Adebiyi of Igbaja. He is a professional recordist and recorded music for all 13 chapters of the book of Hebrews. Parts of these were then performed by the E.C.W.A. church choir of Egbe under the direction of Mr. Paul Kolawole, the choir of the Christ Apostolic Church of Ajase directed by Mr. S. O. Aina, and the King's Singers of Lagos. Through the efforts of these men and the choirs concerned, the entire book of Hebrews was set to music and recorded on professional equipment.

In these musical renditions of the text translational adjustments in a few lines were necessary in order to produce a more poetic rhythm. The composers and the Yoruba translation committee were, however, satisfied that these alterations occasioned no alteration of the sense of the text. Some parts were cantillated rather than sung to handle sections that did not lend themselves to singing. A variety of Yoruba music styles were represented in the work of the various composers. None of these styles were felt to have evil or "pagan" associations for Yoruba people. The choirs used written copies of the text, but learned the music line by line without any system of musical notation. Both the choirs and the choir directors were amazed at the ease with which the choirs learned the music and memorized the words.

At Ajase several very interesting things happened. The choir had been learning Scripture verses as part of their rehearsals and devotions led by the choir director. They had been struggling to memorize a group of about four verses for some months. But with the musical version of Hebrews they learned an entire chapter of some eighteen verses in three meetings! The pastor of the church happened to hear some of the rehearsals and stayed to listen a bit. To his own amazement he easily learned a stretch of several verses which he sang as he worked on the farm and went about his other work. As he repeatedly sang these verses, they struck his heart in a new way so that he began to preach on the book of Hebrews.

A carpenter who worked near the church but who never attended the rehearsals, was also heard singing sections. The choir members stopped to talk to him and he told them how he had heard them singing. He didn't realize that he had memorized any Scripture, but he liked their song and sang it as he went about his work.

When musical versions of the text were recorded and duplicated, arrangements to teach a series of Bible study classes

were made with the help of the elders of the churches of
Igbaja and Okeya. The elders of the churches were asked to
host Bible studies in their homes for their families and
neighbors.

The elders were told we were conducting an experiment to
obtain their opinions of our paraphrase of Hebrews and the
best ways of teaching from it. In the classes we focused
attention upon the new translation and obtaining comments
about it.

METHODOLOGY FOR TESTING THE COMPREHENSION THAT RESULTED FROM THE EXPERIMENT

(1) Before teaching the lessons, an extensive scheduled
interview was orally administered to each participant. This
was to determine the level of schooling, religious background
and amount of specific knowledge of the book of Hebrews
possessed by each participant prior to the teaching of the
lessons. A copy of the interview schedule completed by the
interviewers is contained in Appendix D.

(2) Eight sessions were held. These included an organiza-
tional meeting and some interviews, six lessons based on
three themes from the first six chapters of Hebrews, and a
review of culminating experience. Individual interviews were
conducted after the lessons were completed and included an
oral test consisting of the same questions on the knowledge
of the book of Hebrews asked in the pre-test. All partici-
pants were interviewed in some depth concerning our teaching
method. We wanted to gauge emotional reactions to the use
of Yoruba music.

The lessons focused on the following three themes: (a)
Jesus is our great High Priest who sacrificed himself to
atone for all our sins. All we must do to be saved is to
believe Him and repent of our sins; (b) There is a danger
that people who think they are Christians can fall back into
the old religious practices and be lost for not believing in
Jesus Christ; and (c) Christians need to learn what Christ
has done for them so that they can become mature Christians
who will not fall back into the old ways. The lessons are
outlined in Appendix F.

(3) The same lessons were taught to all classes, but
Hebrews 1 to 6 was presented and taught using four different
teaching methods. The groups using each method were labeled
W, X, Y, and Z. There were five teachers. Each teacher
taught a class using each method. There were 20 classes.

In classes using method W, Bible studies were conducted using only a teacher and written copies of the text. Students were loaned copies of the text for the duration of the sessions and were encouraged to read them between lessons and to memorize as much as they could.

With Group X, Bible studies were conducted using the written text as in Group W, with a teacher plus a cassette tape containing a reading of the text. Students were encouraged to listen to the cassette at home, to follow along in their text as they listened, and to memorize as much as they could.

With Group Y, Bible studies were conducted using a written text, a cassette version of the text set to music and a teacher. Students were encouraged to listen to the songs, follow along in the written text and memorize as much as possible.

With Group Z, Bible studies were conducted using only a cassette with player containing the text set to music plus a teacher. No written version of the text was used at all with this group, and the teachers used no written materials at all during these lessons. The students were encouraged to listen to the tapes between lessons and to memorize as much of the text as they could.

(4) A post-test was given which contained exactly the same questions on factual information plus additional questions. It did not repeat the personal inventory. It was administered in individual interviews. A copy of the post-test is given in Appendix E.

(5) The factual knowledge in the pre-test was compared to the amount of factual knowledge retained at the end of the lessons and was analyzed to compare the difference in information gained by people taught by each of the four different methods. The teachers completed the interview forms and wrote anecdotal reports on the reactions of the people.

(6) We selected and trained a group of five teachers and a supervisor whose job it was to visit all the classes while they were in progress. The basic control of teacher variability was to have each of the teachers teach one class using each method, so that none of the differences between the results of a given method would be due to the quality of teacher involved. We structured two kinds of lessons using songs, to have a comparison between two methods using music.

To have some means of evaluating the variation due simply to
the presence of additional teaching techniques, two methods,
X and Y, have a teacher plus two teaching aids.

According to Cole (1971) the greatest single factor in
increasing academic and problem-solving ability is schooling.
There was the possibility that previous schooling would give
those experienced with academic games a great advantage over
those who lacked this experience. This factor was controlled
by noting the education of each candidate and preparing to do
an analysis of co-variants to trace the impact of schooling
as a factor influencing performance.

The sample sizes were not large enough to attempt any
other co-variant analysis for such items as spiritual zeal,
Christian experience and other items of individual variation.
But the issue of previous knowledge was cared for by measur-
ing and computing only the gain in knowledge for each candi-
date. By subtracting previous knowledge from total knowledge
at the end, we hoped to measure only new information gained
from the lessons using these four methods of presenting the
text.

Under the circumstances of a rural, farming community of
modernizing Africa, it is not possible to control all the
variables that could impinge upon a study such as this. It
is hoped, however, that the variables that did exist would
be averaged out via the use of five different groups or
cells for each method, and having each teacher teach each
of the methods. In the course of events, the order in
which the teachers taught these methods became irregular
and varied due to scheduling problems.

 THE CLASSES

The classes were held with voluntary attendance. One
hundred and fifty-five people attended. There were an uneven
number of participants in each class, but nearly equal num-
bers of schooled and non-schooled participants in each
method.

Of the 155, 75 had less than four years of formal schooling
and 80 had more. This means 51.61 percent of the entire group
had more than four years of schooling. We shall call these
people literate. All of those in the schooled group could
read our maximum readability paraphrase aloud with ease.

We compared and analyzed the effects of two variables.
The first kind of variable was the teaching methods, described

as "the row effect" in this dissertation. The second variable was the two levels of schooling factor, described as "the column effect."

The graph given (Figure 14) summarizes the four different teaching methods (indicated by the use of the symbols "W", "X", "Y", "Z" to stand for the different teaching methods). A more complete explanation of this graph and the manner in which the data was computed is given in Appendix C.

RESULTS

From the computation of the contrasts also shown in Appendix C, the following conclusions appear to be supported by the statistical comparisons.

1. When a group of people had the advantage of listening to a recorded reading of the text with which to practice reading of the text, as in method X, there was a significant gain in knowledge in contrast to group W which lacked the recorded reading of the text.

2. In comparison to group W which used only the written text, there was significantly more information learned by groups which used a singing version of the message as in method Y. It is clear that the addition of Yoruba rhythm and music to the total communication did not detract from the factual content which was communicated and retained.

3. The gain in knowledge of the group using the reading tapes, group X, was compared to the average of the two methods using songs (Y and Z). The method using songs and the written text, Y, had results higher than X for both the schooled and unschooled alike who wanted to follow the oral tapes in their books. This seems to be caused by a common desire to improve skill in reading Yoruba.

4. The fourth contrast was between methods Y and Z. Both methods used singing versions of the text. This contrast was made to determine if it is possible to communicate Bible knowledge among the Yoruba people by purely oral communication and to evaluate the difference in performance in comparison to other methods. Without the written text, both the schooled and unschooled groups scored lower than in method Y. However, this did not prove to be a statistically significant difference. The slight decline in the scores could have been due to the difficulty the teachers experienced in teaching without books.

FIGURE 14

GRAPH OF MEAN INCREASE OF SCORES

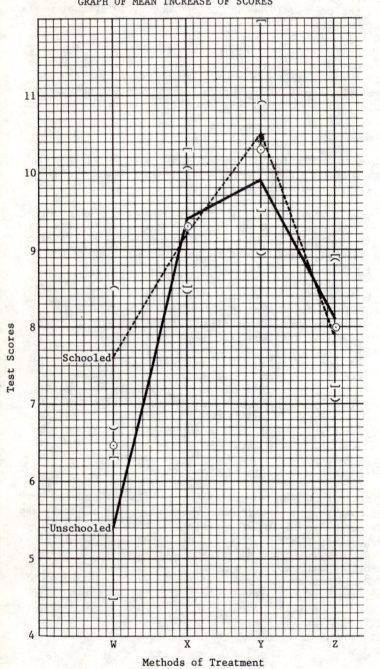

Test Scores

Schooled

Unschooled

Methods of Treatment

W X Y Z

5. The last contrast was the comparison of Y (which used a combination of songs and a written text) with the average of W and X (the two non-singing methods). There was a significant contrast in favor of the singing method Y. But the average scores of W and X were very far apart. Averaging them together may wrongly support a low opinion of method X. This contrast clearly shows the importance of using songs in contrast to traditional teaching methods, but should not be understood as sufficient reason for rejecting method X.

Using the principles for interpreting the analysis of variants presented by Minimum, it is legitimate to draw inferences from both the specifically chosen contrasts and the graphic presentation of the data shown in Figure 14 (Minium 1970:369-376).

The most striking feature of the graph (Figure 14) relates to the performance in method W in which the Biblical materials were read aloud from a written text and then discussed. This is the traditional method used by most teachers, missionaries and pastors. Using this method, those who had formal schooling generally did much better than those without schooling, as indicated by the fact that the means for the two groups are so far apart. The superiority of performance of people with schooling could seem to be in harmony with the traditional missionary emphasis on literacy and education.

However, in the other methods, X,Y,Z, the text was not presented primarily by having the class read aloud from the text. The text was presented orally, and those who could read had the added benefit of being able to follow along in their books. In all of these methods there was no longer a significant difference in the performance between those with and those without schooling. There appears to be no significant interaction between the levels of performance of the schooled and the unschooled groups when the primary presentation of the text is through the oral means. In methods, X, Y, and Z, the means and standard errors were very close together.

Another striking and significant observation is that none of these methods produced results inferior to the traditional teaching method of book and teacher. With the introduction of the oral reading of the text, both the schooled and unschooled groups improved their retention of the material taught, as indicated by the significant difference in the pooled means between methods W and X.

I had anticipated a rise in the scores for the non-reading group when they used a tape recorder, due to the fact that they would now be able to review the information as they pleased. This gave them an advantage which only readers usually have. I had not expected a similar rise in the scores of the schooled group. Such a result does, however, seem to fit my view of the difficulty of reading Yoruba. In the same way in which the non-schooled group had problems with reading Yoruba, some of those with advanced schooling also experienced difficulty in reading Yoruba due probably to the out-of-consciousness quality of the use of tone. The tapes compensate for this weakness in the written presentation of Yoruba.

I believe these factors relate to the enjoyment of the combined use of a written text with an oral presentation and are part of the reason for the rise in the scores of both the schooled and the unschooled groups when a cassette was introduced.

There is another factor at work here that relates to the interpretation of the data. This factor is that in the group with less than four years of schooling were some people who had some marginally useful literacy skills. With a tape, as in Method X, that starts and stops and repeats itself exactly every time, these people had a chance to follow the tape and practice reading. Where the reader had enough skill to sound out some of the letters, the tape supplied the complete sound and correct tone, thus helping these marginal readers to learn to read these passages of Hebrews. They did not read well, but were very pleased to get help with learning to read Yoruba tones correctly.

When a third factor is introduced, the use of songs which are composed in Yoruba, there is continued improvement in the scores as indicated by the continuous rise on the graph from methods W to X (when readings are included), and further improvement as the readings are replaced by singing versions of the text. This indicates that there is definitely no loss of factual information communicated and retained when the Scripture texts are set to Yoruba music.

The fact that the very best scores for schooled and unschooled alike occurred in response to a singing method indicates the positive value of using songs among the Yoruba people to communicate factual information, just exactly the same as it does in the West.

PERSONAL RESPONSES

I had expected that non-reading people would be pleased
with the introduction of more distinctly Yoruba methods of
communicating the Bible text. They were very pleased, as is
indicated in these comments.

One teacher said,

> During the time I was not with them they listened to
> the songs enthusiastically. They liked to sing the
> songs. One boy aged ten can sing the whole of Hebrews
> chapter one. Others could sing some of the verses.
> This group knows the lessons better because they have
> the songs. They learned the memory verses better too
> because of the songs...

From another class a tailor who graduated from primary
school spoke about the song tapes. He knew Mr. Kolawole,
the man who had composed chapter two.

> I and my children enjoyed the songs that were sung by
> Mr. Kolawole and the songs of chapters five and six.
> The pupils (youth in school) could easily catch the
> songs they can sing with their books, but it was hard
> for them to sing from memory.

The teacher's report on this class states that Muslims
came both to the lessons and to the home to listen to the
tapes between lessons. They particularly enjoyed chapters
2, 5 and 6. As a result of the lessons in this home, the
people around have continued to study the book of Hebrews.

The wife of this elder wanted to sing all the songs. She
said,

> I am certain that this was the best method for teach-
> ing the Word of God. I really appreciate it. I know
> that I am not yet too old to sing for the glory of God.

The teacher of these people said the young people from
secondary school also enjoyed the music. One teacher said
that a few days after the materials were collected from the
participants a group of students performed chapter one from
memory with their guitar in church. Additional comments from
the participants are in Appendix G.

When the written text is withdrawn from the singing
method Y, as in method Z, the graph indicates a decline in

information retained. But this was not a significant
difference at the .05 level of significance, even though it
was the greatest contrast among the oral methods.

The decline caused by the removal of the written materials,
and the higher scores in method Y seem to indicate that the
most effective method is a combination of songs and written
materials. However, the scores in method Z, which used only
one tool, songs, are also higher than those of the schooled
group using traditional book oriented methods. The graph
clearly shows a higher mean for Z than for any of the three
means produced in method W. The greatest advantage of this
method is that it has a greater potential for being used by
the masses than literacy-based methods used in method W.

It is possible that these findings support the concept
that the introduction of literacy, schooling and "moderniza-
tion" to traditional African society gives definite voca-
tional advantages to the schooled people. These advantages
contribute to socioeconomic divisions among the people.
However, if vital vocational information were taught via
appropriate oral methods, some of these differences could
be minimized. It seems to me that church education programs
which are intended, among other things, to promote unity in
a congregation, would better succeed in this regard if they
were taught and shared via appropriate oral methods. It is
my judgment that appropriate use of oral teaching methods
would not inhibit the growth of literacy but would actually
prepare more of the people to readily accept it.

SUMMARY

This experiment indicates that both the schooled and
unschooled groups performed better and more nearly alike when
oral teaching methods are used. It indicates that oral
teaching methods in the church can help to reduce the social
distance between people who have been to school and those
who have not. The use of traditional music to present a
Bible passage does not detract from what is heard or learned.
It is likely to improve retention of the message. Such an
approach will also allow an indigenous image of the church
with which the non-reading masses can readily identify. If
we are concerned to convey a detailed knowledge of the text
of the Bible to the people, suitable oral methods are as
useful as written materials in providing factual knowledge.
But the oral materials can be used by the entire population,
while the written materials can presently be used by only a
minority. And even this minority are not likely to make use
of written materials in the normal routines of daily life.

16

Conclusion
and Recommendations

CONTEMPORARY AFRICAN SOCIETY
AND THE COMMUNICATION OF THE GOSPEL

In this study we have seen that the educational philosophy of the founding fathers of modern missions was based upon one of the central convictions of the Reformation, that God has not vested His authority in any one group of men but in His written Word. Therefore, the only proper foundation of a self-governing, self-propagating, self-supporting church was seen as the written Word of God and the ability of the church members to read and interpret it for themselves. With Luther they did not feel that men are free to interpret the Bible any way they want to, but that each man is responsible to find the truth and hopefully to have the same understanding of the Bible as the missionary. In West Africa this was thought to require pastoral training similar to that of the missionary, written communication of the Bible, plus at least a minimum of literacy for the masses. Upon this philosophy many of the schools of Africa were established.

I am in agreement with the doctrine of the Reformation concerning the liberty of the Christian man under the authority of Scripture through the ministry of the Holy Spirit. But the insistence that in the oral societies of Africa the Scriptures can be popularized and/or properly used only in written form is greatly limiting the use and the public knowledge of the Scriptures.

Furthermore, definitions of Christian maturity that demand
literacy for Bible reading in predominantly oral societies
reflect a rather culture-bound understanding of indigeneity.
Spradley (1972) and others have shown that communications
and language arts are at the very core of a society's culture.
Therefore in a predominantly oral society the church ought
to minister and teach primarily through indigenous oral
media. Then the church will have an indigenous communica-
tional image, and the majority of the people will be able to
employ their present communicational skills as the basis for
their growth in the faith.

If a denomination in a predominantly oral society depends
primarily upon written materials for most of its Bible study
and teaching ministry, then at the heart of its ministry
such a denomination is not indigenous. Its communicational
policies are hardly indigenous. A more truly indigenous
strategy would have the advantage of being able to reach the
masses of the people because it could make more skillful use
of indigenous communicative media. Individuals and groups
already literate should also be encouraged to use their
talents in the church but not to dominate it simply because
they possess those skills.

Missions have played an important part in the introduction
of western methods of reading, western definitions of reading
and western standards of learning. This has had the result
of creating a new elite and introducing a new set of vertical
socio-economic and communicational divisions. People became
divided according to the system of communication upon which
they depended for vital information. Literacy has become
the badge of those youths who have sought to attain prestige
outside of the traditional system. Those loyal to the
indigenous system tend to resist literacy, relapse from it
or avoid reading in the home. These social and communica-
tional divisions cut off the flow of communication about the
Gospel from the new elite to the masses who do not read.

The heavy dependency upon literacy for the public life of
the church has fostered the selection of leaders on the basis
of skill in the use of the foreign medium of instruction.
This is a foreign method of leadership selection. These two
factors give a West African church an exceedingly foreign
image. Indeed, if a church organized in a culture zone
where the majority do not read is dependent upon the use of
literate communication, an essentially foreign medium of
communication, it cannot be considered an indigenous church.

Where churches among non-reading populations of 50, 80 or
90 percent or more insist on using written communication,
and select leaders on the basis of knowledge gained through
reading, it is understood to be an attack on African systems
of oral communication and West African patterns of leader-
ship selection. The cultural resistance to literacy results
in resistance to Christianity. This is in large part due to
the western image literacy gives mission-related churches.
This western and literacy image is attractive to some
Africans. Westernizing West Africans need church structures
where they can be at home. But so do the masses of West
Africans who prefer oral communication to written communica-
tion and all the culture changes it implies.

In many parts of Africa, even after more than 100 years of
mission effort to teach literacy, 80, 90 or greater percen-
tages of the people cannot read a simple paragraph. Hence
the vast majority cannot be effectively reached with Bible
knowledge through written communication.

The apparently slow growth of literacy, and the reversion
from literacy can be understood from two perspectives. They
can be considered the result of resistance to literacy on
the part of those who perceive literacy to be an attack on
the indigenous system of communication, the concept of oral
art and methods of indigenous leadership selection. This
attack endangers the identity, cohesion and perhaps the
endurance of the social organization of the indigenous cul-
ture.

Or, more positively, the lack of use of printed materials
in West Africa may be seen as resulting from the vitality of
the oral communication system and of African oral arts in
general. In chapter 9 and 14 we have seen that systems of
West African oral art have a future in modernizing West
Africa. Even if the majority of West Africa's people reject
literacy it need not hurt the spiritual growth of the people.

In first century Palestine a similar communicational sit-
uation prevailed. Literacy was known, but it was the property
of the elite communities who used Greek or Hebrew. Both were
foreign languages. Proficiency in reading was related to
correctly intoning passages that a person had to be taught
to cantillate properly. Memorization was very important for
this definition of reading. Private possession of the
wirtten text was rare, due to the great cost of manuscripts
and the cultural preference for memorized knowledge. Very
few people had the incentive or the opportunity to develop
anything like our concept of functional literacy in Aramaic.

Jesus did not use either the communicative mode of the educated minority of the Hebrews or that of the Greek-speaking foreigners. Jesus used the oral communicational vehicle--Aramaic--for the circulation of His own teachings. Later, when the Gospels and sayings of Jesus were written, it was for Greek-speaking audiences which were different from the one in which Christ ministered.

Jesus seems to have shaped an oral ministry for the masses of His people who did not read. He believed the people were capable of learning and spreading the essentials of His message without first surrendering their communicational identity. He did not spend His limited time teaching an elite form of communication, but used forms of communication already in use among His primary audience. In this way the focus of attention remained upon the content of His teaching rather than on the elite mode of communication. His message remained encoded in a style pertinent to the masses of the common people.

Today's missionaries often consider it necessary to extract people from their customary frame of reference because they consider that frame of reference to be communicationally and ideologically impoverished, if not antagonistic to the Christian message. Some communicators feel compelled to use a foreign frame of reference or foreign mode of communication to teach adults of another culture. This is not an indication of the poverty of the receptors' frame of reference but rather, it shows the communicator's ignorance. He does not know enough about the resources of the receptor's culture.

From the study of African oral art, and the systems for communicating it, we can see that West African structures for oral communication are very similar to those of Bible times. These are very adequate and powerful systems for communicating religious messages. African oral communication utilizes nine of the eleven symbol systems in a way that is emotionally rich and communicationally powerful.

Indigenous oral communicational events are multi-directional in their format. African oral art is a communicational system that is identified with the non-reading masses and the very soul of the culture. It is ideally suited to communicating spiritual truth in a form with which the people can readily identify.

It is little wonder that current mission thinkers such as Kraft, Ward and Sogaard are recommending the use of oral

techniques in ministering to the billion or more who do not
read. They can be won for Christ and led into Christian
maturity without first being taught to read. They can become
ministers of the Good News now because their own indigenous
communications systems are adequate for them to learn and to
teach others. It is not just a question of allowing oral
communicators to exercise their Christian birthrights while
maintaining their identity with their people as oral communi-
cators who know Jesus and the Word of God. Where people con-
fuse Christianity with western education, oral communicators
are needed to minister among the people to help them distin-
guish between the content of the faith and western ways of
communicating Christian truth. Oral communicators are needed
now to provide indigenous Christian leadership in towns and
villages regardless of the progress in matters of literacy.
They are vital to the structure of an indigenous church.

When an oral method of communicating factual information
was tested, it was found that the amount of information
retained is greater than when western book and lecture methods
are used. The wide gulf between the schooled and unschooled
groups was closed when oral media were used. Readings pre-
sented via tape cassette that enabled people to repeatedly
hear the same message over and over significantly increased
retention of the material for those who merely listened and
for those who wanted to improve their ability to read a
limited segment of the text. The addition of distinctively
Yoruba music greatly increased the enjoyment, interest in
learning to perform the text, and the material retained.
The informal use of the songs in "secular" working situations
was a very valuable side effect.

This experiment indicates that both the schooled and
unschooled groups performed better and more nearly alike when
oral presentations were used. This indicates that the use of
oral teaching methods in the Church can help to minimize the
social distance between people who have been to school and
those who have not. It will allow the Church to have a more
relevant ministry among the majority of the people who do not
read well enough to feel at home in churches making prominent
use of written materials. As we have noted, the highest
scores occurred in classes where the text was sung to dis-
tinctly Yoruba music. These scores were higher than when the
text was merely read over and over. The participants were
emphatic that the songs were the most enjoyable way to present
the text. It is significant that the greatest retention of
information came as a result of the method the audience
enjoyed the most. This is evidence that the Yoruba people

are right when they say that songs are the best way to popu-
larize a message among the Yoruba.

Even in groups where the songs were used but no written
text was present at all, more information was remembered
than in classes where the text was present and read aloud as
in a normal western teaching situation. The factors empha-
sizing tone and promoting identification helped make the
material easier to remember. The result was a great deal of
enthusiastic informal use of the songs. Secondary school
youths performed chapters from memory, and elderly non-readers
memorized chapters with the intention of performing them
orally. This is a form of ministry they considered to be
relevant to their people. The interest of the adults in
learning to sing the Word of God indicates that we may have
found a method of communicating the Bible that has the
potential of reaching the masses of the people who either do
not read or do not take pleasure in gatherings that feature
the use of reading and writing. We have found a form of pre-
senting the Christian message that uses the communicative
styles and methods of encoding messages with which the non-
reading masses are pleased to identify themselves. Due to
the revival of interest in African culture and the love of
songs among the people, young people who can read well also
took a keen interest in learning to sing the songs from
memory.

It is the live performances of these elders who have heard
the tapes and have meditated upon the meaning of the message
as they have gone about their chores, that has real potential
for reaching the masses. As these people reproduce the
message with the media indigenously available, we will realize
a richer type of presentation. As they give themselves to
the act of performing from memory, they can spread the Word
in social contexts where people do not usually read from
books. They become one with the presentation and present
the meaning of the text they understand in multi-channel
communication that uses all the symbol systems used in live
performances.

NEEDS FOR FURTHER STUDY

(1) Replication. The experimental part of this work is
research in progress. We plan to continue teaching lessons
using various types of oral presentation of the text. We
plan to teach similar lessons over the entire book of Hebrews.
The people who took part in the lessons have asked for this
and so have the teachers. There is a great need to replicate

the experimental work in other African languages, in both rural and urban situations.

(2) Teaching Reading. It has long been stressed that Bible reading can be a strong motivation for the promotion of reading skills. In our lessons we saw that advanced students and very marginal readers alike were motivated to improve their skills in reading Yoruba through the use of the Yoruba songs and the written versions of the text. The repetitious readings, with the help of the cassettes, did promote interest in reading the text, but we were not in a position to judge improvement in reading ability. Further work ought to be done to explore the value of teaching reading with a closer relationship to partial or complete memorization of such music materials. The use of reading in a more indigenous way may also reduce the tension between those who use this medium and those who do not.

(3) Study of Independent Churches. Due to the fact that the vast majority of the peoples of Africa do not read, our emphasis must remain upon the use of indigenous means of communicating Christian truth. The Independent churches of Africa have been at greater liberty to experiment with various types of worship service and evangelistic presentations in the community. They make use of a variety of non-verbal systems. We need to learn more from the communicative strategies of these churches. Systematic studies need to be done on their teaching methods and communicative strategies, particularly those that make little use or different use of written materials.

(4) Finding Oral Communicators. Thus far, most of our studies have been directed toward teaching the Bible to non-readers. We have been concerned about admitting them to the churches that have refused them baptism and membership. Now we need to turn our attention to understanding the genius of non-literate communication so that we may release the teaching potential of non-reading Christians. Non-readers have the potential for becoming mature Christians, and are urgently needed to communicate with their peers and fellow oral communicators. We have found that the cassettes help them to learn. But the capacity of such foreign communication tools to spread the message is limited due to the scarcity, costliness and appetite for batteries of these tools.

If we learn how to produce materials that oral communicators can learn to repeat without the cassettes, we have a form of the message that has the potential for being

indefinitely extendable within the resources of the non-
reading masses of the population. (a) We need to study the
most helpful kinds of material to prepare for oral repetition.
(b) We need to explore the social roles of oral communica-
tors to discover the most natural and culturally fitting
roles for oral communicators of the Gospel to assume in the
various societies of Africa and then to motivate mature
Christians to assume these roles. (c) We need to make
further investigation into the most natural times and occa-
sions for encouraging informal performances by these Chris-
tian oral performers so that the message will have maximum
impact on the daily lives of the people addressed.

(5) Prepare Media Response Survey. The studies here
indicate that there are westernizing African people who are
interested in learning to read, and are willing to abandon
the oral communicational system. They may profitably be
taught to read, and reached with Christian training through
the use of printed materials. With these peoples literacy
evangelism may be very productive.

But the vast majority of the people are in the process of
resisting literacy, ignoring written communications and
supporting young people in the process of reverting from the
use of literacy. The feelings and attitudes of any given
group on this matter ought to be discovered before offending
such audiences by the conspicuous use of literacy in con-
junction with the Christian message. Then appropriate
indigenous, oral presentations can become the major method
of presenting the text publicly, through the featured use of
oral communicators. This would promote social roles for
Christians which the people could identify with and communi-
cate to them so that they can successfully attain membership
in a community of fellowship using such oral presentations.

Survey tools are needed to determine not just the extent
of functional literacy in an area but the attitude of various
audience segments to oral and written media. Such survey
tools, if properly developed, could save much wasted effort
on the part of literacy workers. This would also provide a
much broader data base concerning attitudes toward literacy
than this present study has been able to discover.

If it is indeed possible to discover attitudes toward
literacy for various audience segments over an extended area,
it would be very instructive to compare the prevalence of
these attitudes within the various segments of Christianity.
Are there significant differences in attitude toward literacy

between those segments of Christianity that are flourishing and those that have grown slowly or were unable to take root?

(6) Selecting Initial Passages. In areas where there is limited literacy or a limited amount of Scripture previously translated, it may be very profitable to start translating in the Gospels. Selected poems of Jesus could be brought out in oral form and performed. Audience-testing could be done orally with or without cassettes before distribution of written copies.

If literacy is to be promoted, the memorized oral material could be used in conjunction with the written text for introducing adults to reading. This would allow for an indigenous use of written materials more in harmony with the practices of oral literature. It may also help to reduce the need to afflict adult readers with irrelevant, meaningless or childish materials.

(7) There are a vast variety of non-verbal means of communicating (D. K. Smith 1961a; Mehrabian 1972; Sawyerr 1968). The Old Testament is full of non-verbal communicative devices for teaching the people about their relationship to God. There was a dramatic sacrificial system, dietary codes, and elaborately decorated objects used in the worship of God. These non-verbal media communicated factual information and elicited emotive response.

African societies are also accustomed to making good use of similar symbolic and artifactual communications. But symbols are arbitrarily assigned meaning by each culture. Thus, symbols from one culture may have completely the opposite meanings in another culture. We may not assume that Christian symbols used in one culture will be correctly understood by the people of other cultures. This book has focused on communicating the propositional content of the Bible in verbal form. Much additional work needs to be done concerning the use of indigenous non-verbal communication. Amen

These studies indicate that mission teaching structures have expected African learners to leave the indigenous frame of reference and learn western modes of communication as a prerequisite to the study of the Scriptures. If we learn to provide instruction in Bible knowledge within the communicational structures used by the majority of the people, we will improve our potential for reaching the masses with the Word of God, and also improve the ability of the people to

identify with the Christian message in order to receive
Christ into their hearts and lives. For purposes of evan-
gelism and leading converts into a better working knowledge
of the Word of God, indigenous oral communications will more
effectively reach the great majority of the people than
written presentations. It is urgent that the Christians of
Africa be encouraged to study, appreciate and make skillful
use of indigenous techniques to reach their own people.
Rather than inhibit or resist this use of African culture
patterns in evangelism, missions need to accept, appreciate
and encourage work with these media! We can anticipate
(1) new converts will be able to witness and to accurately
teach early in their Christian experience, (2) indigenous
patterns of leadership will have a better chance of enduring
in the church and (3) the Church of Jesus Christ will have a
better potential to endure in the heart of Africa.

Appendices

Appendix A

Comparison of the Form of Aramaic Poetry and Yoruba Ijala

One of the characteristics of poetry from many parts of Africa is that the lines are frequently quite short and each one stands as an independent sentence. A sample given here is Yoruba Ijala chanting given by Babalola (1966:62). It was recorded from an oral competition in which two artists, hunters one and two, engage in a poetic debate and contest. While the lines vary in length of words the number of stressed beats is usually more regular.

Example i

Ọdẹ Kinní: Ng ó re'lé Ọ̀fà Mọ̀ká ọmọ Ayèéjìn.
 Ọmọ eléwé ilá dógba 'mọ ìjà Ìlàlá ọmọ ẹrù ọfà.

Ọdẹ Kejì: Máa gbọ́ o o o, nítorí ọjọ́ mîí ọjọ́ ire.
 Ifá kò m'ẹ́bọ nî'hà ibẹun.
 Ifá já'ko jẹ.
 Tí o bá ńlọ sí 'lé Ọlọ́fà.
 Má ṣe gb'ọ̀nà ilé Ẹlẹ́rìn lọ o o.
 Ọ̀nà ilé Oníkòyí ni o má sì gbà.
 Torí ọ̀tọ̀ ni Tọ́lú.
 Ọ̀tọ̀ ni Tọ̀lú.
 Ọ̀tọ̀ ni Tọ́lùúwò.
 Ọ̀tọ̀ ni Akintọ̀lú.
 Tí o bá ńlọ sí 'lé Ọ̀fà Mọ̀ká ọmọ Ayèéjìn.
 Máa wí pé: Yẹrú ọ̀kín Ọlọ́fà Mọjọ̀.
 Ọlálọmí mi nì ó là're mo dijú ng tó la'ṣu.
 Ọ̀kan ò gbọdọ̀ jù'kàn l'Ọfà.

(*First Hunter*: I will sing the praises of Ọfa Mọka, offspring of
Ayeejin.

Offspring of a town where okro vegetables
abound with their uniformly sized leaves.

Offspring of a warrior at Ilala.

Offspring of He-who-carried-a-load-of-arrows-
to-the-war.)

(*Second Hunter*: Listen to me attentively for the sake of the
future.

That it may be good for you.

You have erred on your journey.

The oracle cannot support you on that route.

If your destination is the house of Ọlọfa

Never you take the way leading to Ẹlẹrin's house.[1]

And never you follow the path that goes to the
house of Onikoyi.

For Tọlú is different from Tọlú.

And Tọlú differs from Tọlùúwọ.

While Akintọlu differs from all three.

If you want to chant a salute to Ọfa Mọka,
offspring of Ayeejin,

You should say:

Citizen of a town of sandy streets frequented by
ọkin birds.

King of Ọfa, the Handsome One.

My dear Ọlalọmi was the successful cutter,

At the traditional blindfold yam-tuber-cutting
ceremony

In which the two sections of the yam must be of
comparable size.

(Babalola 1966:62)

On the following page is a sample of the line structure
of the Aramaic poetry of Jesus Christ as reconstructed by
Jeremias (1971) who builds upon the work of Matthew Black.
The example shows even line structure with some variation
allowed in length of line but with a general expectation of
the same number of stressed syllables per line.

Note the double rhyme and the application of the law of compensation in the second line: the verb of the first line is not repeated in the second, but a disruption of the rhythmic balance is avoided by compensating for the missing stress with the genitive *diš*mayyā.*[1]

mōdénā lák 'abbá
*māré diš*mayyá ūd*'ar'á*
*diṭ*márt hallén min ḥakkimín w*sukl*tānín*
*w*gallít 'innún l*ṭalyín*
'ín 'abbá ―――
dikdén ra'ᵃwá q°dāmák

(Matt. 11.25f. par. Luke 10.21f.)[2]

*ṭūbēkón mísk*nayyá*
*d*dīl*kón malkūtá dēlāhá*

(Luke 6.20, following sy^pal)

*ṭūbēhón d*raḥᵃmánayyá*
 *d*hinnón yítraḥᵃmún*
*ṭūbēhón did*ké libbá*
 *d*hinnón yaḥmūnéh lēlāhá*
*ṭūbēhón d*ᶜāb*dín š*lāmá*
 *d*yítq*rón b*nóy dēlāhá*

(Matt. 5.7, 8, 9)

*lā yāk*lá m*dīná d*tiṭṭ*már*
*dil*ʾél min ṭúr mitt*sāmá*

(Matt. 5.14)[3]

*kol mán d*kāᶜés ᶜal 'aḥúh*
 *y*hé mitḥayyáb bēt dīná*
ūmán d'āmár l*'aḥúh rēqá*
 *y*hé mitḥayyáb sanhedrīná*
ūmán d'āmár šaṭyá*
 *y*hé mitḥayyáb nūr gēhinnám*

(Matt. 5.22)[4]

*lēt k*sí d*lá yítg*lá*
*ūṭ*mír d*lá yíty*dáᶜ*

(Matt. 10.26 par. Luke 12.2)

*hēk*dēn yanhár n*hōr*kón q°dām b*nē 'ᵉnāšá*
*d*yiḥmón ᶜōbādēkón ṭābayyá*
*wišabb*ḥún laᵃbūkón d*biš*mayyá*

(Matt. 5.16 sy^pal)[5]

[1] *Op. cit.*, 106. Further examples of the use of the law of compensation in the three-beat line: Ps. 24.5; 15.1; Amos 5.24; Mark 13.25 (‡Burney, 105f.).

[2] *Op. cit.*, 171f. Burney deletes the fourth beat in the third line, but this correction is not necessary, as such licence is allowed; nor does the fifth line need to be filled out, as the law of the pause, mentioned on pp. 21f. above, is applied here.

[3] *Op. cit.*, 130f.

[4] Dalman, *Jesus-Jeshua*, 73.

[5] At the beginning of the second line, sy^pal also has *liglēl = ὅπως*; in Palestinian Aramaic, simple *d** corresponds to this.

(Jeremias 1971:24)

Appendix B

Sample of Maximum Readability Format of SiNdebele Text

The following selection is taken from a modern translation
of the book of Hebrews, chapter 2, verses 6 to 9, prepared
as a Living Bibles International text in a format that is
easy for new readers to use. The lines are broken where it
is natural to pause or hesitate without injuring the meaning
and the margins are uneven on both sides making it easy to
keep track of ones place.

> UNkulunkulu kanikanga izithunywa
> zasezulwini
> ukuthi zilibuse lelo lizwe.
>
> 6. Hatshi, ngoba encwadini yamaHubo
> uDavida uthi,
> "Kungani uze ukhathazeke
> ngomuntu kangaka na?
> Njalo ingubani lindodana yomuntu
> uze uyihloniphe kangaka na?
>
> 7. Ngoba loba wamupha isikhundla
> esingaphansi kwesezithunywa zasezulwini
> okwesikhatshana.
> Kodwa khathesi usumethwese umqhele
> wobukhosi lenhlonipho.
>
> 8. Usubekile izinto zonke
> ngaphansi kwezinyawo zakhe.
> Akulalutho oluseleyo.
> Kasikakuboni konke lokhu kusenzeka.

9. Kodwa siyambona uJesu,
okwesikhathi esifitshane waba ngumuntu.
Wababaphansi kwezithunywa zasezulwini.
 UNkulunkulu uyamnanza umuntu kakhulu.
 Yikho-nje uJesu wahlupheka
 wezwa ukufa ngenzayabantu bonke.
Khathesike uNkulunkulu usenike uJesu

Appendix C

Statistical Analysis of the Experiment in Oral Communication

Due to the unevenness of the sample sizes in the various groups, the computations for the analysis of variance had to be done on a computer. I was fortunate to obtain consultation of a professional statistician, Mr. Carl Pierchala, affiliated with the Public Health Department of the University of California, who was able to obtain access to computer time, courtesy of the University. I would like to express my appreciation to him for his interest and careful work on this project.

The analysis of the data was carried out using the method of the general linear hypothesis described by Afifi and Azen in section 4.5 (Afifi and Azen 1972:194:194-203). This is a model for computerized two way analysis of variants.

In this formula i stands for the row and j represents the column. The overall mean is u, the effect of the i-th teaching method is a_i, the effect of the j-th education level is B_j, and Y_{ij} is the interaction, that is, the part not explained by simple addition of row effect and column effect. The

formula is given, H_1 u_{ij} = uta$_i$ + B$_i$ + U$_{ij}$ (i = 1..., 4, j = 1, 2). The a$_i$, B$_j$k and Y$_{ij}$ are subject to the usual constraints, Ea =0, EB =0, EY = 0, EY =0, =1,...4

i =1 j =1 i =1 j=1

(Afifi and Azen 1972:467).

However, with the use of this general linear hypothesis formulation, it is possible to test the adequacy of an alternative model, H_2 = u_{ij} = u+a$_i$ +B$_j$, i = 1,..., 4 and j = 1, 2. The test statistic is:

$$F = \frac{S_{H2}\ S_{H1}\ /\ df_{H2}\ -\ df_{H1}}{S_{H1}\ /\ df_{H1}}$$

where S_{HA} is the residual sum of squares under the model H_A, A = 1,2.

Using a computer program to compute the required sums of squares, it was found that F = 0.712 with 3 and 147 degrees of freedom, which is not significant at a = .05 level of significance. Thus it appeared that the model H_2 sufficed to describe the data.

Next the adequacy of the model was tested, using this hypothesis.

$$H_3 : u_{ij} = u+a_k,\ i = 1,...., 4,\quad j = 1,2$$

In this equation B$_j$ = 0, j = 1, 2 was tested on the assumption that the H_2 model was correct. The result of this computation is shown in Figure 20: Two-Way Analysis of Variance Table. In this computation the test statistic was computed to be F = 0.879 with 1 and 150 degrees of freedom, which is not significant at .05 level of significance.

FIGURE 20

TWO-WAY ANALYSIS OF VARIANCE

Source	SS	df	MS	
Due Teaching Methods (A)	318.80	3	106.26	
Due Educational Level (Adj. for Teaching Methods (A)	14.49	1	14.49	F 0.879^p
Due Interaction (Ajh. for A,B)	35.49	3		F 0.712
Error	2437.83	147	16.58	
Total	2806.61	154		

Note: In Testing Educational Level, the error and intraction
 of the sums of squares were pooled, giving a pooled
 estimate of residual variance of 16.49.

Based on the evidence of calculations indicated above, the
analysis was continued as a one-way analysis of variance. The
result of the computation of the sums of squares in the one-
way analysis of variance are summarized in Figure 21.

FIGURE 21

ONE-WAY ANALYSIS OF VARIANCE

Source		Sum of Squares	Degrees of Freedom	Mean Square	
Between groups	SS_B	318.80	4	106.26	F = 6.45
Within groups	SS_W	2487.81	150 MS_W	16.48	

Figure 21 shows the results of the one way analysis of
variance in which there is an F value of F = 6.45, which is
significant at a .05 level of significance. This suggests
that certain of the teaching methods give better results than
other of the methods, and the rejection of the nul hypothesis
which stated that there was no difference between these
methods.

A review of the four different methods of teaching four groups may be helpful. This is given in Figure 22.

FIGURE 22

TEACHING METHODS AND FORMAL SCHOOLING

Teaching Method	Description
W	Printed material, read aloud in class
X	Printed material, cassetted Scripture reading
Y	Printed material, cassetted Scripture songs
Z	Cassetted Scripture songs

Levels of Schooling	
S	Educated with more than four years schooling
NS	None or less than four years of schooling

The dependent variable is the improvement due to receiving the Bible-study lessons, that is, the improvement between the pre-test and the post-test. In the results below, none are net scores. They are rather, the scores of the post-tests minus the scores of the pre-tests.

Prior to the computation of the data five contrasts were chosen for statistical comparison. We considered it unwise to increase the number of statistical comparisons from the data. The level of reliability for these comparisons with comparatively small cell sizes would either have decreased the level of reliability of the figures or else significantly increased the levels of difference in scores required to report a significant difference due to teaching methods.

The following contrasts, shown in Figure 23, were chosen prior to the data analysis.

FIGURE 23

STATISTICAL COMPARISONS CHOSEN

Symbol	Description
$X - W$	Difference of X minus W
$Y - W$	Difference of Y minus W
$X - \dfrac{Y + z}{2}$	Difference of X minus the average of Y and Z
$Y - Z$	Difference of Y minus Z
$Y - \dfrac{X + W}{2}$	Difference of Y minus the average of X and W

The mean increase in scores between the pre-test and the post-test for each of the methods of teaching is summarized in Figure 24, in which N stands for the number of participants in each section, \overline{X} is the mean, and S is the standard deviation of the group.

FIGURE 24

MEAN INCREASE IN SCORE

	Schooled	Unschooled	Combined
W	N = 18 \overline{X} = 3.71 S = 3.67	N = 20 \overline{X} = 5.40 S = 3.94	N = 38 \overline{X} = 6.45 -------
X	N = 23 \overline{X} = 9.22 S = 4.06	N = 16 \overline{X} = 9.38 S = 3.85	N = 39 \overline{X} = 9.28 -------
Y	N = 22 \overline{X} = 10.50 S = 4.75	N = 19 \overline{X} = 9.95 S = 4.44	N = 41 \overline{X} = 10.24 -------
Z	N = 17 \overline{X} = 7.88 S = 3.81	N = 19 \overline{X} = 8.05 S = 3.69	N = 41 \overline{X} = 7.97 -------

N = Number per group
\overline{X} = Mean of the group
S = Standard Deviation of the group

Since certain contrasts among the teaching methods were
selected for analysis prior to computation of the results,
it was decided to compute multiple type confidence intervals
according to a formula suggested by Afifi and Azen for these
contrasts (Afifi and Azen 1972:75). The results are indi-
cated in Figure 25. For each contrast the spread of points
between the means of each methods is listed as the estimated
value of the contrast. The confidence interval is a result
of the formula mentioned above. Those intervals which
include a zero value are not considered significant at the
.05 level, while scores entirely above or entirely below
zero are considered significant at this level. On this table
the three contrasts marked by asterisks are significant for
a combined nominal .05 level of significance.

FIGURE 25

CONFIDENCE INTERVALS FOR PRESELECTED CONTRASTS

Contrast	Estimated Value	Confidence Interval
$X - W$	2.83	(0.42, 5.24)*
$Y - W$	3.79	(1.41, 6.17)*
$X - \dfrac{Y + Z}{2}$	0.18	(-1.90, 2.25)
$Y - Z$	2.27	(0.13, 4.67)
$Y - \dfrac{X + W}{2}$	2.38	(0.33, 4.24)*

* Significant, for a combined nominal .05 level of signifi-
cance. Figure 26 presents the same information in the form
of a graph.

As indicated above, only three contrasts were indicated
to be significant, the first, second and fifth.

1. The first contrast compared method W, (the way we
usually teach from books) to method X which supplied a
recorded reading of the text. The gain in scores was sta-
tistically significant here when the students had the advan-
tage of being able to repeatedly practice reading the text
with the aid of the tapes.

2. The second contrast was between the traditional method, W, and Y which presented the same text with the aid of a musical version on cassette tapes. Both methods using oral presentations to help teach the written text produced significantly higher test scores than when the text was merely read aloud from a book during the lessons.

3. The third contrast compared the average of the two methods using songs (Y and Z) to the other method (X) in which the cassette tapes contained no songs but just a reading of the text. The purpose of this contrast was to help compare the effectiveness of songs compared to merely reading the text. The song method Y did produce higher scores, but they were not statistically significant at the .05 level of significance.

4. The fourth contrast was designed to assess the significance of the written text when the text was presented in song. Method Y used both books and song, while method Z used only songs and no books at all. Although the scores were lower in the purely oral method the contrast did not prove to be statistically significant at the 0.05 level of significance.

5. The last contrast was the comparison of Y, which used a combination of written texts and songs, against the average of the first two non-song versions W and X, or $Y - \frac{W + X}{2}$). There was a difference of 2.38 in favor of the singing method, Y, which is significant at the level of .05. But due to the great difference between W and X, it does not seem wise to use this contract in assessing the value of the songs in comparison to the other orally assisted method, W.

These relationships are more clearly shown by a graph of the test results in Figure 26. Using the principles for interpreting the analysis of variants as indicated by Minium it is legitimate to draw inferences both from the specifically chosen contrasts and from the graphic display of the data as shown in Figure 26 (Minium 1970:369-376). Of course the statistical analysis must be compared with the reactions and comments of the participants before making final conclusions.

Figure 26 shows the performance of the schooled group and the unschooled group under each of the four conditions of treatment. The points on the graph from which the lines are drawn indicate the mean score for each group under the conditions of the four different treatments. The range of scores

FIGURE 26

MEAN INCREASE IN SCORES

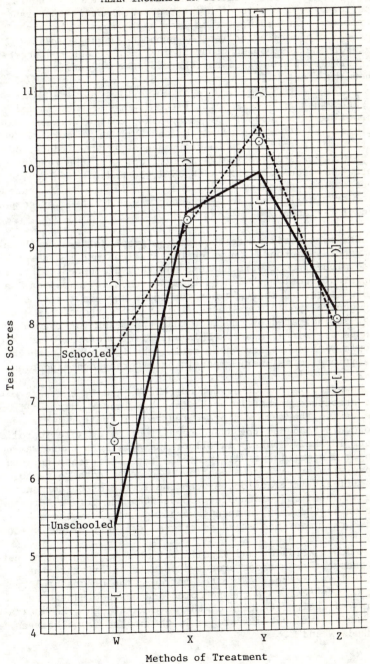

Test Scores

Schooled

Unschooled

Methods of Treatment

achieved by the majority of the testees in each group is indicated by two sets of brackets, representing the standard error (or standard deviation) for each group. The symbol for the standard error for the schooled group scores is ◯ and for the unschooled group it is ⊐. The combined scores of both groups averaged together for each treatment is shown by a dot with a circle around it.

The graph indicates some effect due to lack of formal schooling in method W, for those using only a written text. But for the other methods X, Y, and Z there is comparatively little difference in the performance of the two education levels. It is most likely the similarity of the results of both education levels in methods X, Y, and Z which caused the test for the adequacy of the one way analysis to indicate a lack of significance between a one way and a two way comparison of variance.

The most striking feature of the graph relates to the performance in method W in which the Biblical materials were read aloud from a written text and then discussed. This is the traditional method used by most teachers, missionaries and pastors. Using this method, those who had formal schooling generally did much better than those without this schooling, as indicated by the fact that the means for the two groups are so far apart. This superiority of performance of people with schooling would seem to be in harmony with the traditional missionary emphasis on literacy and education.

However, in the other methods, X, Y, and Z, the text was not presented primarily by having the class read aloud from the text. The text was presented to all orally, and those who could read had the added benefit of being able to follow along in their books. In all of these methods there was no longer a significant difference in the performance between those with or without schooling. There appears to be no significant interaction between the levels of performance of the schooled and unschooled groups when the primary presentation of the text is through oral means. In methods X, Y, and Z the means and standard errors were very close together.

Another striking and significant observation is that none of these other methods produced results inferior to the traditional method. With the introduction of the oral reading of the text both the schooled and unschooled groups improved their retention of the material taught, as indicated by the significant difference in the pooled means between methods W and X.

I had anticipated a rise in the scores for the non-reading group when they used a tape recorder due to the fact that they would now be able to review the information as they pleased. This gave them an advantage which only readers usually have.

I had not expected a similar rise in the scores of the schooled group. But this rise in the scores of the schooled group, while working in Yoruba does seem to fit my view of the difficulty of reading Yoruba.

In the same way in which the non-schooled group had problems with reading Yoruba, some of those with advanced education also experience difficulty in reading Yoruba due to the out-of-consciousness quality of the use of tone. The tapes compensate for this weakness in the written presentation of Yoruba.

I believe these factors relate to the enjoyment of the combined use of a written text with an oral presentation, and are part of the reason for the rise in scores of both the schooled and unschooled groups when a cassette was introduced.

There is another factor at work here that complicates the interpretation of the data. This factor is that in the group with less than four years of schooling were some people who had some marginally useful literary skills. With a tape that starts and stops, and repeats itself exactly every time, these people had a chance to follow the tape and practice reading. Where the reader had enough skill to sound out some of the letters, the tape supplied the complete sound and correct tone, thus helping these marginal readers to learn to read these passages for themselves. This would indicate that songs could be of great value in the teaching of reading skills to new literates.

It is also possible that some of the people with marginal reading skills in the unschooled group distorted the test results. They could have caused the scores in the group W unschooled section to be higher than if it contained only those who could not read at all. This would have reduced the contrasts between the schooled and unschooled in the method used by group W where literacy was more important. Had the participants been grouped solely on the basis of literacy the contrast would have been greater between the two kinds of students, and the remaining contrast between groups would have been due to method of learning.

We must also notice that in methods X (book plus cassette)
and Y (book plus song) there were two teaching aids to pre-
sent the text to each class. While in methods W (book only)
and Z (songs only) there was only one teaching aid. Figure
27 illustrates the sections benefiting from both visual and
audio teaching methods.

FIGURE 27

CLASSES WITH TWO TEACHING AIDS

	W	X	Y	Z
Books used				
Cassette tapes		IIIIIIIIIIIIIIIII		
			IIIIIIIIIIIIIIIII	
Total number of methods	1	2	2	1

If each method of treatment were of equal value to these
students we would expect each one-method approach (W & Z) to
be equally effective and each two-method approach (X & Y) to
be twice as effective as methods W & Z. If this were true
Figure 26 would look like Figure 28.

FIGURE 28

EXPECTED GRAPH IF TEACHING METHODS EQUALLY EFFECTIVE

But the graph of the test results in Figure 26 shows a
distinct peak for treatment Y which uses books and songs.
Both the schooled and unschooled did their best with this
treatment. However, the unschooled group did far better
hearing the text sung than by hearing it read from a book.
This is the largest audience segment in Africa today and it
continues to grow in number.

Appendix D

Pre-test Interview Schedule

A. GENERAL INFORMATION

1. Name_____ Male_____ Female_____
2. Teacher_____ Class_____ Method_____
3. Age 5-10_____ 10-19_____ 20-34_____
 35-50_____ 50+_____
4. Did you go to school? Yes___a No___ How many years?__
5. If they have children ask:
 How many children do you have?___
6. Did any of them go to school? Yes___a No___b
 Are they too young? ___c Too old___d
 Did any of them go to primary school Yes___a No___b
 Did any of them go to secondary school?Yes___c No___d
 Did any of them go on to higher education?Yes___eNo__f
7. What is your religion? Christian___a Muslim___b Other___c
8. Do you go to church
 every day? _____a
 every week? _____b
 sometimes? _____c
 hardly ever? _____d
9. How many years have you been going to church?
 less than one year _____a
 1 to 2 years _____b
 3 to 5 years _____c
 more than 6 years _____d
10. How many people in your house are Christians?
 all of them _____a
 many _____b
 some of them _____c
 none but you _____d

11. Do you read in Yoruba? ___a English ___b Both ___c
12. Do you read your Bible outside of church in your home
 more than three times a week ___a
 about three times a week ___b
 less than three times a week ___c
 not at all ___d
13. When you read your Bible, do you read it in
 Yoruba ___a
 Engligh ___b
 Both ___c
14. Can you read this book to me?
 He reads well ___a
 He reads with some trouble ___b
 He reads with great difficulty ___c
 He does not read, or makes an excuse ___d
15. Have you ever studied the book of Hebrews before?
 Yes___a No___b
16. Do you ever try to memorize verses from the Bible?
 Every week ___a When I was younger ___d
 Every month ___b Not at all ___e
 Sometimes ___c

B. KNOWLEDGE OF HEBREWS

1. Who is the greatest High priest in the Bible?
 Jesus___a Aaron___b Other wrong Answer___c
2. The Book of Hebrews teaches us how to avoid falling away
 from God. What are some of the things we should do
 so as not to fall away?
 Study the Bible ___a Encourage each other___d
 Pray ___b Learn enough to teach others___e
 Warn each other ___c Other good ans.___f None___g
3. The Book of Hebrews tells some of the powers of Jesus.
 What are some of these powers?
 He sustains the universe ___a
 Creator ___b
 Revealor of God's glory ___c
4. What should a Christian do if he finds he has fallen into
 serious sin?
 Repent ___a
 Come to Jesus for forgiveness ___b
 Other good answers ___c
 No good answers ___d
5. Where is Jesus now?
 In heaven ___a
 In the hearts of believers ___b
 Other good answers ___c
 No good answers ___d

6. What is Jesus doing now?
 Resting _____a
 Interceding for us before God _____b
 Acting as our High Priest before God _____c
 No good answers _____d
7. Do we think it is possible for a true Christian to fall
 away from God and go to Hell?
 No _____a Yes _____b
8. Tell me some of the things God said about Jesus in the
 book of Hebrews?
 Number of correct answers_____a No good answers_____b
9. What are some of the ways Jesus is superior to the
 messenger spirits?
 Number of correct answers_____a No good answers_____b
10. Can you say any verses from the Book of Hebrews?
 Number of verses _____a
 Number of chapters quoted_____b
 None _____c

Appendix E

Post-test Interview Schedule

A. PART I

1. What is Jesus doing now according to the Book of Hebrews?
 Making intercession for us ___ a
 Acting as our High Priest for our sin ___ b
 Waiting to come back to earth as King ___ c
 Other good answers ___ d
 No good answers ___ e
 Write the total number of correct answers _____

2. God said many things about Jesus that are in the Book of
 Hebrews. How many of them can you remember?
 You are my sons this day have I begotten you ___ a
 Let all the angels of God worship Him ___ b
 I will be a father...and He a son... ___ c
 Thy throne oh God is forever ___ d
 You loved right and hated evil ___ e
 You Lord did found the earth ___ f
 You are the same ___ g
 Sit at my right hand ___ h
 You will never change ___ i
 Your throne will never end ___ j
 Write the total number of correct answers _____

3. The Book of Hebrews gives many of the powers of Jesus.
 How many of these can you remember?
 He created the world and the stars ___ a
 He holds all things together ___ b
 He shows us who God is ___ c

He washed our sins away ____d
He has power to sit at God's right hand ____e
He is in a place of highest honor ____f
There is no disunity in Him ____g
Write the total number of correct answers_____

4. Why did Jesus suffer?
 To pay the penalty of our sins ____a
 To make a sacrifice for our sins ____b
 To better understand us when we are in trouble ____c
 To learn obedience - to become a perfect savior ____d
 Other good answers from Hebrews ____e
 Other good answers from the Bible ____f
 Wrong answers ____g
 Write the total number of correct answers ____

5. What must we do to be good enough to come to Jesus?
 Believe on Him ____a
 Believe He loves us ____b
 Nothing ____c
 Other good answers ____d
 Good works ____e
 Other wrong answers ____f

6. How many verses from Hebrews can you say by yourself?
 If it is less than 10 verses write the number ____a
 If it is more than 10 verses estimate the number ____b
 How many whole chapters ____c
 How many sections of chapters (over 3 verses
 per section) ____d

7. How many verses can you say with a group of people
 ____ (1-10) or

8. How many sections of chapters (over 3 verses) can you
 say alone ____

9. How many sections of chapters (over 3 verses) can you
 say with a group?____

10. What can we do so as not to fall into sin?
 Study the Bible ____a
 Pray ____b
 Try to endure to the end ____c
 Teach others ____d
 Warn others ____e
 Other good answers ____f
 Total number of good answers ____

Directions: Give the attitude section here. Check the
correct number for each line.
In this section, read the options to them.
 For those who read the book ask: When you
 read our *book*, did you find it............
For those who only studied the lessons ask:
 When you listened to the tapes, did you find
 it..............

11. very valuable no answer very small no value
 valuable value
 _____5 _____4 _____3 _____2 _____1

12. very hard hard to no answer easy to very
 to under- under- under- easy to
 stand stand stand understand
 _____1 _____2 _____3 _____4 _____5

13. I read (or from duty no answer I read or with much
 listened) for listened w/ joy
 when I had present happiness
 to_____1 _____2 _____3 _____4 _____5

14. very in- interest- no answer boring very
 teresting ing boring
 _____5 _____4 _____3 _____2 _____1

15. Total number of points on the above 5 items _____

What did you think of the lessons the teacher taught?

16. very valu- valuable no answer very small no value
 able___5 _____4 _____3 _____2 _____1

17. very hard hard to no answer easy to very easy
 to under- under- under- to under-
 stand stand stand stand
 _____1 _____2 _____3 _____4 _____5

18. I read (or from duty no answer I read or with much
 listened) for listened w/ joy
 when I had present happiness
 to_____1 _____2 _____3 _____4 _____5

19. very in- interest- no answer boring very
 teresting ing boring
 _____5 _____4 _____3 _____2 _____1

20. Write the total points_____

B. PART II

1. Do we think it is possible for a true Christian to fall
 away from God and go to Hell?
 Yes____a No____b

2. How do we tell a true Christian from someone who is just
 pretending?
 By his works ____a
 We cannot tell at all ____b
 Other good answers ____c
 A wrong answer ____d

3. What should a Christian do if he finds he has fallen
 into serious sin?
 Repent and come to Jesus for forgiveness ____a
 Other good answers ____b
 A wrong answer or no answer ____c

4. Who is the greatest High Priest in the Bible?
 Jesus ____a Aaron ____b Other wrong answer ____c

5. What is the most important way God speaks to us today?
 Through Jesus ____a through the Bible ____b
 through dreams ____c and visions ____d through
 friends ____e other ways ____f no answer ____g

6. What is the second most important way God speaks to us
 today?
 Through Jesus ____a through friends ____d
 through the Bible ____b other ways ____e
 through dreams and visions ____c no answer ____f

7. What are the other ways to God beside the blood of Jesus?
 There is no other way ____a There is no other
 sacrifice for sins which is good enough ____b
 Islam or Mohammed ____c
 He does not know or gives a wrong answer ____d

8. How did Jesus make a sacrifice for our sins?
 He sacrificed himself for us ____a
 He died on the cross for us ____b
 Any other good answer ____c
 A wrong answer ____d

9. Do you have to be good to come to Jesus?
 Yes ____a No____b

10. What could you tell a person if he wanted to know how
 to be saved from Hell?
 He can explain the way of salvation very well ____ a
 He can explain most of the main points ____ b
 He can explain only part of the main points ____ c
 He made some serious errors ____ d
 He can't explain the way of salvation at all ____ e

11. Do you think you are a Christian who is going to heaven?
 He is very sure he is a Christian ____ a
 He thinks he is a Christian, but has some doubt ____ b
 He is not sure or does not know ____ c
 He knows he is not a Christian ____ d

12. If he answers c or d, ask if he would like to be sure
 of being a Christian and help him. Pray with him.
 He prayed to receive Christ ____ a
 He prayed to thank God for Christ's atonement ____ b

13. Did you decide to accept Christ as a result of these
 lessons?
 Yes ____ a No ____ b

14. Did you become sure of your salvation during these
 lessons?
 Yes ____ a No ____ b

15. Did you read much between lessons?
 1/2 hour or more between lessons ____ a
 1/4 hour or more between lessons ____ b
 sometimes ____ c
 hardly ever ____ d
 none ____ e

(For groups B to D)

16. Did you listen to the tapes much between lessons?
 1/2 hour or more between lessons ____ a
 1/4 hour or more between lessons ____ b
 sometimes ____ c
 hardly ever ____ d
 none ____ e

17. We had eight lessons. How many did you attend?
 8 ____ a 5 ____ d
 7 ____ b 4 ____ e
 6 ____ c less ____ f

18. What part of the lessons did you enjoy the most?
 The tape reading ____a the taped songs ____b
 singing the songs ____c the teaching method ____d
 the teacher ____e the gifts ____f
 something else ____g

19. Were there any parts of the lessons you did not like as much?
 The reading ____a The test ____c
 The memorization ____b Other. Please write a note____d

20. Do you have any suggestions about how we should change the lessons?

21. Did you buy a copy of the textbooks?

22. Did you order others for friends?

23. Would you like to buy a cassette player and tapes?

24. If we sold them for ₦20.00 would you buy one for yourself or the class?

Appendix F

The Lesson Outline

LESSON I HEBREWS 1:

 1-3, 7-14 Jesus is superior to other messenger spirits.

LESSON II HEBREWS 2:

 1-4 There is a danger of drifting away from Jesus.

 9,10,17 & 18 Jesus is our High Priest who sacrificed himself for us.

 14-18 He can save us from the fear of death and give us eternal life.

LESSON III HEBREWS 3:

 1, 7-15 There is a danger of disbelieving Jesus, and disobeying Him. The Jewish people sinned; many were killed, and they will never enter God's rest (4:1).

 14 & 15 We will be saved if we are faithful and obey.

 15 If you have sinned, today is the day to repent and find forgiveness.

LESSON IV HEBREWS 4:

9:15 Heavenly rest is waiting for those who believe and
 follow Jesus.

13 God knows everything we do.

14 He is our High Priest who understands us and wants to
 help.

15 Jesus was tempted to sin, but did not.

LESSON V HEBREWS 5:

1-3 Jesus is the High Priest to sacrifice to help you if
 you make a mistake or sin.

7-9 Jesus had to suffer for us to be able to forgive our
 sins.

12-14 People who believe in Jesus need to learn how to
 follow Him so they don't remain weak like babies.

LESSON VI HEBREWS 6:

1-3 Some people remain weak like babies, so they can not
 keep from sin. List the basic doctrines.

4-8 The weak ones who keep falling into sin and do not
 have the fruit of good works are in danger of being
 burned up.

9 What are the good works you have done for Jesus?
 (They can not save you, but it shows you believe and
 love Him).

LESSON VII HEBREWS 10:

21-23 If we come to Jesus He can forgive us for all our
 sins and save us.
 We will surely go to heaven.
 We will tell other people about Jesus, and help
 them.
 We will go to church and warn people who live in
 sin.

LESSON VII HEBREWS 10 (Continued)

24-31 If anyone thinks he is a Christian, but lives in
 great sin and sacrifices to other gods or uses
 other spirits he is on the way to Hell.
 If you have sinned, today is the time to repent
 and come to Jesus.

LESSON VIII CULMINATING EXPERIENCES

 Post-testing, recitation of memory verses, sale of
 texts.

Appendix G

Comments
of the Participants

From the very start of the translation project we had worked
quite closely with the local church and had been rewarded
with a very positive relationship to the community. The
elders' interest in the work was made clear to us by the
fact that for nearly a year they had been asking to see the
finished translation of Hebrews. As we planned the experi-
ment we had some fear of not having enough homes in which
to conduct such a concentrated set of lessons with examina-
tions before and after the lessons. But as it worked out
the elders were so anxious to take part that we could not
supply enough teachers and lessons to please the elders who
wanted to sponsor lessons in their homes. So it was not a
surprise to us that the majority of the comments were very
favorable. Yet there were enough negative comments from
the people and the teachers to indicate that the people were
speaking their opinions honestly.

In summarizing the comments of the people and the teach-
ers, we will present first the comments on each of the four
methods, coming from the people and then the opinions of the
teachers. It is unavoidable that many of the comments in
method W which focused on the use of the written paraphrase
and reading aloud, should also focus very much on the read-
ability and understandability of the paraphrase itself.
Since it is undesirable to present all the comments gathered,
those given here have been selected as representative of the
type of comments received.

COMMENTS ON METHOD W

The reactions from classes using method W were generally very positive, in spite of the fact that these classes did not have the use of any cassette machines. The novelty of the new, more readable text, even with traditional teaching methods seems to have attracted considerable attention.

One of the householders said,

Pastor, we really appreciate the lesson from the Book of Hebrews. It has improved our spiritual growth. We don't want this program to stop, but since you are coming from a far place, we can't say anything.

The teacher of the class commented that only the young people going to school could read the text, but that the older people still showed interest enough to attend class regularly and to pay attention. The older people with little or no reading ability took part with a distinct disadvantage in comparison, but they were still willing to take part in the same class and to be tested at the conclusion. However, in a classroom-like situation the social stigma of not reading well seemed to inhibit them. Most non-readers were comparatively reserved and allowed the young people to lead and be more active in the discussions.

Young and old alike were pleased with the written text. A fifth grade girl found she could understand this Bible passage on her own and asked, "Will you please translate our Yoruba Bible into simple form like this?"

In another class, at the end of the lessons, an elder of the church brought three of the battered mimeographed copies saying, "The Book of Hebrews has been simplified to the level of us common people."

Two teachers reported that their entire classes in method W showed great interest, but since many of them could not read, they did not study or get much help between lessons. As a result they did not do as well as those who could study between lessons.

There were a few complaints about typing errors in the text which had not been caught by the Yoruba translation committee, but some of these could have been due to differences of opinion over the old and the new orthography. The committee is looking into each of the alleged errors.

There were also some questions about the reasons we had for changing the words of the Bible. In this regard our use of the title, "The Meaning of the Book of Hebrews," was very helpful since it clearly shows our intent to express the meaning of the text in good Yoruba. The class accepted the teachers' explanation. In the same method W class that raised this question, a spokesman for the class told the teacher at the end of the lessons that in comparison to other Bible study lessons, these lessons "...drew us nearer to God."

Memory work was stressed in all the classes, but there was not much time between lessons. In method W only a few verses were learned. In the first teacher's class two secondary school students tried to memorize the first chapter, but only managed six verses each. There were two exceptionally fine examples of memorization reported in method W, but the teacher did not think they were typical of the group. Both students were good readers. The teacher reported,

> Kolawole and Komolafe memorized chapter two from the book and recited it individually. They were somehow unique. If it were possible to have the same people in method Y the result sill be better... As an observer and teacher I could sincerely recommend method Y for our people.

The memorization of a complete chapter is not without precedent in Yoruba churches. I had previously heard Yoruba men recite whole chapters of the Bible in church. But it is considered an exceptional feat when someone goes to such an effort. The memorization of a complete chapter of our paraphrase by two young people working together indicates a high degree of acceptance, interest and motivation. However, using these methods, only a small minority of the general population could possibly duplicate the feat, since most people could not work from a written source.

In conclusion about method W, it would seem that readers and non-readers alike could remember some information using this method. But the older people and those who did not read well were disadvantaged. It meant the lessons could only attract adult non-readers who were strongly enough motivated to endure a certain amount of loss of face for the younger people could out-perform them in the reading skills which are vital to a lesson based on written literature. Instead of being looked up to as natural leaders, the older

people using this method were usually reduced to the status
of interested spectators. For this reason the classes did
not tend to be attractive to some adult non-reading church
people or to non-Christian adults who never attended any of
the classes.

COMMENTS ON METHOD X

The second method, X, used a written copy of the text,
plus a reading of the text on a cassette. Typical comments
from the five classes taught with these materials have been
selected from the reports of the teachers.

Both of these comments come from one class which included
a pastor and a Muslim. A tailor of about thirty years of
age had some very interesting things to say:

> The reading cassette helps me greatly because I cannot
> read fast, and as I follow the reading cassette my
> reading speed is improved. Also the book (the para-
> phrase) is much easier to read and understand than the
> Bible.

A Muslim neighbor of one of the church people came to the
classes because he wanted to practice his reading. A pastor
who attended this class said,

> It will be good if the committee that is doing this
> work can try to translate other books of the Bible
> into such a good clear form.

But they complained that they did not want to buy many copies
of a mimeographed book which had only a paper cover which
ripped easily.

The second teacher was pleasantly surprised to find that
with the reading cassette he had a group of about twenty
adults who were very faithful in attending and practicing
with the cassettes between lessons. This gathering included
a Muslim man who was attracted to the lessons because of the
pattern of reading a passage over and over with the help of
the cassette player. He was impressed with how beautifully
the person recorded on the cassette had read from the book.

> I was a poor reader thinking that I was one of the
> best readers. But when I heard the reading of the
> tape I knew that I was a poor reader who needs to
> improve.

During the lessons, he practiced his reading from the Bible portions and prayed every day.

Another man in the same class said,

If this were the method that the white men used when they first came to Nigeria, people of Nigeria would easily and clearly understand each lesson taught them.

His wife added,

If this method was used to teach people in schools, Sunday schools and churches, there would be no illiterates in villages and towns.

This particular class thanked the teacher for the lessons. They asked that similar but longer series of lessons be taught each year.

The reports of the next teacher were very similar. His class told him that during the time between lessons many Muslims would want to listen to the tapes. A church elder complained about the quality of the oral reading of the third cassette, but went on to say,

There is nothing like this that...attract(s) the Muslims. They have great interest in this program... If this program continues, even in Muslim dominated areas, many of them will turn to the Lord.

The people were enthusiastic, and requested a continuation of the lessons. But none of them in this section succeeded in memorizing any substantial section of any of the chapters of the text.

In the class of the fifth teacher, an elder spoke about the tape player as if it were a radio, saying, "we tuned the radio (tape player) repeatedly till we were able to become better readers."

Other people in the class were very happy for the chance to practice reading in this fashion.

This kind of practice also helped non-readers who sat through the repetition. This teacher noted that in method W, which used reading aloud from a book, it was the readers who dominated the discussions. Non-readers were quite passive. But with the cassette repeating the messages for them upon

their demand, the non-readers felt entitled or competent to take part in the class discussions. They felt included and capable. This factor of participation on a level of equality was also verified by the test results of method X which showed non-schooled people doing as well or better than the schooled group. It would appear that in a community with large numbers of non-readers, the use of messages not primarily derived from books has an equalizing effect--an effect which allows the schooled and non-schooled to interact together on more nearly equal terms.

All of the class reports on method X, with the taped readings from Hebrews included complaints on a few mistakes in tone by the reader of the last cassette, demands for continued lessons, comments on improved reading of the class members, and the definite interest by Muslims in the Word of God through this program. The interest seemed to be both in hearing the Word of God which they could not, or would not read for themselves, and in practicing reading by repetition.

COMMENTS ON METHOD Y

The most exciting classes were those that used method Y. This is the one that used Yoruba songs plus the written text. The class participants had no way of comparing method Y to the other methods, but all of the teachers (who could make such comparisons) agreed that these were the liveliest classes. Older non-readers simply enjoyed the songs and tried to learn to sing them. Others listened as a way of improving their reading. The young people frequently showed a strong desire to learn the songs, using the books, the tapes, their own guitars and drums. It was not necessary for the participants to be fully literate to take part in these singing sessions. There was a general enjoyment of Scripture set to Yoruba music. This shows up in the comments of students and teachers alike. It is possible that the very use of songs inspires a higher level of learning, because so many of the people wanted not only to hear the songs, but to be able to sing them from memory for themselves.

One teacher said,

During the time I was not with them they listened to the songs enthusiastically. They liked to sing the songs. One boy aged ten can sing the whole of Hebrews chapter one, while others could sing some of the verses. This group knows the lessons better because they have the songs. They learned the memory verses better too because of the songs...

From another class a tailor who graduated from primary school spoke about the song tapes. He knew Mr. Kolawole, the man who had put chapter two to music.

> I and my children enjoyed the songs that were sung by Mr. Kolawole and the songs of chapter five and six. The pupils (youth in school) could easily catch the songs they can sing with their books, but it was hard for them to sing from memory.

The people apparently enjoyed the songs, but were not very successful at reproducing large parts of them from memory. It would seem to me that if fewer chapters were attempted, and the practice sessions were to continue longer than two weeks, that the difficulty these young people experienced singing from memory could be reduced.

A middle-aged man from the same class said,

> You know African people like songs very much. Our people here liked the song cassettes very, very much. It helped them to read the book as the songs were going on.

The teacher's report on this class states that Muslims came both to the lessons and to the home to listen to the tapes between lessons. They particularly enjoyed chapters two, five and six. As a result of the lessons in this home, the people around have started a prayer group in which they have continued to study the book of Hebrews. Though the book is clear, the people enjoyed the songs the most. The man felt that if the entire Book of Hebrews could be circulated in song, it would help with the problem of reading the words with the correct tones.

In one of the other classes a mother told us,

> This book, Hebrews, which you translated into simple Yoruba words has helped our children to read Yoruba well. There are some words in the Book of Hebrews I didn't understand. But your translation made everything clear. I had no more problems...studying this modern Yoruba...

In this quotation we can see that the woman seems to have combined the problems of reading and comprehension of difficult terms, indicating that the simplified version seemed to help with both issues. She is also very interested to see

that her children learned to read Yoruba, and feels the
songs and books together helped to improve their reading.

The teacher commented that he felt the songs also helped
those who could not read, by improving their comprehension
of the message. He said, "The songs helped many of them to
understand quickly, especially those who could neither read
nor write. Perhaps it is the factor of repetition, expected
in songs, which is done so easily with a cassette. The
other methods which seem to focus on the words themselves,
may not lend themselves to as much natural repetition as
songs because they focus so much on the verbal message and
lack the additional qualitied of art and rhythm which mark
them as indigenous culture products. Perhaps these addi-
tional elements do not detract from the meaning of the words,
but actually cause them to be repeated over and over till
the meanings begin to get through to the participants.

In another class one of the elders said,

I understand the lessons better because of the songs
...They aroused the interest of the people and pre-
pared them to have more interest in singing than before.

The wife of this elder wanted to sing all of the songs. She
said,

I am certain that this was the best method for teach-
ing the word of God. I really appreciate it. I know
that I am not yet too old to sing for the glory of
God.

In the same way another man said, that he too wanted to use
his voice for the Lord. The teacher reported,

This group is the best group so far, because I could
see up to two persons who could sing two chapters
each. Some others could sing a chapter, and some
others could sing a few verses...

The elder said for the people,

The songs prepared us and challenged us more than
ever to praise the Lord with our voices...These
lessons and songs are nothing but a challenge to
our souls to wake us from sleeping.

The report concludes,

Therefore, I suggest that you continue to put the
other books into songs. People will really enjoy
them, and it will bring many souls to Christ...Our
people will be very glad to have...songs of the
other books of the Bible.

Other teachers reported consistent comments telling how
the songs helped non-readers to listen to the message and to
remember it. But perhaps the best retention was by people
who could read the book as they listened to the songs. A
mature mother of several children, a qualified school
teacher said,

It will best help if the whole Book of Hebrews could
be studied and put into songs such as this. For the
little time I have had with the tape has helped me to
master three songs, chapters one, two and three.

Another woman of about the same age and schooling
listened to the tapes and followed along in her book.

As I glanced along with the songs, the facts of the
text became real to me. With good song composers,
Christians can accomplish much through singing the
Word to the people.

Several secondary school students took part in the program
with another teacher and found the idea of singing and
learning the songs to be quite attractive. A girl said,

Many times we wished to go out (visiting in the town),
but the tape has stimulated us to stay till our
friends come to us to enjoy it with us.

One of her friends said,

We practiced our guitar with the tape daily. This
helps us so much that we could easily sing the
songs without any difficulty.

A secondary school graduate from the same group expressed
his pleasure with the songs this way:

I loved the book dearly and credit the composers.
It has helped me in my spiritual life in general.
It has stimulated us to become singers and masters
of the six chapters of Hebrews (used in the lessons)
...For we daily practice on the guitar along with

the tape. This draws many friends, both Christian and non-Christians. This holiday was best enjoyed as a result of this program.

Another secondary school student made her comments in English.

I best enjoyed chapters one and two of the songs. For they brought a great challenge to my heart. I had a clear understanding of the Scriptures and my position in Christ. Many families drew near (to us) as we play the tapes and (use) the books. For we used the book as a hymnbook. We shall like to continue (and have this program) introduced to the secondary schools. For many would be kindly interested.

Another indication of the attractiveness of this program was that one of the young people attracted to this class claims to have found Christ as Savior as a result of the program.

The teacher of these young people felt that the superiority of the combination of books and songs was indicated by the fact that a few days after the materials were collected from them, these young people performed chapter one from memory with their guitar in church. While individuals had memorized sections of the text using other methods, none of these other methods produced as much memorization or any group performances from memory.

There was a general agreement among the teachers that the combination of songs and the easy-to-read , written text helped many people. They improved their reading ability, their comprehension and their retention of the material.

The people found that they could use these materials in their homes and understand them without special help. We would hope that this would have an impact on the spiritual and devotional lives of the people concerned. The reports do indicate that many people experienced something of a personal revival and renewed interest in Bible study. Many people spoke about renewed interest in devotions. This church elder's statement is representative.

I and my wife had been holding our family prayers without calling our children. But since the introduction of the Living Bibles research in teaching methods, we have started gathering together our children to hold our family prayer meeting every day.

Others told of renewing a devotional life that had been com-
pletely abandoned. From another group sprang a regular Bible
study in one home and prayer centers in the homes of the
people who attended. Another elder said that the simple
book and the songs had made him "...more interested in songs
and reading the words of God than ever before."

While there were similar statements of renewed interest
in Bible reading and meditation from other methods, the
teachers were unanimous in their verdict. In their opinion,
the unique use of both songs and a written text as in method
Y was the most interesting and productive of the ways we pre-
sented the Scriptures among their people.

COMMENTS ON METHOD Z

The reports from method Z, which used only the recorded
songs, showed a very interesting and consistent pattern of
comment from the people and from the teachers. This was the
only method which did not use any written materials in the
class at all. The people were pleased with the lessons.
But among the church people, and particularly those with
more than primary school education, many expressed distress
and frustration about not having a book to follow the words
of the tape. This is probably related to the fact that we
held structured classes. A comparatively large number of
primary and secondary school students were attracted. They
expected books. When they found out that people in other
classes had books they expressed unhappiness about not hav-
ing a written copy of the text to compare with the tape.
"Why are we not given textbooks like other groups?" they
asked. As the elder of one group said, "They wanted to see
with their eyes what they heard in songs."

Two of the teachers had difficulty keeping the attention
of the young people who had been to school because they
wanted the books. Those who did not read did not feel this
tension. One teacher's report sums up the reaction to this
method:

They enjoyed the songs but were not satisfied with
only songs because there were some teachers and
secondary school graduates within the group. Samuel
O. asked, "Are we not going to have booklets as
others with whom we see books?" Really, they
enjoyed the way the lessons were taught, and the
cassette songs left with them throughout the course.
But the matter of not having the books was the thing

they could not understand despite all our attempts to explain the methods we used.

This same pattern of pleasure with the lessons taught through songs, but unhappiness over not being able to compare it with a written version shows in the comments of another teenager in secondary school. The boy first said, "It would be better to continue (the Lessons). Even some so-called Christians will be changed or awakened." He then went on to complain bitterly about not being given a book from which to study.

As would be expected, non-readers and marginal readers had much less frustration over the lack of a written text. The leader of one household was a farmer with no formal schooling, but was a church elder who had some reading ability. He complained that part of the tape was hard to hear. This was due to our problems in reproducing some of the tapes. This may have contributed to some of the agitation of the readers who wanted a written version to help them with the words they may have missed. The teacher helped them from his memory because he was not allowed to make any use of written materials in this method. These problems did not, however, prevent this household head from having a very positive attitude toward the lessons and their impact on his neighborhood. He said,

Pastor, this is a revival program to me. Before we were holding a prayer group here, but it has died off. Now you started this with us. Therefore, as from now, we will continue with our prayer group.

The report from this man's interview continues,

They really enjoyed the cassette...especially the song of chapter two sung by Mr. Aina...They tried to learn that song that Samuel Aina sang, and followed along as it played...The house holder said that even the Muslims came to listen whenever they are playing the player in the night.

Another household head was a farmer over 40 years of age. He was an elder of the church but had no formal schooling. He could read a little, and had three sons in secondary school who attended the classes with him. His comments about the lessons show no frustration about lack of a printed text.

> The unbelievers came closer (to God) as a result of
> this study of the singing tape. One Muslim said,
> "How could someone be able to use the Bible for song"
> Please call me whenever you play it..."

> It seems as if I myself had never read the book of
> Hebrews. For it strengthened my faith and presented
> the book in a new way. I wish it could continue.

The comments of the elder about the interest of outsiders
being attracted to the songs seems to be confirmed by the
fact that visitors were attracted to his house for some of
the lessons. One young woman not registered for the lessons
made a profession of faith in Christ during the lessons.

There were complaints from two of the classes using this
method mentioning difficulty with some of the tapes. This
was due to problems with some of the reproduction of our
cassettes. They were done individually on non-professional
equipment. When the singing tapes were the only means of
presenting the message, this must have been frustrating to
a people eager to know what the lessons were teaching. In
the face of this difficulty we must accept the willingness
of the people to complete the program as a sign of the
graciousness of the people and the high regard in which they
held the program.

The united opinion of the teachers, was that using
Scriptures set to music was an important step in their own
development. The combined use of a written text and an oral
performance in an indigenous style has made an impression
both on the people and on themselves as well. They agreed
that Yoruba people like songs very much. The songs are a
natural and indigenous memory aid. When the lessons were
over, people could be heard singing the songs in the streets.
Singing solos on the streets, in a taxi, or at the market
may be strange in some cultures, but among the Yoruba, sing-
ing at a moderate level of volume is quite normal. Singing
Scriptures is hardly new, nor new in Yoruba land.

Teaching people to sing extended Scripture portions is a
very ancient Hebrew tradition. The use of the technique
along with tape recorders and modern literacy materials in
a program geared to produce functional literacy is a new
approach. The popular reaction to the use of songs to pre-
sent extended Scripture portions seemed quite positive. One
of the teachers wrote,

Many thanks to God who has put this idea into the
mind of His people in order to approach the people
of all classes of work in a better form. For when
we lacked method, we thought people were not inter-
ested in the gospel. But when they were reached in
a better way, they responded enthusiastically.
Really, this is a new discovery.

The teacher wrote this partly because he had received many
comments from the people thanking him for the translation and
the songs. Many people from sections which used songs
requested not only that the rest of the Bible be translated
in a simple paraphrase, but it also be set to music. They
were quite aware that the use of Yoruba music made Bible
study and development of reading habits much more attractive
activities. They also helped them to remember what they had
studied. Another teacher, weary of the work of travelling
between the two towns, trying to keep his classes on schedule
and interviewing each participant could still celebrate his
experience.

Comparing the problems we met with the blessings we
received someone could not but thank God that He has
laid the burden on someone's heart to carry out such
a research like this among our people.

Various people complained about typographical errors in the
typing of the text, the intonation of the Yoruba reader, his
voice, mechanical problems with some tapes, the quality of
the paper in the book and the scheduling of the lessons.
But there was a consistent demand for further translation,
more songs and a continuation of the lessons. One enthusias-
tic participant expressed his concern in the form of a
question:

Shouldn't this course be performed in E.C.W.A.
churches throughout the country to let our brothers
enjoy and see what we have experienced?

This kind of reaction from the participants is a strong
indication that further work of this nature is needed and
will be warmly received by the people whether they are
interested in improving their reading or studying orally.

Bibliography

ABRAHAM, Roy C.
 1958 *Dictionary of Modern Yoruba*. London, University
 of London Press.

ADEDEJI, Joel
 1972 "Obatola," in Dorson 1972:321-340.

ADEGBOLA, E.A.A.
 1969 "The Theological Basis of Ethics," in Dickson
 and Ellingsworth 1969:116-136.

AFIFI, A. A. and AZEN, S. P.
 1972 *Statistical Analysis: A Computer Oriented
 Approach*. New York Academic Press.

AJAYI, J. F. Ade
 1965 *Christian Missions in Nigeria 1841-1891: The
 Making of a New Elite*. Evanston, Northwestern
 University Press.

ALBRIGHT, W. F.
 1956 "Recent Discoveries in Palestine on the Gospel
 of St. John," in Davies 1956:153-171.

ALL NATIONS LITERACY MOVEMENT
 1968 "World Illiteracy Rate." Santa Ana, California.

ALLEN, W. C.
 1912 *The Gospel According to Mark*. New York,
 MacMillan Press.

AWO, Omo
 1974a "Arts Festival: How Good is Our Best?" *Nigerian
 Herald*. Nov. 1974:6.

 1974b "Mere Stage Show Isn't the Ideal Method."
 Nigeria Herald, Dec. 13, 1974:8.

AYANDELE, E. A.
 1966 *The Missionary Impact on Modern Nigeria*. London,
 Longman Group.

BABALOLA, S. A.
 1966 *Content and Form of Yoruba Ijala*. London,
 Oxford Press.

BARCLAY, William
 1966 *First Three Gospels*. London, SCM Press.

BARKER, G. and LANE, W. and MICHAELS
 1969 *The New Testament Speaks*. New York, Harper and
 Row.

BARRETT, David
 1968 *Schism and Renewal in Africa*. London, Oxford.

BASCOM, William
 1969 *Ifa Divination, Communication Between Gods and
 Men in West Africa*. Bloomington, Indiana,
 University Press.

BAUMAN, Richard
 1975 "Verbal Art As Performance." *American Anthro-
 pologist* 77:290-295.

BEAR, Francis W.
 1962 "Earliest Records of Christianity." New York,
 Abingdon Press.

BEAVER, R. Pierce
 1966 "Christianity in Africa." Grand Rapids, Wm. B.
 Eerdmans.

 1967 *To Advance the Gospel: Selections from the
 Writings of Rufus Anderson*. Grand Rapids,
 Eerdmans.

BEDE, the Venerable
 1963 *Ecclesiastical History of the English Nation*
 (originally published 1895). London, Deut and
 Sons.

BEEKMAN, John and CALLOW, John
 1974 *Translating the Word of God*. Grand Rapids,
 Zondervan.

BEIER, Ulli (ed.)
 1966 *The Origins of Life and Death: African Creation*
 Myths. London, Heinemann.

 1970 *Yoruba Poetry: An Anthology*. Cambridge, The
 University Press.

BELSHAW, Harry
 1950 "'Africanization' and the Church," *World
 Dominion* XXCIII:288-291.

BERG, Paul (ed.)
 1960 *Fostering Reading Interests and Tastes*.
 Columbia, S.C., University of South Carolina
 Press.

BERKOUWER, Gerritt
 1955 *General Revelation*. Grand Rapids, Eerdmans.

BERNSTEIN, Basil
 1966 "Elaborated and Restricted Codes: Their Social
 Origins and Some Consequences," in Alfred G.
 Smith 1966:427-441.

 1972 "A Sociolinguistic Approach to Socialization
 with Reference to Educability," in Gumperz and
 Hymes 1972:465-497.

BERRY, Jack
 1961 *Spoken Art in West Africa*. London, Lutterworth.

BIBLE MIMO
 1966 (Originally published 1900). Lagos, The Bible
 Society.

BICKERMAN, Elias
 1949 and 1966 *From Ezra to the Last of the Maccabees*.
 Shocken Books: New York.

BIRDWHISTELL, Ray L.
 1970 *Kinesics and Context*. Philadelphia, University
 of Pennsylvania Press.

BLACK, Matthew
 1967 *An Aramaic Approach to the Gospels and Acts.*
 (Originally published 1954). London, Oxford.

BOOTH, Henry
 1933 *The World of Jesus.* New York, Charles S.
 Scribner's Sons.

BROOM, Wendell
 1970 *Growth of Churches of Christ Among Ibibios of
 Nigeria.* Unpublished M.A. Thesis, School of
 World Mission, Fuller Theological Seminary,
 Pasadena, California.

BURGER, Henry
 1971 *Enthno-pedagogy: A Manual in Cultural Sensitivity.*
 Albuquerque, South Western Cooperative Educa-
 tional Laboratory.

BURNEY, Charles Fox
 1925 *The Poetry of our Lord.* London, Oxford.

BURT, Cyril
 1946 *The Backward Child* (Originally published 1937)
 London, University of London Press.

CIPOLLA, Carlo M.
 1969 *Literacy and Development in the West.* New York,
 Penguin Books.

COLE, Michael and GAY, John
 1971 *The Cultural Context of Learning and Thinking:
 An Exploration in Experimental Anthropology.*
 New York, Basic Books.

COOPER, Herbert
 1926 *Indigenous Principles in Nigeria.* London,
 World Dominion Press.

COWAN, George M.
 1972 "Power in 21 Marks," *Interlit* (David C. Cook
 Foundation News) 9:2, pp. 1,2,12.

CRAWFORD, Dan
 1914 *Thinking Black.* London, Morgan and Scott.

CROWDER, Michael
 1966 *A Short History of Nigeria.* New York, Praeger
 Press.

CURLE, Adam
 1964 *World Campaign for Universal Literacy*. Cambridge, Mass., Harvard Occasional Papers.

DAHOOD, M. J.
 1967 "Hebrew Language," *New Catholic Encyclopedia 6*. New York, McGraw Hill.

DALMAN, Gustaf
 1929 *Jesus-Jeshua: Studies in the Gospels*. (Translated by Paul Levertoff). Londong, SPCK.

DAMACHI, Ukandi and SEIBEL, Hans D. (eds.)
 1973 *Social Changes and Economic Development in Nigeria*. New York, Praeger Press.

DAUB, D.
 1956 *The New Testament and Rabbinic Judaism*. London, University of London.

DAVIES, W. D.
 1956 *Background of the New Testament*. Cambridge, The University Press.

 1962 *Christian Origins and Judaism*. Philadelphia, Westminster.

 1967 *Invitation to the New Testament*. London, Darton, Longman and Todd.

DENG, Francis M.
 1973 *The Dinka and Their Songs*. London, Oxford.

DICKSON, Kwesi and ELLINGWORTH, Paul
 1969 *Biblical Revelation and African Belief*. London, Lutterworth.

DISCH, Robert
 1973 *The Future of Literacy*. Englewood Cliffs, N.J., Prentice Hall.

DODD, C. H.
 1968 *More New Testament Studies*. Grand Rapids, Eerdmans.

DOMSKY, Aaron
 1972 "Masorah," *Encyclopedia Judaica*, Vol. 16.

DORSON, Richard
 1961 *Folklore Research Around the World.* Bloomington, Indiana University.

 1972 *African Folklore: Papers of the African Folklord Conference.* New York, Doubleday Anchor.

✓ DOUGLAS, Mary
 1954 "The Lele of Kasai," in Forde (ed.) 1954:1-26.

DRIVER, G. R.
 1965 The Judaean Scrolls. London, Oxford.

EBNER, Eliezer
 1956 *Elementary Education in Tannaitic Period.* New York, Block.

EDWARDS, Harry
 1970 *Black Students.* New York, The Free Press.

EKECHI, F. K.
 1972 *Missionary Enterprise and Rivalry in Igboland.* London, Cass Library of African Studies.

ELLIS, A. B.
 1964 *The Yoruba-Speaking Peoples of the Slave Coast of West Africa.* Chicago, Beni.

ERICKSON, Edwin
 1972 *Towards Designing a Culturally Relevant Program for Training of Ethiopian Rural Church Leadership.* Unpublished M.A. Thesis, School of World Mission, Fuller Theological Seminary, Pasadena, California.

ERNST, Morris L. and POSNER, Judith (eds.)
 1968 *Comparative International Almanac.* New York, Macmillan.

FENTON, William
 1962 "Ethnohistory and Its Problems," *Ethnohistory* 9:1-23.

FILBECK, David
 1974 "Observations on the Prospects of a Translation into Northern Thai," *The Bible Translator,* 25:227-231.

FILSON, F.
 1964 *A New Testament History*. Philadelphia,
 Westminster.

FINNEGAN, Ruth
 1967 *Limba Stories and Story-telling*. London, Oxford.

 1970 *Oral Literature in Africa*. London, Oxford.

FITZGERALD, Thomas K. (ed.)
 1974 *Proceedings No. 8 of Southern Anthropoligical
 Society*. Athens, Georgia, University of Georgia.

FLOWER, Fred
 1972 "The Language of Failure," *English in Education*,
 Vol. 4, 3:7-20.

FORDE, Daryll (ed.)
 1954 *African Worlds*. London, Oxford.

FOSTER, George M.
 1972 *Traditional Societies and Technological Change*.
 New York, Harper and Row.

FRIEND, Andrew
 1972 *The Contribution of Mission Schools to Church
 Growth in Sub-Saharan Africa*. Unpublished M.A.
 thesis, School of World Mission, Fuller Theo-
 logical Seminary, Pasadena, California.

GEORGES, Robert (ed.)
 1968 *Studies on Mythology*. Homewood, Illinois,
 Dorsey.

GERHARDSSON, Birger
 1961 *Memory and Manuscript*. Upsala C.W.K. Copenhagen,
 Gleerup and Lund.

GILLETTE, Arthur
 1972 *Youth and Literacy*. Paris, UNESCO.

GILLIMORE, Ronald and HOWARD, Alan (eds.)
 1968 *Studies in Hawaiian Community*. Honolulu,
 Bernice P. Bishop Museum.

GILLIMORE, Ronald, BOGGS, Stephen and MACDONALD, W. S.
 1968 "Education," in Gillimore and Howard (eds.)
 1968:36-38.

GOODY, Jack (ed.)
 1968 *Literacy in Traditional Society.* London,
 Cambridge University Press.

GRAY, William S.
 1956 *The Teaching of Reading and Writing.* Paris,
 UNESCO.

GREEN, Robert W.
 1973 "Protestantism and Capitalism and Socialism."
 Lexington, Mass., Heath.

GRIMES, Barbara (ed.)
 1974 *Ethnologue.* Huntington Beach, California,
 Wycliffe Bible Translators.

GRIMLEY, John B. and ROBINSON, Gordon
 1966 *Church Growth in Southern Nigeria.* Grand
 Rapids, Eerdmans.

GUMPERZ, John and HYMES, Dell
 1972 *Directions in Sociolinguistics: The Ethnography
 of Communication.* New York, Holt, Rinehart and
 Winston.

GUTHRIE, Donald
 1965 *The Gospels and Acts, New Testament Introduction.*
 Chicago, Inter-Varsity.

GWYTHER JONES, Roy
 1972 "Authors from the Bush," *Interlit* (David C. Cook
 Foundation News), 9:3, pp. 14,15.

HALL, Edward T.
 1959 *The Silent Language.* Greenwich, Conn., Fawcett.

HARRIES, Lyndon
 1962 *Swahili Poetry.* London, Oxford.

HARRISON, R. K.
 1969 *Introduction to the Old Testament.* Grand
 Rapids, Eerdmans.

HAULE, Cosmas
 1969 *Bantu Witchcraft and Christian Morality.* Paris,
 Nouvelle Revue de Science Missionaire.

HAYES, Albert
 1969 *Recommendations of the Work Conference on
 Literacy*. Paris, Center for Applied Linguistics
 for International Development Fund.

 1964 *Recommendations of the Work Conference Held for
 the Agency for International Development of the
 United States Department of State, Airlie House,
 Warrenton, Virginia*. Washington, D.C., Center
 for Applied Linguistics.

HAYS, William
 1963 *Statistics for Psychology*. New York, Holt,
 Rinehart and Winston.

HENDERSON, Richard
 1972 *The King in Every Man: Evolutionary Trends and
 Culture in Onitsha Ibo Society*. New Haven, Yale.

HENSHAW, T.
 1952 *New Testament Literature*. London, George Allen.

HERKLOTS, Hugh G.
 1950 *A Fresh Approach to the New Testament*. New
 York, Abingdon-Cokesbury.

HERSKOVITS, M. J. and HERSKOVITS, F. S.
 1958 *Dahomean Narrative*. Evanston, Illinois, Rout-
 ledge and Paul Kegan.

 1961 "The Study of African Oral Art," in Dorson, R.
 (ed.) 1961:165-170.

HERZOG, Avigor
 1972 "Mascoretic Accents," Encyclopaedia Judaica,
 Vol. 11, New York, McGraw Hill.

HEYWOOD, Christopher
 1971 *Perspectives in African Literature*. New York,
 African Publishing.

HINDE, R. A. (ed.)
 1972 *Non-verbal Communication*. London, Cambridge.

HOCART, A. M.
 1973 *The Life-Giving Myth and Other Essays*. London,
 Methuen.

HOIJER, Harry (ed.)
 1954 *Language in Culture*. Chicago, University of
 Chicago.

HORTON, Robin
 1967 "African Traditional Thought and Western
 Science," *Africa* 36:50-71 and 37:155-187.

HOSTETTER, Charles
 1974 Interview in Lagos, Nigeria, Nov. 14, 1974.

HOWARD, Alan
 1973 "Education in Aina Pumehana," in Kimball and
 Burnett (eds.) 1973:115-131.

HOWAT, Lois
 1974 "The Talking Bible," Missiology 2:439-453.

HUNTER, James
 1961 "A Flame of Fire." Toronto, The Sudan Interior
 Mission.

IDOWU, E. Bolaji
 1963 *Olodumare: God in Yoruba Belief*. New York,
 Praeger.

 1965 *Towards An Indigenous Church*. London, Oxford.

 1973 *African Traditional Religion*. New York, Orbis
 Books.

IJIMERE, Obotunde
 1966 *The Imprisonment of Obalatala* (translated by
 Ulli Beier). London, Heinmann Educational Books.

IYARE, Air
 1972 "Our Cultural Heritage: Benin Deities." Lagos
 Daily Times, September 11, 1972:18.

JACOBS, Louis
 1964 *Principles of the Jewish Faith*. New York,
 Basic Books.

JEFFERIES, Sir Charles
 1967 *Literacy A World Problem*. New York, Praeger.

JEREMIAS, Joachin
 1964 *The Unknown Sayings of Jesus*. London, SPCK.

1969 *Jerusalem in the Time of Jesus* (trans. from
 German by F. H. & C. Cave). Philadelphia,
 Fortress Press.

1971 *New Testament Theology*. London, SCM.

KALU, Ogbu
1975 "The Peter Pan Syndrome," Missiology 3:15-30.

KIAMBALL, Solon T. and BURNETT, J. R. (eds.)
1973 Learning and Culture, Seattle, University of
 Washington.

KLAPPER, Joe T.
1960 *The Effects of Mass Communication*. New York,
 The Free Press.

KLASEN, Edity
1972 *The Syndrome of Specific Dyslexia*. Baltimore,
 University of Park Press.

KLEM, Herbert
1975 "Yoruba Theology and Christian Evangelism."
 Missiology 3:45-63.

KNELLER, George F.
1965 *Educational Anthropology*, New York, John Wilsey
 and Sons.

KOELLE, S. W.
1970 *African Native Literature* (originally published
 1854). Plainview, New York, Books for Libraries.

KRAFT, Charles
1973a "Dynamic Equivalence Churches," *Missiology*
 1:39-58.

1973b "God's Model for Cross-Cultural Communication--
 the Incarnation," *Evangelical Missions Quarterly*
 4:205-215.

1973c "The Incarnation, Cross-Cultural Communication
 and Communication Theory," *Evangelical Missions
 Quarterly* 5:277-284.

1973d *Christianity and Culture*. Unpublished manuscript,
 School of World Mission, Fuller Theological
 Seminary, Pasadena, California.

1974 "Ideological Factors in Intercultural Communication," *Missiology* 2:295-312.

1975 Lectures on Intercultural Communication. Unpublished presentations given at The School of World Mission, Fuller Theological Seminary, Pasadena, California.

LANE, William L.
1971a *Syllabus for New Testament 45: Dead Sea Scrolls and the New Testament.* Duplicated Class Notes, Wenham, Mass., Gordon Divinity School.

1971b *Judaism in the Greco Roman Period.* Duplicated Class Notes, Wenham, Mass., Gordon Divinity School.

LAUBACH, Frank C.
1960 *Toward World Literacy: Each One Teach One.* Syracuse, University Press.

LEAKEY, L.S.B.
1954 *Defeating Mau Mau.* London, Oxford.

LEAP, Edward
1974 "Etics, Emics and the New Ideology," in Fitzgerald 1974:51-62.

LEVI-STRAUSS, Claude
1966 The Savage Mind (translated by George Weidenfeld). Chicago, University of Chicago.

LEWIS, L. J. and WRONG, Margaret
1948 *Towards a Literate Africa.* London, Longmans.

LINDFORS, Bernth and OWOMOYELA, O.
1973 Yoruba Proverbs. Athens, Ohio, Ohio University Center for International Studies.

LITERACY HOUSE
1967 *Definitions and Concepts of Functional Literacy: Research Studies Number 2.* Lucknow, India.

LOMAX, Alan
1970 *Three Thousand Years of Black Poetry.* New York, Dodd Mead & Co.

LOMAS, Louis E.
1968 *To Kill a Black Man.* Los Angeles, Holloway.

LORD, Albert
 1960 *The Singer of Tales*. Cambridge, Mass., Harvard.

LOWRY, Dennis and MARR, Theodore
 1974 *A Two-Culture Validation Study of Clozentropy As
 a Measure of Inter-Cultural Communication
 Comprehension*. Paper presented at the Inter-
 national Communications Association, New Orleans.

LUCAS, Jonathan O.
 1948 *The Religion of the Yorubas*. Lagos, CMS
 Bookshop.

LUZBETAK, Louis
 1963 *The Church and Cultures*. Techny, Illinois,
 Divine World (reprinted by William Carey Library,
 South Pasadena, California).

MACHEN, J. Gresham
 1921 The Origins of St. Paul's Religion. New York,
 Macmillan.

MAHU, Rene
 1965 *World Congress of Ministers of Education on the
 Eradication of Illiteracy*. Paris, UNESCO.

MANSON, T. W.
 1949 *The Sayings of Jesus*. London, SCM.

MARIOGHAE, Michael and FERGUSON, John
 1965 *Nigeria Under the Cross*. London, Highway.

MARTIN, Ralph
 1964 *Worship in the Early Church*. London, Marshall,
 Morgan and Scott.

 1975a New Testament Foundations, Vol. 1, The Four
 Gospels. Grand Rapids, Eerdmans.

 1975b Class Notes in New Testament Introduction,
 2/3/75. Fuller Theological Seminary, Pasadena,
 California.

MBITI, John
 1969 *African Religions and Philosophy*. New York,
 Praeger.

 1970 *Concepts of God in Africa*. London, SPCK.

McGAVRAN, Donald A.
 1970 *Understanding Church Growth*, Grand Rapids,
 Eerdmans.

 1972 *Crucial Issues in Missions Tomorrow*. Chicago,
 Moody Press.

McLUHAN, Marshall
 1966 *Understanding Media: The Extensions of Man*.
 New York, McGraw-Hill.

MEHRABIAN, Albert
 1972 *Nonverbal Communication*. New York, Aldine,
 Atherton.

MENDELSOHN, Jack
 1962 *God Allah and Juju: Relition in Africa Today*.
 New York, Thomas Nelson and Sons.

MEYE, Robert P.
 1968 Jesus and the Twelve. Grand Rapids, Eerdmans.

MISSIONS ADVANCED RESEARCH COMMUNICATIONS CENTER
 1973 *Unreached Peoples: A Preliminary Compilation*.
 Monrovia, California, World Vision.

MOBLEY, Harris W.
 1970 *The Ghanaian Image of the Missionary*. London,
 E. J. Brill.

MONTEFIORE, Claude
 1930 *Robbinic Literature and Gospel Teachings*.
 London, Macmillan.

MONTGOMERY, James
 1973 *New Testament Fire in the Philippines: Church
 Growth in the Philippines*. Carol Stream, Ill.,
 Creation House.

MOORE, George Foot
 1946 *Judaism* (Vol. 1 and 2). London and Cambridge,
 Mass., Harvard University Press.

MOREL, Edmund
 1968 *Nigeria: Its Peoples and Its Problems*. London,
 Cass.

MORRIS, H. F.
 1964 *The Heroic Recitations of the Bahima of Ankole.*
 London, Oxford.

MULAGO, Vincent
 1969 "Vital Participation," in Dickson and Elling-
 worth 1969:137-158.

NASUTION, Amir
 1972 *From Traditional to Functional Literacy and
 Development.* Ibadan, Ibada University Press.

NDUKA, Otonti
 1964 *Western Education and the Nigerian Cultural
 Background.* London, Oxford.

NIDA, Eugene
 1954 *Customs and Cultures.* New York, Harper and Row.

 1964 *Toward a Science of Translation.* Leiden, E. J.
 Brill.

 1967 "Sociological Dimensions of Literacy and
 Literature," in Schacklock 1967:127-141.

 1972 *Message and Mission* (originally published 1960).
 South Pasadena, California, William Carey
 Library.

NIDA, Eugene and TABER, Charles
 1969 *Theory and Practice of Translation.* Leiden,
 E. J. Brill for The United Bible Societies.

NURSE, George T.
 1964 "Popular Songs and National Identity," *African
 Music* 3:101-106.

OBEDEL, Dick
 1975 "Soaring Prices, Farmers Blamed," *Lagos Daily
 Times*, February 3, 1975:26.

OGUNBOWALE, P. O.
 1970 *Essentials of Yoruba Language.* London,
 University of London Press.

OJO, G.J.A.
 1967 *Yoruba Culture: A Geographical Analysis.*
 London, University of London Press.

ORSO, Ethelyn
 1974 "Folklore and Identity," in Fitzgerald 1974:24-
 38.

OXFORD UNIVERSITY PRESS
 1962 *A Dictionary of the Yoruba Language* (originally
 published 1913). London and Ibadan, Oxford
 University Press.

PARSONS, Robert
 1963 *The Churches and Ghana Society* 1918-1955.
 Leiden, E. J. Brill.

PEEL, J.D.Y.
 1968 *Aladura: A Religious Movement Among the Yoruba*.
 London, Oxford.

PICKETT, J.W., WARNSHUIS, A.L., SINGH, G.H. and McGAVRAN, D.A.
 1973 Church Growth and Group Conversion (5th ed.;
 originally published 1936). South Pasadena,
 California, William Carey Library.

POLLOCK, J. C.
 1962 *Hudson Taylor and Maria*. New York, McGraw-Hill.

PRIDE, J. B.
 1971 *The Social Meaning of Language*. London, Oxford.

PREDICASTS ECONOMIC INDEX/SURVEY CUMULATIVE EDITION #54.
 1974 Cleveland, Ohio, Predicasts.

RAMM, Bernard
 1956 *Protestant Biblical Interpretation*. Grand
 Rapids, Baker House Books.

RATTRAY, R. S.
 1930 *Akan-Ashanti Folk-Tales*. London, Oxford.

REX, Frederick
 1967 "Illiteracy is a World Problem," in Shacklock
 1967:1-19.

ROPS, Heri Daniel
 1962 *Daily Life in the Time of Jesus*. New York,
 Hawthorn.

ROSOWSKY, Solomon
 1957 *The Cantillation of the Bible*. New York,
 Reconstructionist Press.

RUBADIRI, David
 1971 "The Development of Writing in East Africa," in
 Heywood 1971:148-156.

SAWYERR, Harry
 1968 *Creative Evangelism*. London, Longmans.

 1970 *God: Ancestor or Creator*. London, Longmans.

SCHATZMAN, Leonard and STRAUSS, Anselm
 1973 Field Research: Strategies for a Natural
 Sociology. Englewood, N. J., Prentice Hall.

SCHRAMM, Wilbur
 1964 *Mass Media and National Development*. Stanford,
 Stanford University.

SCHRAMM, Wilbur and ROBERTS, Donald F.
 1971 *The Process and Effects of Mass Communication*.
 Chicago, University of Illinois.

SHACKLOCK, Floyd (ed.)
 1967 *World Literacy Manual*. New York, Committee on
 World Literacy and Christian Literature.

SIDHOM, Swailem
 1969 "The Theological Estimate of Man," in Dickson
 and Ellingworth 1969:83-115.

SMITH, Alfred G.
 1966 *Communication and Culture*. New York, Holt,
 Rinehart and Winston.

SMITH, Donald K.
 1969 *Development and Testing of a Low Cost Periodical
 for Use in Developing Areas of the World*.
 Unpublished Ph.D. dissertation, Eugene, Oregon,
 University of Oregon.

 1971a "Your Hands are Deceiving Me," duplicated
 article, Eugene, Oregon, and Nairobi, Kenya,
 Daystar Communications.

 1971b "The People Must Change," *Practical Anthropology*
 18:49-54.

SMITH, Edgar, H.
 1972 *Nigerian Harvest*. Grand Rapids, Baker Bookhouse.

SMITH, Paul
 1975 *Communique* (Fall). Cedar Hill, Texas, Bible
 Translations on Tape.

SOGAARD, Vigo
 1975 *Everything You Need to Know for a Cassette
 Ministry.* Minneapolis Bethany Fellowship.

SOLADOYE, E. A.
 1974 "Cultural Revival - A Christian Viewpoint,"
 Unpublished paper presented at the Christian
 Youth Centre, Ilorin, Nigeria, August 18, 1974.

SPINDLER, George (ed.)
 1963 *Education and Culture: Anthropological
 Approaches.* New York, Holt, Rinehart and
 Winston.

SPRADLEY, J. P.
 1972 *Culture and Cognition: Rules, Maps, and Plans.*
 San Francisco, Chandler.

STEVICK, Earl and AREMU, Olaleye
 1963 *Yoruba Basic Course.* Washington, D.C., Foreign
 Service Institute.

STEWARD, Roy
 1961 *Rabbinic Theology.* London, Olver and Boyd.

SUKENIK, E. L.
 1934 *Ancient Synagogues in Palestine and Greece.*
 London, British Academy and Oxford University.

TALBOT, Percy A.
 1922 *Life in Southern Nigeria: The Magic, Beliefs
 and Customs of Ibibio.* London, Macmillan.
 (Reprinted 1967 London, Frank Cass).

 1927 *Some Nigerian Fertility Cults.* London, Oxford.
 (Reprinted 1967 London, Frank Cass).

TAWNEY, Richard H.
 1920 *The Acquisitive Society.* New York, Harcourt &
 Brace.

 1952 Religion and the Rise of Capitalism (originally
 published 1926). New York, Harcourt and Brace.

TEMPELS, Placide
 1959 *Bantu Philosophy*. Paris, Presence Africain.

THOMPSON, Stith
 1946 *The Folktale*. New York, Dryden Press.

 1955 Motif-Index of Folk-literature (revised edition).
 Helsinki, Suomalainen.

TIME
 1975 "Poor vs. Rich: A New Global Conflict," Time,
 December 22, 1975:34-42. *Read —*

TIPPETT, A. R.
 1967 *Solomon Islands Christianity*. London, Lutter-
 worth Press.

 1973a "Possessing the Philosophy of Animism for
 Christ," in McGavran 1967.

 1973b *Aspects of Pacific Ethnohistory*. South
 Pasadena, California, William Carey Library.

 1961 "Ethnic Cohension and Intra-Configurational
 Involvement in the Acceptance of Culture Change
 in Indonesia," in Acceptance and Rejection of
 Christianity, unpublished volume at School of
 World Mission, Fuller Theological Seminary,
 Pasadena, California.

TORREND, J.
 1921 *Specimens of Bantu Folk-lore from Northern
 Rhodesia*. London, Kegan Paul, Trench, Trubner.

TORREY, Charles
 1941 *Documents of the Primitive Church*. London,
 Harper Brothers.

TOYOTOME, Masumi
 1953 *Poetic Images and Forms in the Sayings of Jesus*.
 Unpublished Ph.D. dissertation, New York,
 Columbia University. *Read*

TREMEARNE, Arthur H. N.
 1913 Hause Superstitions and Customs (reprinted 1970,
 London, F. Cass). John Bale, Sons & Danielsson,
 Ltd., Oxford House, London.

TUCKER, Theodore L.
 1966 "Protestant Educational Enterprise in Africa"
 in Beaver 1966:47-60.

TURNBULL, Colin
 1962 *The Lonely African*. New York, Simon and
 Schuster.

TURNER, L. Harold
 1967 *History of an African Independent Church*.
 London, Oxford.

TURNER, Victor
 1969 *The Ritual Process, Structure and Anti-structure*.
 Chicago, Aldine.

TYNDALE HOUSE
 1975a *The L.B.I. Eye*. January to March. Wheaton,
 Tyndale House.

 1975b *The Church Around the World*. June, 1975, Vol.
 5, No. 7, Wheaton, Tyndale House.

TYSON, Joel
 1973 *A Study of Early Christianity*. New York,
 Macmillan.

UNESCO
 1957 *World Literacy at Mid-Century*. Paris, UNESCO.

 1958 *Basic Facts and Figures*. Paris, UNESCO.

 1970a *Functional Literacy: Why and How*. Paris,
 UNESCO.

 1970b *Literacy 1967-1969*. Paris, UNESCO.

 1971 *Statistical Year Book 1970*. Paris, UNESCO.

 1973 *Practical Guide to Functional Literacy*. Paris,
 UNESCO.

UNITED STATES BUREAU OF CENSUS
 1974 *Statistical Abstract* (95th ed.). Washington,
 D.C., United States, United States Printing
 Office.

VANSINA, Jan
 1961 *Oral Tradition: A Study of Historical Method-
 ology.* London, Routledge and Kegan Paul.

VARG, Paul
 1958 *Missionaries, Chinese and Diplomats.* Princeton,
 Princeton University Press.

WAGNER, C. Peter
 1973 *Look Out! The Pentecostals Are Coming.* Carol
 Stream, Illinois, Creaton House.

WALSH, Richard
 1966 "Educational Policy of the Roman Catholic Church
 in Africa," in Beaver 1966:31-46.

WARD, Ted, McKinney, L. and DETONI, John
 1971 "Effective Learning in Non-formal Modes,"
 unpublished paper, Lansing, Michigan, Michigan
 State University.

WARREN, Max (ed.)
 1971 *To Apply the Gospel: Selections from the
 Writings of Henry Venn.* Grand Rapids, Eerdmans.

WEBER, Max (translated by Talcott Parsons)
 1956 *The Protestant Ethic and the Spirit of
 Capitalism* (originally published 1930). London,
 G. Allen and Unwin.

WEBER, H. R.
 1957 *The Communication of the Gospel to Illiterates.*
 London, SCM.

WEBSTER, James B.
 1964 *The African Churches Among the Yoruba 1888-1922.*
 London, Oxford.

WEITZ, Shirley (ed.)
 1974 *Non-verbal Communication: Readings with
 Commentary.* New York and London, Oxford.

WELMERS, William
 1973 *African Language Structures.* Berkely, Univer-
 sity of California Press.

WHITELEY, Wilfred H.
 1964 *African Prose: Traditional Oral Texts.* London,
 Oxford.

WONDERLY, William
 1968 *Bible Translations for Popular Use.* London.
 United Bible Societies.

Index